IMAGES
of America

CARRBORO

ON THE COVER: Mack Watts must have been standing on top of the train depot when he took this photograph in 1953. This view is from the corner of Roberson Street looking west on Main Street, which was also North Carolina 54 at that time. E. T. Hearn's was one of seven groceries on Main Street. Note that parking was permitted on Main Street. Police chief Alvin Williams is standing behind his police car, parked in front of E. T. Hearn's grocery store. (Courtesy of the Watts Collection.)

IMAGES
of America

CARRBORO

David Otto and Richard Ellington

ARCADIA
PUBLISHING

ISBN 978-1-5316-5844-1

Published by Arcadia Publishing
Charleston, South Carolina

Library of Congress Control Number: 2010935692

For all general information, please contact Arcadia Publishing:
Telephone 843-853-2070
Fax 843-853-0044
E-mail sales@arcadiapublishing.com
For customer service and orders:
Toll-Free 1-888-313-2665

Visit us on the Internet at www.arcadiapublishing.com

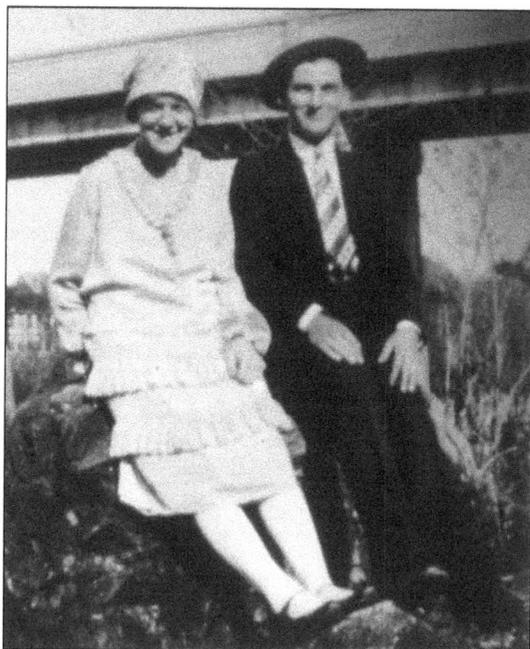

This book is dedicated to Mack Watts, whose passion for the town of Carrboro and collection of old photographs provided the foundation for this book.
This photograph was taken at the Bynum Bridge over the Haw River on the day after the marriage on March 3, 1927, of Mack and Beulah Watts. (The Watts Collection is currently in the possession of Richard Ellington.)

CONTENTS

ACKNOWLEDGMENTS

The creation of this book required the assistance of a devoted army of people and institutions. Researching the history, locating old photographs, and writing the text have been rewarding adventures. We are particularly indebted to Jean Earnhardt, whose ancestors and relatives played crucial roles in Carrboro history from Colonial settlement through the present; Frances Lloyd Shetley, who continues the Lloyd family tradition of service to the community; Rob Hogan, who shared the long and poignant story of the Hogan family; and Debbie Rigdon, who provided extensive information on the Weaver and Adams families.

Many pictures of early Carrboro came from the North Carolina Collection in Wilson Library at UNC–Chapel Hill. Curators Keith Longiotti, Harry McKeown, and Eileen McGrath were particularly helpful. Other pictures came from the North Carolina Archives in Raleigh, thanks to Kim Cumber, and from Durham Public Library North Carolina Room Collection for pictures of Julian Carr, thanks to Lynn Richardson.

We are grateful to Delores Clark, Keith Edwards, Robert Gilgor, James Harris, Polly McCauley, Velma Perry, Vivian Burnette, Natalie Boorman, and Lynden Harris for help in portraying the story of African Americans.

Former mayors Robert Drakeford, James Porto, and Ellie Kinnaird also provided useful insights and commentary on the transition of Carrboro from a sleepy mill town to a cultural center. The support of Carrboro town staff, including Trish McGuire, Sarah Williamson, Sharmin Mirman, Ruth Heaton, and Jeff Brubaker has been invaluable. Former alderman and current poet laureate Jay Bryan also helped us understand the evolution of the town politically and artistically.

Finally we are grateful to local artist Emily Weinstein for the marvelous drawing of "Buck" Taylor; to photographers Catherine Carter, Billy Barnes, and Jackie Helvey for permission to use their images; to Jock Lauterer and Mayor Mark Chilton for encouragement and support; and to our wives, Alice and Priscilla, for their patience in letting us complete the work.

INTRODUCTION

Drop down with me behind the afternoon traffic
And hear the mourning dove sing "hey there there"
The bikes glide down Old Pittsboro Street
The owls hoot above Bolin Creek.
Beneath the pavement and between Mill-style clapboards
Souls whisper and reminisce.

—From "Song to Carrboro" by poet laureate Jay Bryan, 2010

This book is a pictorial introduction to the colorful history of Carrboro in celebration of the town's centennial. Carrboro was incorporated in 1911 as Venable, named after Francis Preston Venable, president of the University of North Carolina at that time. Two years later, the town changed its name to Carrboro at the request of Julian Shakespeare Carr in return for building roads and providing electric power from generators in the cotton mill, which he had purchased from Thomas Lloyd in 1909.

The book contains images of people, buildings, churches, and places prominent in the history of the town. The text is brief, and the selection of pictures is limited. If this book whets your appetite for more detailed accounts of Carrboro history, a reference list is provided at the end.

The first four chapters are organized chronologically, beginning with colonial settlement in the mid-1700s (chapter one). Descendants of many colonial families still live here. Chapter two describes the construction of the railroad spur and its role in spawning the mill town (1880–1920). Chapter three covers the rise and fall of the cotton mills (1920–1960), and chapter four portrays the dramatic transformation from mill town to dynamic cultural center (1960–present). The remaining two chapters tell other parts of the story that do not fit neatly in a chronological framework, including African American history (chapter five) and a peek into the future (chapter six).

Carrboro is renowned for its quirky character, rooted in Colonial history. Thomas Lloyd, who purchased land near present-day Carrboro in the 1750s, was sheriff of Orange County at the time of the Regulator Rebellion (1768–1771). Lloyd was also a major in the Orange County Militia commanded by Edmund Fanning, the notorious tax collector who incited the rebellion. Lloyd was thus at odds with many neighbors who sympathized with the Regulators. Unlike many Tories, Lloyd remained in Orange County after the Revolutionary War, but he never regained a position of power.

John "Buck" Taylor was another salty character in early history. Taylor was hired as the first steward of the university when it opened in 1795. Since he was not a good cook, the students ransacked his quarters and complained that the food was insufficient and inedible. Kemp Battle, in his monumental history of the university (1907), wrote that Taylor "retired to his plantation 3 miles west of Chapel Hill." According to legend, Buck Taylor was buried standing upright with a jug of whiskey in each hand, a tale that has been passed down through time. His unmarked gravesite is located in Carrboro on Buck Taylor Trail.

A second Thomas Lloyd, descendant of the first, was the catalyst most responsible for the creation of Carrboro. The later Lloyd was an industrial genius who immediately understood the commercial value of the railroad spur completed in 1882. The gristmill and cotton gin that he built near the railhead in 1883 were profitable and encouraged him to develop the Alberta Cotton Mill in 1898. Surprisingly, Lloyd could neither read nor write!

Another unforgettable descendant was Braxton "Brack" Lloyd, a beloved country doctor and early mayor of Carrboro. Brack was legendary for his devotion to the people and for his unconventional practice of medicine. He always carried a small surgical kit with him. When needed, he would pull out a scalpel, wipe it on his sleeve, and perform minor surgery. If questioned about hygiene, he would reply, "I was born sterile!" Brack was best known for delivering babies. When women went into labor, he would go to their home and stay until the baby was born. If the labor was long and the baby born in

the wee hours, Brack was known to ask the new mother to move over so that he could get some rest.

Frances Lloyd Shetley has also left an indelible imprint on Carrboro history. Frances chaired the Transportation Advisory Board, was instrumental in efforts to preserve Carr Mill, and served as alderwoman from 1987 to 1997. A bikeway that runs between Greensboro and Shelton Streets near Carrboro Elementary School is named after her in recognition of many years of service to the community. Shetley, an avid gardener, suggested a wildflower garden along the greenway. The Piedmont Wildflower Meadow provides pleasure to all who use this popular connector.

Some aspects of Carrboro history, like the antebellum and Jim Crow periods, have seldom been discussed. Early census reports indicate that the majority of landowners in Orange County had slaves to cope with the hardscrabble existence of yeoman farmers. Descriptions of the life of African Americans during this period are scant, although the Lloyd family is known to have had slaves, because Stephen Lloyd was reportedly shot to death in 1792 by a slave named Isaac.

After the Civil War, few African Americans settled in the fledgling community due to its unwelcoming reputation. Carrboro, like most other towns in the South, embraced segregation and Jim Crow practices that emerged after Reconstruction. Oral histories collected from people who grew up in Carrboro prior to World War I paint a harsh picture. Children "learned, very early, the structures of race relations in the community. Black people lived in separate areas of the village, and several people remembered that Blacks did not venture into the village after dark. They did not work in the mill except in menial job," wrote Valerie Quinney in 1980.

This book includes a chapter about African American businessmen, educators, and citizens who have been prominent in the history of Carrboro. Integration of the public schools in Chapel Hill–Carrboro and the larger community in the 1960s brought both frustration and opportunity to African Americans. The end of segregation was an important factor in the transformation of Carrboro from a provincial backwater to the progressive and dynamic community of today.

Ellie Kinnaird (former mayor, longtime state senator, and devotee extraordinaire to the town) likes to emphasize the resiliency of Carrboro. The town emerged when the railroad spur to University Station near Hillsborough opened in 1882 and the Alberta Cotton Mill was built in 1898. The fate of the town was closely linked to the textile industry for the next 60 years. With the closing of the mills in the early 1960s, Carrboro stumbled briefly but quickly reinvented itself as one of the leading cultural centers in the Southeast.

Several factors contributed to the renaissance of Carrboro, including the decision of the university in the mid-1960s to outsource student housing, which stimulated the rapid growth of apartment complexes and an influx of students; the arrival in 1975 of the charismatic French painter Jacques Menache, who conceived and nurtured the ArtsCenter; and the decision in 1976 to restore the old Alberta Mill, which culminated in the opening of Carr Mill Mall in 1978.

The recent economic turndown has drastically slowed the growth of Carrboro, but the good times are bound to return as they always have in the past. When the economy rebounds, fasten your seat belts for a dizzying ride. The final chapter provides a brief sketch of four high-rise developments that will dramatically alter the landscape of downtown Carrboro. During the first century, Carrboro prided itself on its old-fashioned look. As the town enters the second century, Carrboro is on the cusp of a major transition upward into the future!

Sing to Carrboro,
No one silent, no one not ever heard
Or more important than the other,
And everyone with hands to be held
In the nights of wind and storm
And folding mine into yours, we'll take them into your heart,
And in the unknown homes
We will flood you with emotion

—From "Song to Carrboro" by poet laureate Jay Bryan, 2010

One

COLONIAL SETTLEMENT

Scotch-Irish immigrants, moving from Pennsylvania and New York in search of more land, began settling near present-day Carrboro in the mid-1700s. Orange County, created in 1752, was named in honor of William of Orange, king of England from 1689 to 1702. Early settlers included Thomas Lloyd (1753), John Hogan (1750s), Joseph Barbee (1763), Gilbert Strayhorn (1769), and Thomas Weaver (c. 1800). Many descendants of these families still live in the area.

Thomas Lloyd was one of the largest landowners in Orange County, whose land included 599 acres near Calvander purchased from Lord Granville in the 1750s. Lloyd was prominent in Orange County, serving as sheriff, assembly member, and major in the provincial militia. His loyalty to the crown, however, put him at odds with many other local residents, and his role in quelling the Regulator Rebellion was not appreciated by patriots.

Some of the original Lloyd property has been passed down in the family (see family tree, page 14). Eppie Brewer inherited the property in the late 1800s and married Chesley Andrews, descendant of another local family dating back to Colonial days. Jean Andrews Earnhardt currently owns the land. The Earnhardts realized that southern Orange County was growing so rapidly that it would be difficult to keep the remaining property intact. To preserve some of the land, they put 120 acres, known as the Lloyd-Andrews Historic Farmstead, in a conservation easement with the Triangle Land Conservancy in 1997, which ensures that this land will never be developed.

The Lloyd family has been prominent in the history of Orange County and Carrboro for more than two centuries. Another Thomas Lloyd realized the commercial potential of the railroad spur in 1882 and built the first cotton gin, steam-powered gristmill, and cotton mill near the station. Braxton Lloyd was a legendary country doctor and early mayor. Frances Lloyd Shetley served as alderwoman for many years and has been a civic leader for generations. Black and white descendants of the Barbee, Cheek, Hogan, Hardee, Sparrow, Strayhorn, and Weaver families have also served the community with distinction for centuries.

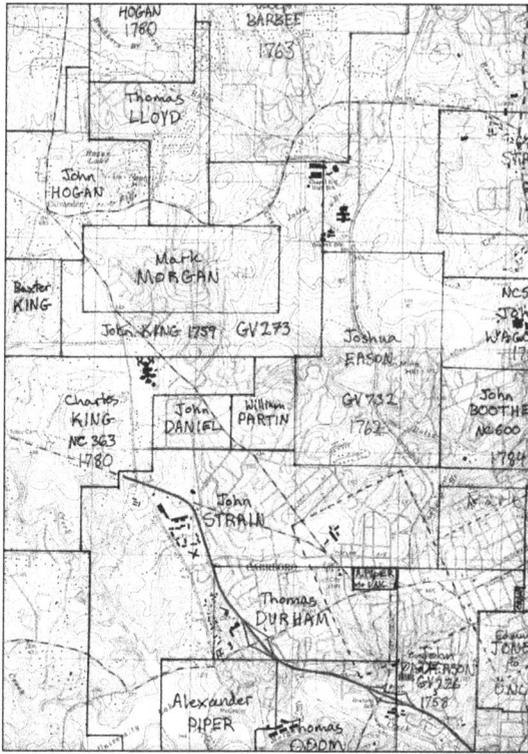

Mayor Mark Chilton (2010), a local history buff, superimposed the present Carrboro town limits on this map (left), which shows the original land grants from Lord Granville. Although the town was not established for another 120 years, many names prominent in the history of Carrboro appear on this early map, including Thomas Lloyd, Mark Morgan, and John Hogan. Descendents of these families still walk the land. The Collet map below was prepared for King George III of England in 1777. This detailed section is part of a larger map of North Carolina. Note the names "T. Loyde" (Thomas Lloyd) and "M. Morgan" (Mark Morgan), which appear in the approximate location of Carrboro today. (Left, courtesy of Mark Chilton; below, courtesy of Jean Earnhardt.)

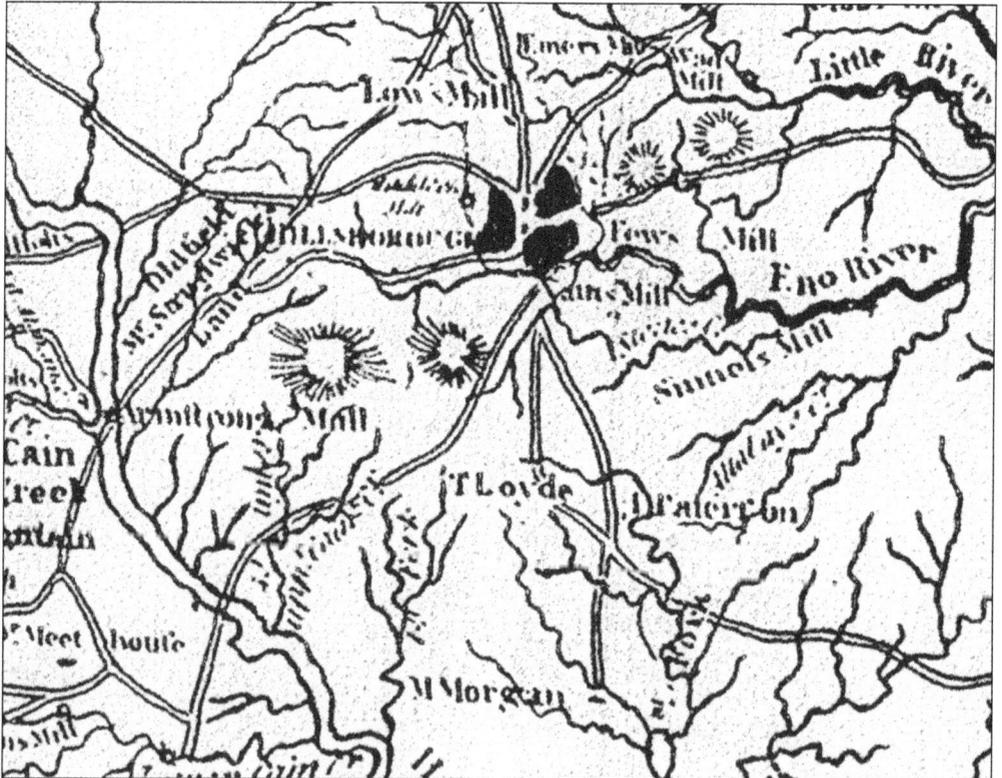

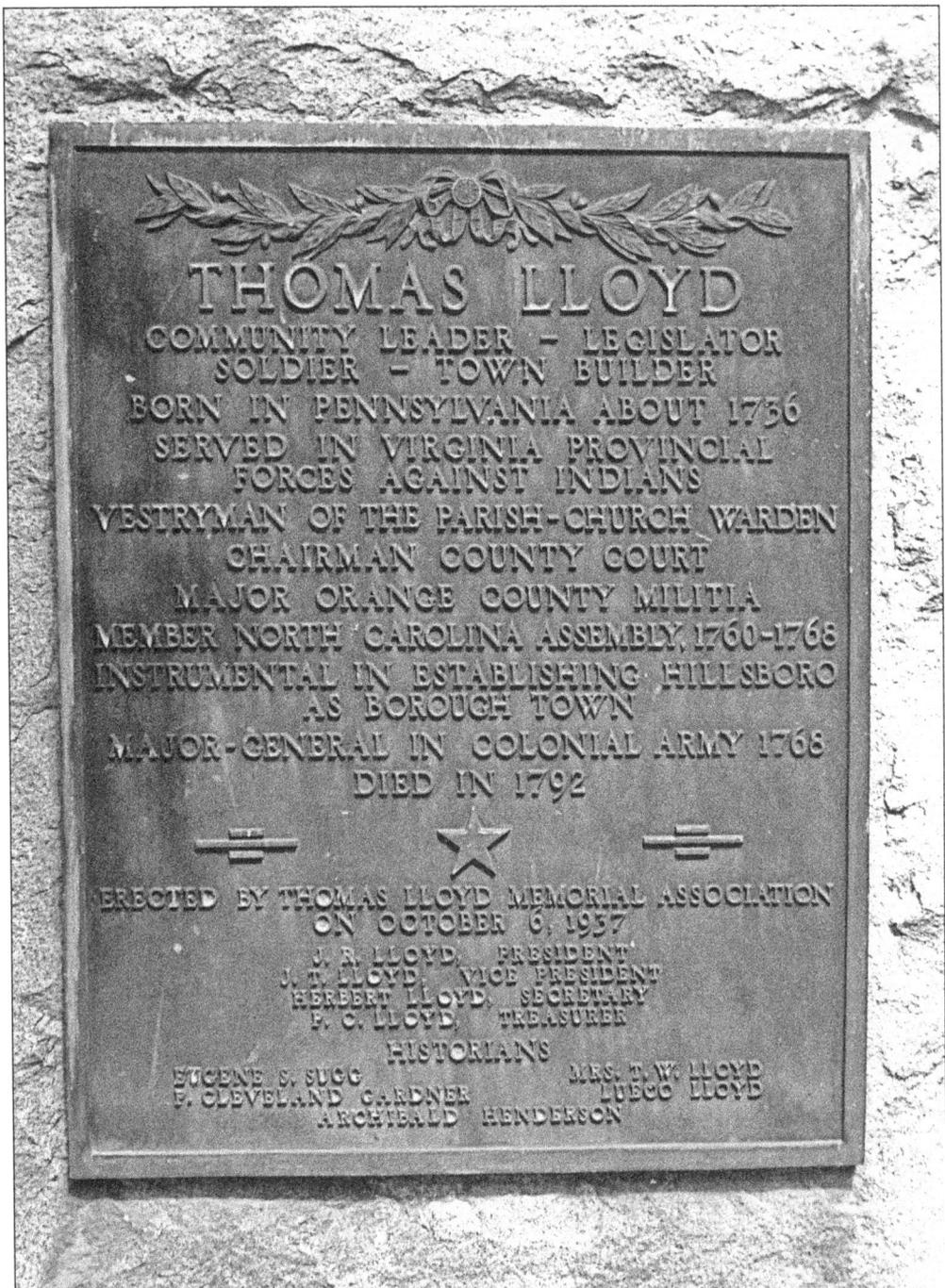

THOMAS LLOYD
COMMUNITY LEADER — LEGISLATOR
SOLDIER — TOWN BUILDER
BORN IN PENNSYLVANIA ABOUT 1736
SERVED IN VIRGINIA PROVINCIAL
FORCES AGAINST INDIANS
VESTRYMAN OF THE PARISH-CHURCH WARDEN
CHAIRMAN COUNTY COURT
MAJOR ORANGE COUNTY MILITIA
MEMBER NORTH CAROLINA ASSEMBLY 1760-1768
INSTRUMENTAL IN ESTABLISHING HILLSBORO
AS BOROUGH TOWN
MAJOR-GENERAL IN COLONIAL ARMY 1768
DIED IN 1792

ERECTED BY THOMAS LLOYD MEMORIAL ASSOCIATION
ON OCTOBER 6, 1937
J. R. LLOYD, PRESIDENT
J. T. LLOYD, VICE PRESIDENT
HERBERT LLOYD, SECRETARY
P. C. LLOYD, TREASURER
HISTORIANS
EUGENE S. SUGG MRS. T. W. LLOYD
F. CLEVELAND GARDNER LULUGO LLOYD
ARCHIBALD HENDERSON

The Thomas Lloyd Memorial Association erected this monument, located off old North Carolina 86 just beyond Calvander, in 1937 with great fanfare. The plaque documents that Lloyd was a prominent man in Orange County before the Revolutionary War. The monument also implies that he was a Revolutionary Patriot, but the historical record suggests otherwise (see next page). Lloyd was a major in the Orange County Militia (loyal to the king), but not a major general in the Colonial Army. (Photograph by Dave Otto.)

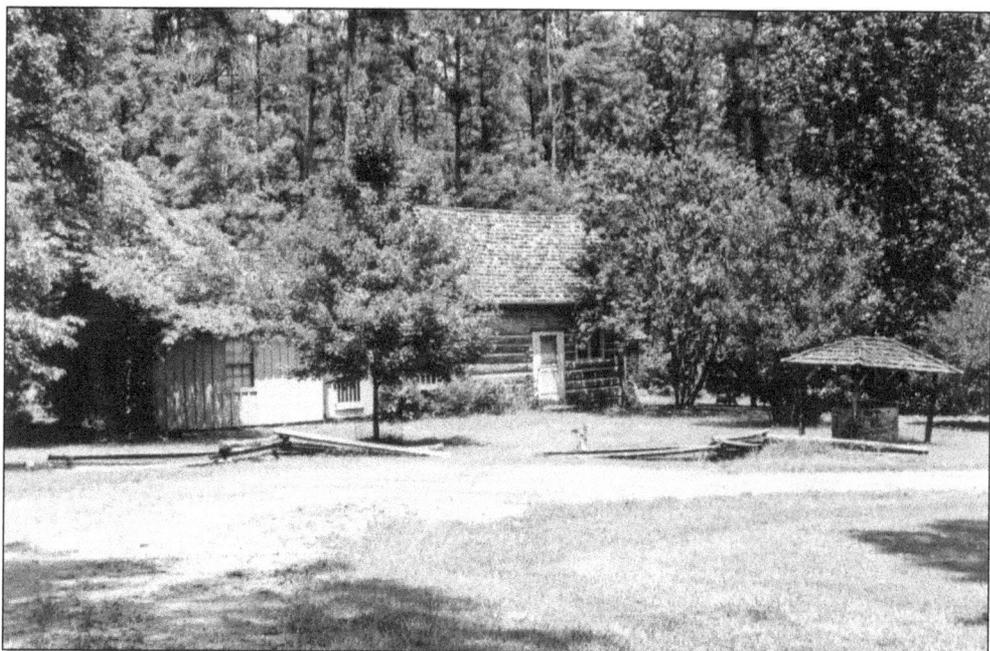

The Lloyd family built the log house visible above on the right around 1800. This structure is one of the oldest houses in the Carrboro area. In 1768, farmers in Orange County rebelled against taxes imposed by Edmund Fanning on behalf of the Colonial government. The rebels, known as "Regulators," rioted in Hillsborough in 1770, severely beating Fanning. To end the rebellion, Gov. William Tryon assembled the militia and confronted the Regulators on May 16, 1771, in present-day Alamance County. The poorly trained Regulators were badly beaten. Sheriff Thomas Lloyd arrested 15 later, and six were hanged on June 19, 1771. James Pugh was quoted at the gallows: "The blood that we have shed will be a good seed, sown in good ground, which soon shall reap a hundredfold." (Photographs by Richard Ellington.)

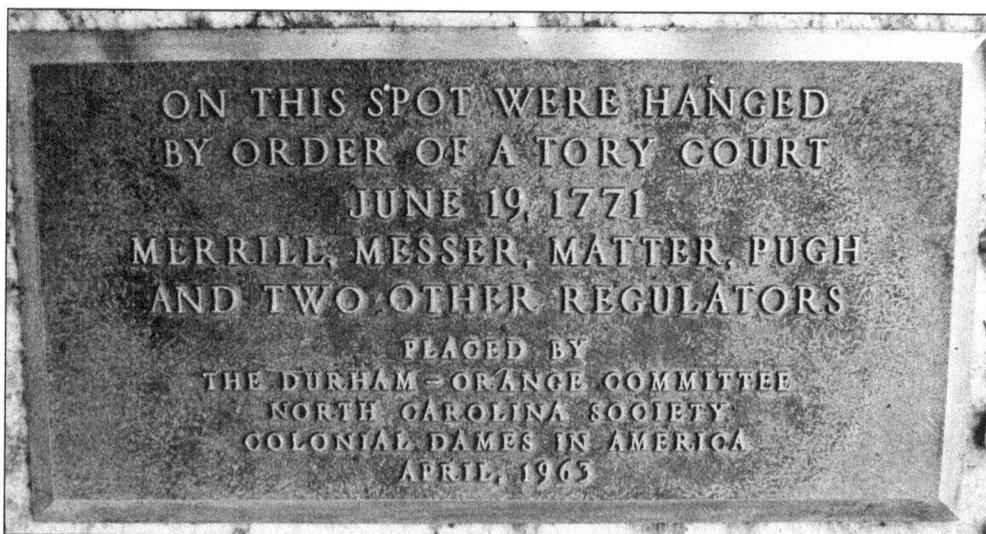

After the Revolutionary War, North Carolina reissued state grants for land grants obtained from Lord Granville. The original land grant had been made to Thomas Lloyd, but the State of North Carolina refused to reissue the grant in his name because of his loyalty to England. The land was therefore deeded to his son, Stephen. (Courtesy of Jean Earnhardt.)

The remnants of a whetstone mine are located on what was once Thomas Lloyd's property. Whetstones were used in the past to sharpen cutting tools, particularly knives and axes. Whetstones were a prized commodity until recently, and owners of the Lloyd-Andrews farmstead shared this valuable resource with friends and neighbors. (Photograph by Dave Otto.)

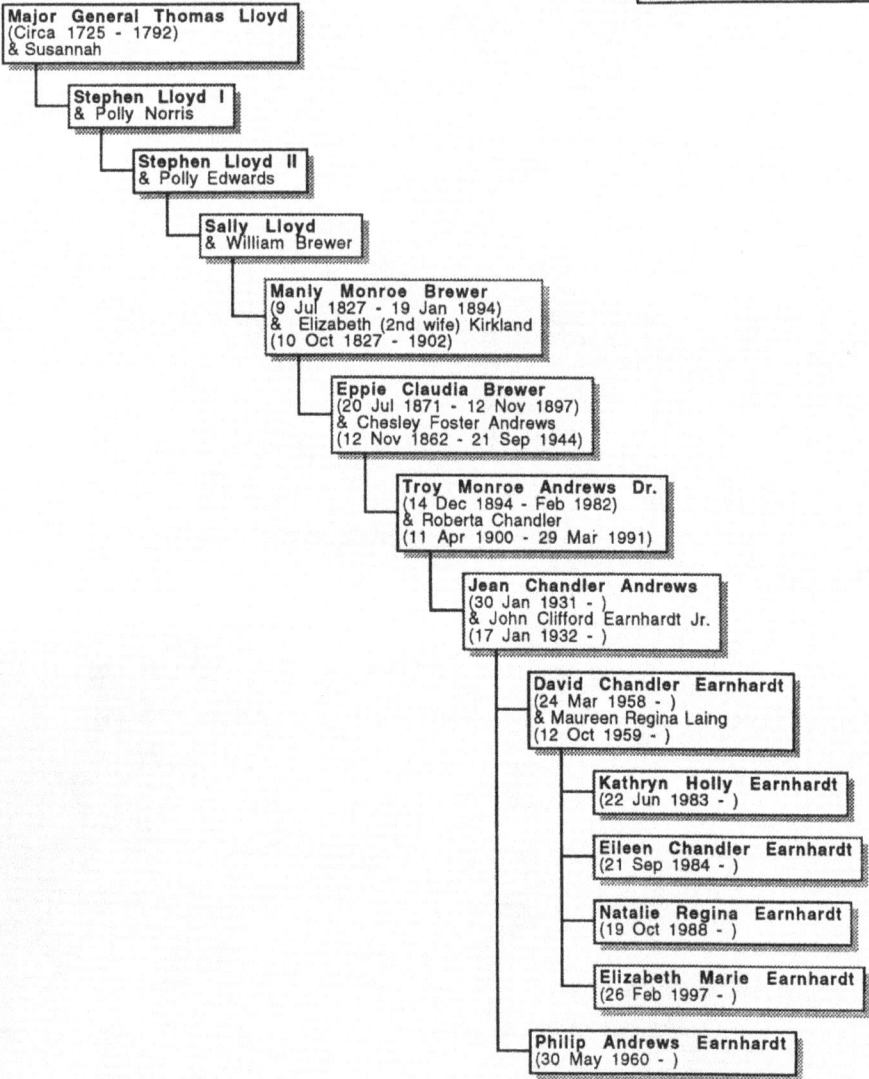

Major General Thomas Lloyd
(Circa 1725 - 1792)
& Susannah

Stephen Lloyd I
& Polly Norris

Stephen Lloyd II
& Polly Edwards

Sally Lloyd
& William Brewer

Manly Monroe Brewer
(9 Jul 1827 - 19 Jan 1894)
& Elizabeth (2nd wife) Kirkland
(10 Oct 1827 - 1902)

Eppie Claudia Brewer
(20 Jul 1871 - 12 Nov 1897)
& Chesley Foster Andrews
(12 Nov 1862 - 21 Sep 1944)

Troy Monroe Andrews Dr.
(14 Dec 1894 - Feb 1982)
& Roberta Chandler
(11 Apr 1900 - 29 Mar 1991)

Jean Chandler Andrews
(30 Jan 1931 -)
& John Clifford Earnhardt Jr.
(17 Jan 1932 -)

David Chandler Earnhardt
(24 Mar 1958 -)
& Maureen Regina Laing
(12 Oct 1959 -)

Kathryn Holly Earnhardt
(22 Jun 1983 -)

Eileen Chandler Earnhardt
(21 Sep 1984 -)

Natalie Regina Earnhardt
(19 Oct 1988 -)

Elizabeth Marie Earnhardt
(26 Feb 1997 -)

Philip Andrews Earnhardt
(30 May 1960 -)

This chart traces the lineage from Thomas Lloyd to Jean Andrews Earnhardt, current owner of the Lloyd-Andrews Historic Farmstead. In 1998, the Earnhardt family put 120 acres in a conservation easement with the Triangle Land Conservancy, ensuring that the property will never be developed. (Courtesy of Jean Earnhardt.)

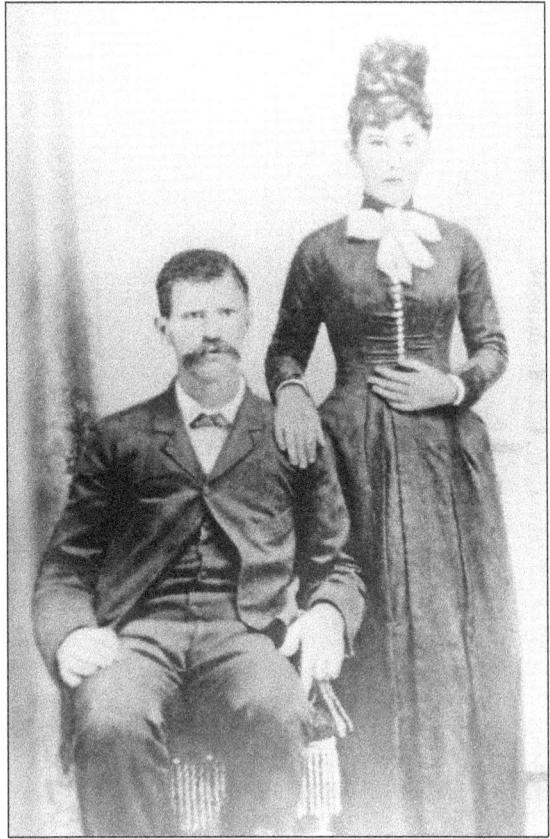

Chesley Andrews (left) and Eppie Brewer are pictured around 1890 in the photograph at right. Eppie inherited the Lloyd property in the late 1800s and married Chesley Andrews around 1890. The Andrews family has also lived in Orange County since Colonial days. A son, Troy, was born in 1894, and daughter Nita was born in 1897, although Eppie died during childbirth. Troy (left) and Nita (right) Andrews are pictured below around 1900. Troy and Nita both obtained doctoral degrees from the University of North Carolina—Troy in organic chemistry and Nita in romance languages. Troy travelled extensively as a consultant, and Nita taught French in several schools, including Catawba College. Both returned to the Lloyd-Andrews Farmstead to live after retiring. (Both, courtesy of Jean Earnhardt.)

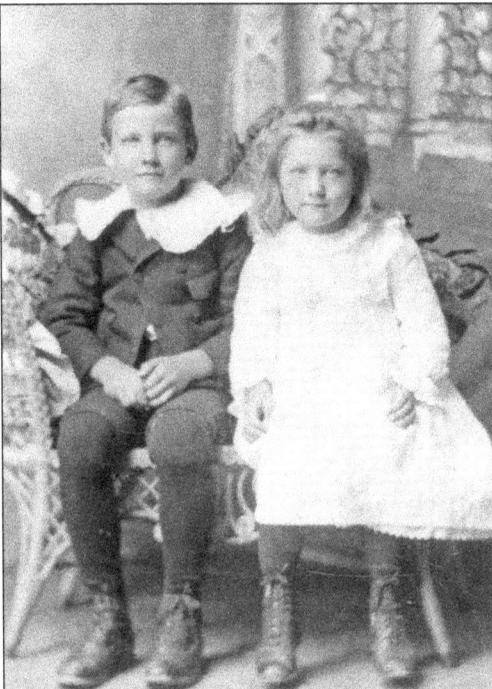

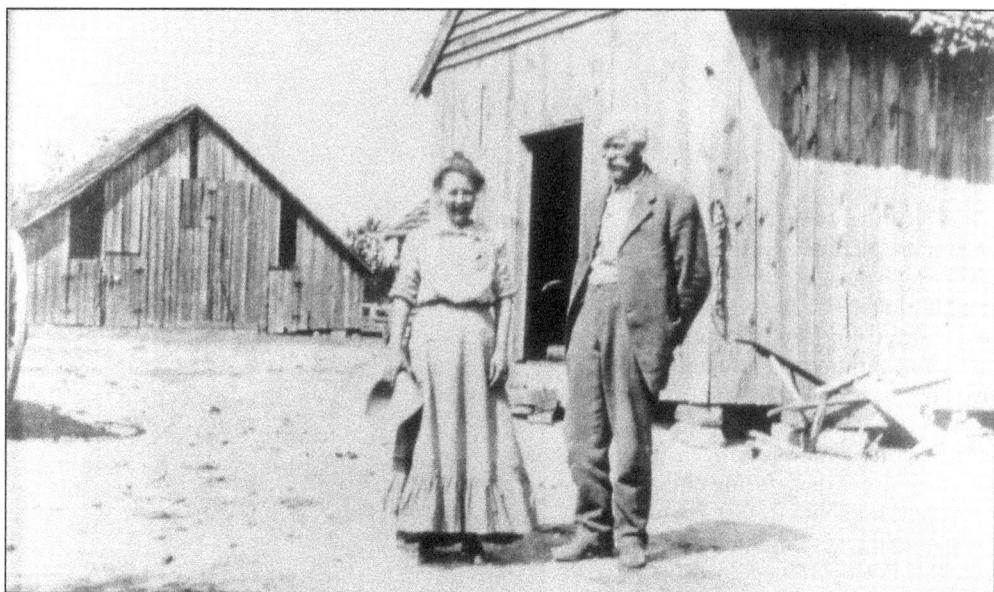

Chesley Andrews and his second wife, Genera Tilley (above), are pictured on the farm around 1900. Chesley raised cotton, tobacco, and vegetables. Genera was a short, spunky woman who enjoyed farm work. Granddaughter Jean Earnhardt remembers her grandmother wringing the necks of chickens and plucking their feathers. Genera also churned butter and pressed the patties for Chesley to sell. Once a week until the mid-1930s, Chesley delivered produce, chickens, and butter to customers in Chapel Hill—first by horse and wagon and later in a truck. Since money was scarce during the Depression, people usually paid in coins. Chesley carried an old sock to collect the coins. In the picture below, Genera (left) and Nita (right) are standing in front of Troy (left) and Chesley (right), who are sitting on a horse and donkey around 1910. (Both, courtesy of Jean Earnhardt.)

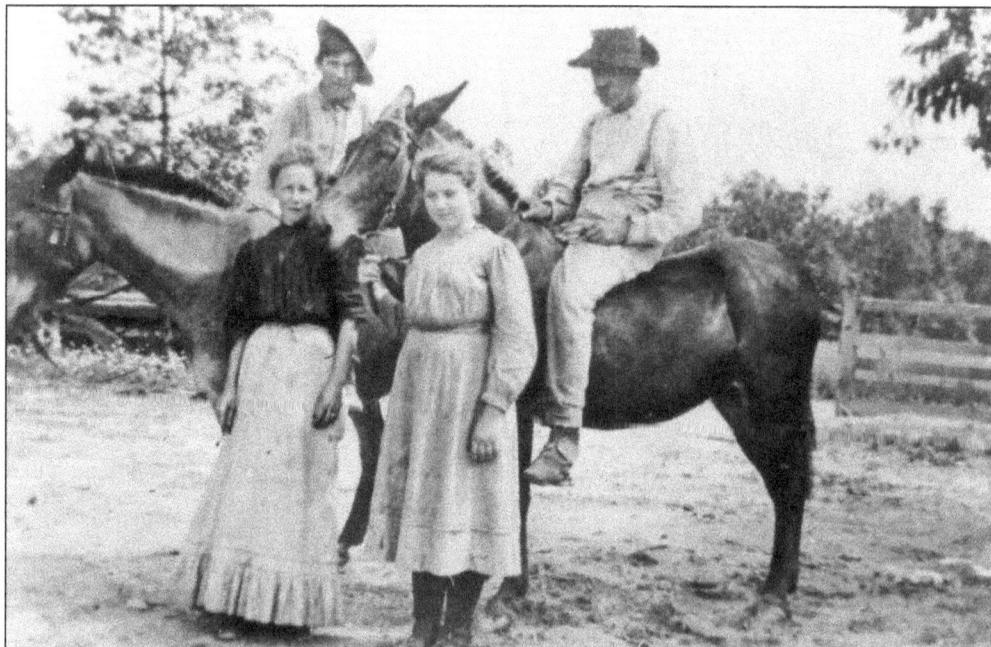

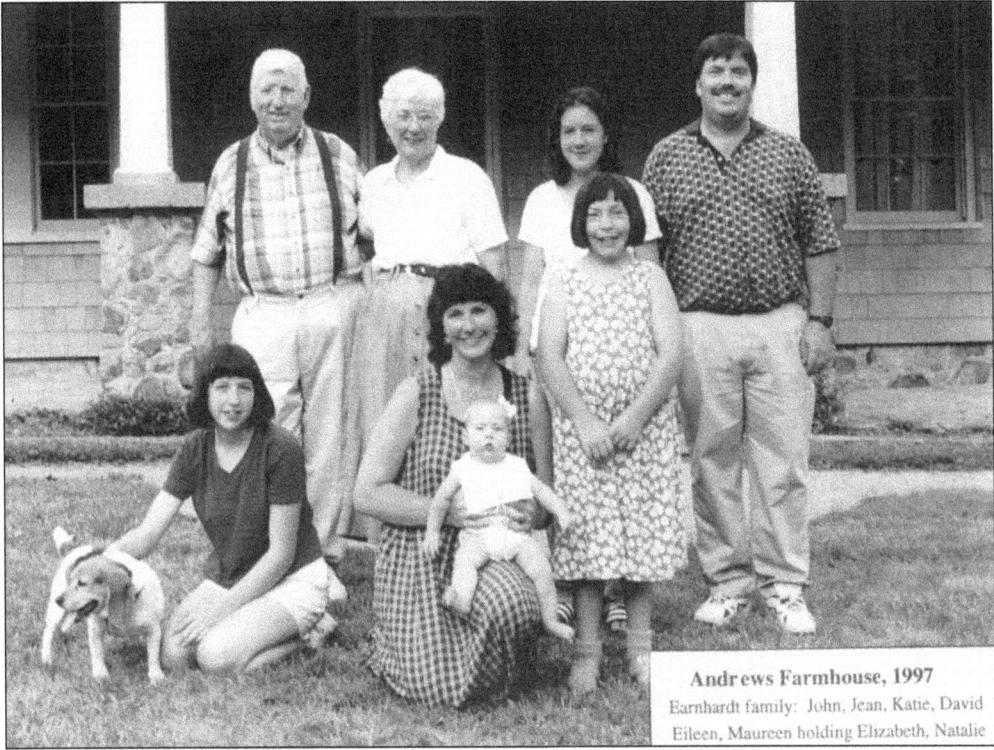

Andrews Farmhouse, 1997
Earnhardt family: John, Jean, Katie, David
Eileen, Maureen holding Elizabeth, Natalie

The Lloyd-Andrews farmstead has an irresistible charm, which has drawn the family back over the centuries. Jean Andrews Earnhardt, daughter of Troy Andrews, inherited the property when her parents died. Jean and her husband, John Earnhardt, moved back to the farmstead when John retired. The Earnhardts brought their two sons, Stephen and David, with them. The group is standing in front of the farmhouse that Chesley Andrews built in 1898. David and his family now live in the old farmhouse. (Courtesy of Jean Earnhardt.)

This road leads from Hillsborough to Chapel Hill and lines up with the road to Fayetteville. It may have connected to what is now Watters Road. This section of the road can be seen just north of Calvander beside Old North Carolina 86 as it crosses Bolin Creek. (Photograph by Richard Ellington.)

17

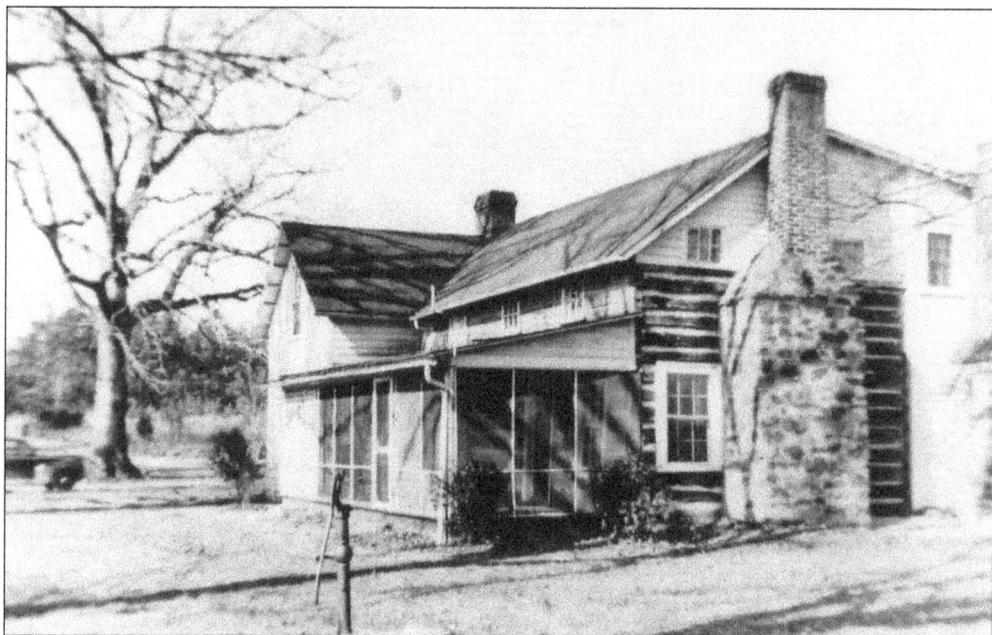

According to Claudia Brown et al (1983), the Weaver House is the oldest surviving structure in Carrboro. The one-and-a-half story log section was built around 1740 and is thought to have been a tavern on the Hillsborough Wagon Road. Thomas Weaver bought the property in 1811, and it remained in the Weaver family for 99 years—hence the name Weaver House. The house shown in the lower picture was originally a barn on the Weaver farm. Walter Kuralt, owner of the former Intimate Bookstore in Chapel Hill, converted it to a house. (Both, courtesy of Deborah Rigdon.)

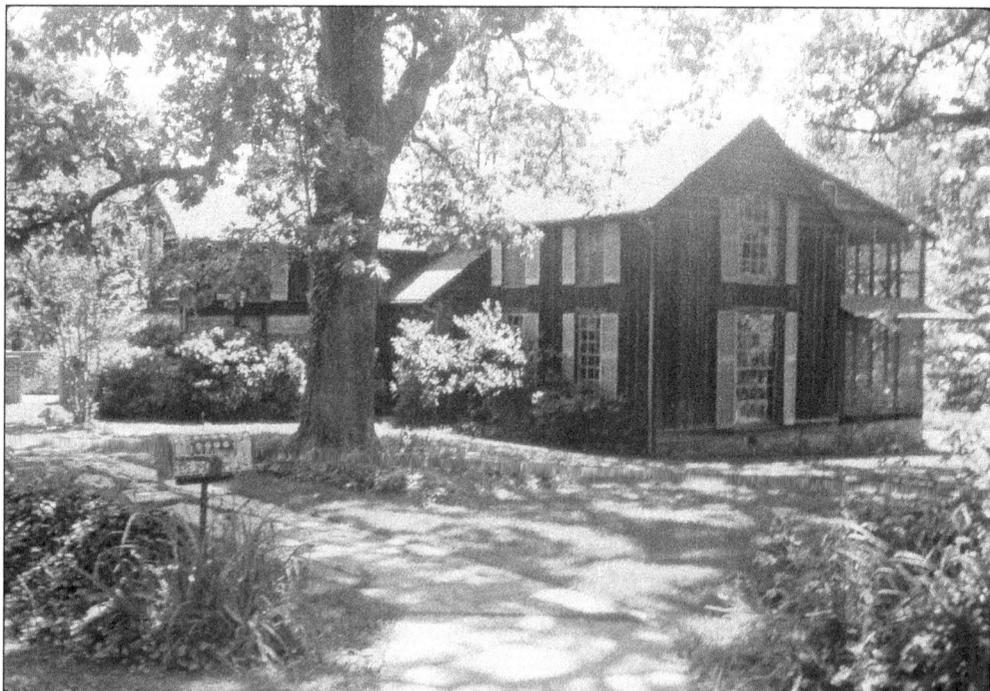

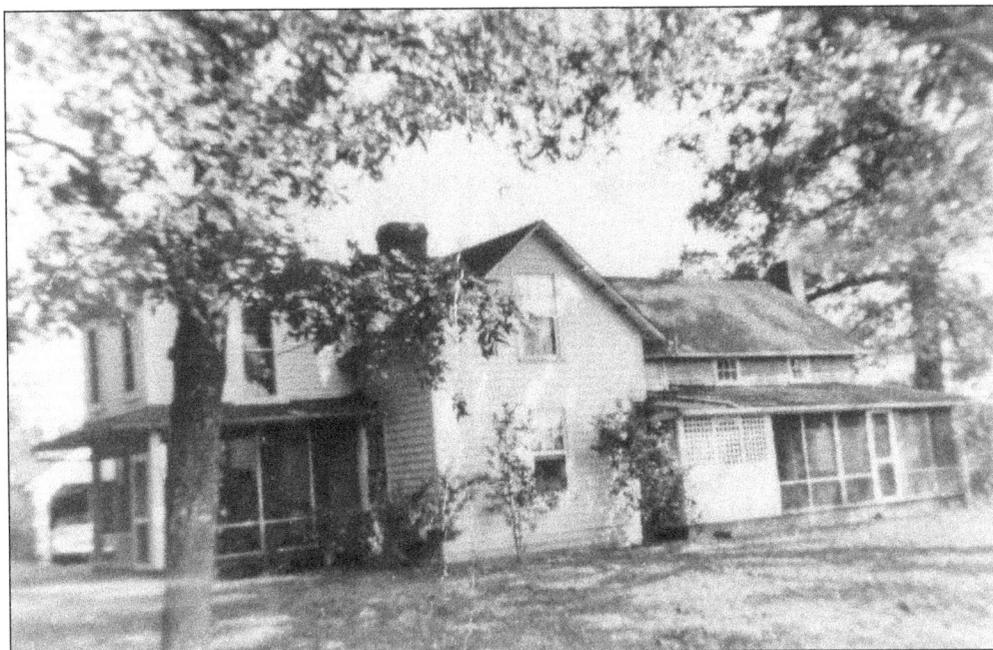

The Hogan family purchased the Weaver Farm in 1910 and sold it to Sarah Watters in 1941. Watters modified the front of the house, as shown in the picture above. J. Edison Adams, a professor of botany at the University of North Carolina, purchased the house and land in 1950. The land had been farmed and timbered for at least 150 years, but Adams decided to let the land revert back to nature. He also removed the renovations made by Watters. Pictured at right, from left to right, are his wife, Katherine Adams, J. Edison, and his sister Harriet Adams. Carrboro acquired 27 acres between Wilson Park and Bolin Creek in 2004 from the Adams family for preservation. (Both, courtesy of Deborah Rigdon.)

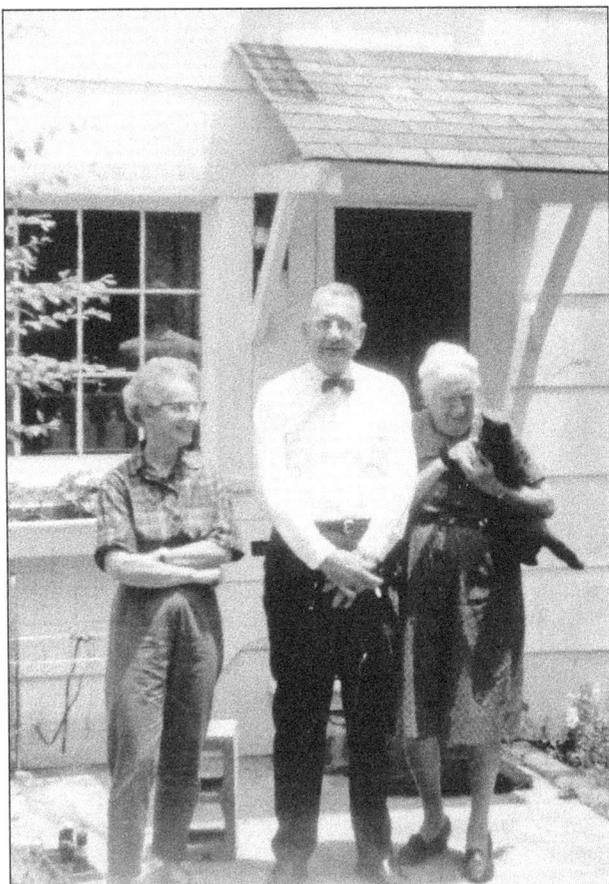

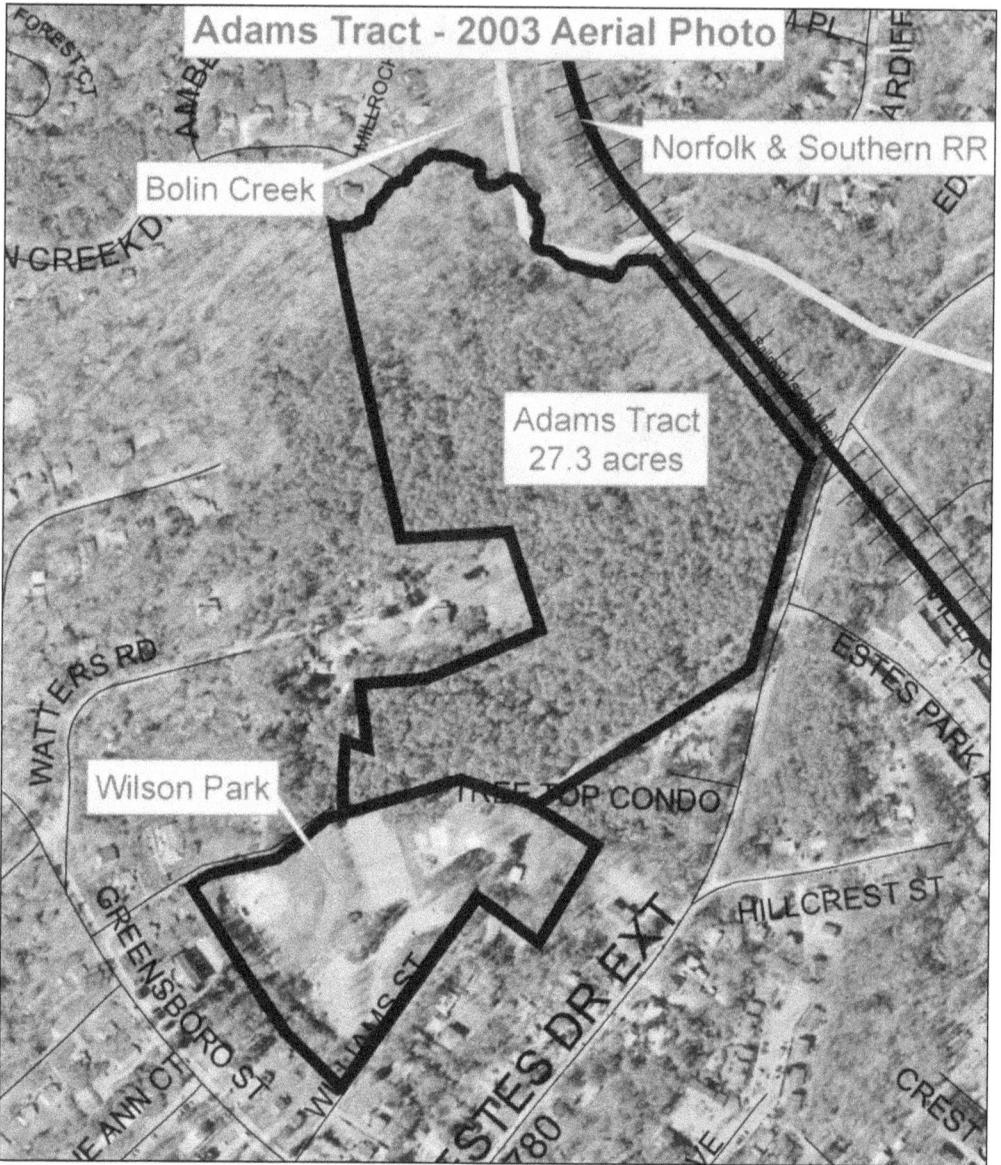

Adams Tract - 2003 Aerial Photo

Norfolk & Southern RR

Bolin Creek

Adams Tract
27.3 acres

Wilson Park

TREETOP CONDO

ESTES PARK

WATTERS RD

GREENSBORO ST

WILLIAMS ST

ESTES DR EXT

HILLCREST ST

CREST

This aerial photograph of the Adams Preserve was taken in 2003. The Adams Tract is a 27-acre plot of urban forest that over the last century has reverted from farmland/pasture to early successional forest and a mature, pine-dominated forest. It is located close to downtown Carrboro and thus is well situated to become a refuge, biological preserve, and educational opportunity for the citizens of Carrboro and vicinity. (Courtesy of www.ci.carrboro.nc.us/TownWide/PDFs/AdamsTractManagementPlan.pdf)

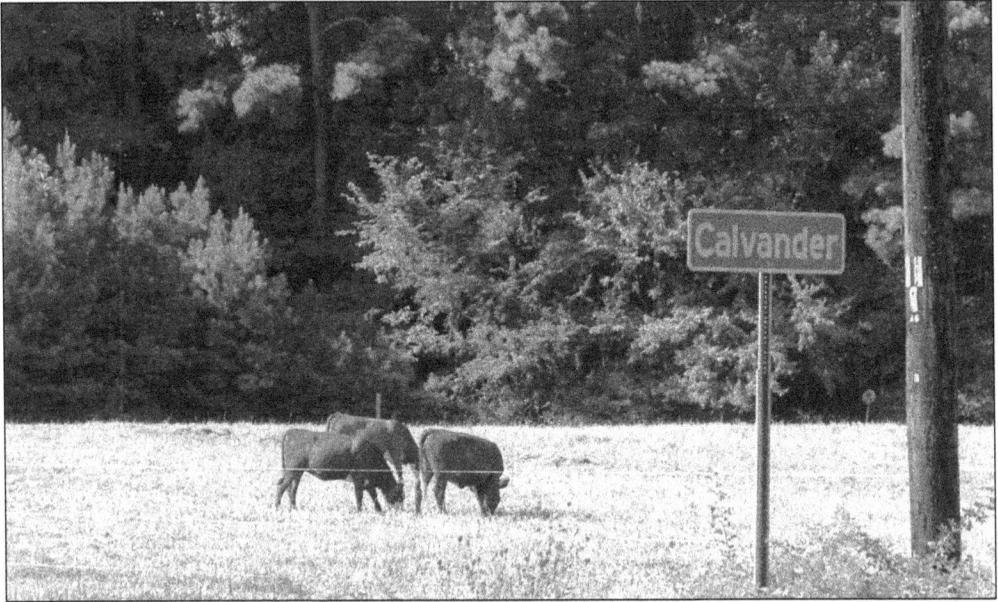

As reported by Sally Hicks in 1996, "The Hogan farm in pastoral Calvander stood testament to the sweat of generations—and a way of life fast disappearing. . . . The green pastures and soft hills of dairy country roll away from the narrow highway, white fences encircle barns and silos stand out against the electric blue sky. This land is home to families who lived there before the Revolutionary War and live there still: the Lloyds, the Cheeks, the Cateses, and the Hogans." Encroaching development forced the Hogans to close the dairy in 1996 after farming the land for over two centuries. Rob Hogan raised cattle nearby (above) until 2010, when he succumbed to a farming accident. His famiy continues to operate the cattle farm. Below is a Hogan family get-together on the dairy farm before it closed. (Above, photograph by Dave Otto; below, courtesy of Rob Hogan.)

In the photograph above, family and friends are gathered on the Hogan farm. Annie Hogan Carr and Sam Alston are seated on the swing. Sam began working on the farm at age 13, when his father died and he needed to help provide for his family. Sam never worked anywhere else. Sam was entrusted to operate the farm when the Hogans were away. Rob Hogan (below) is boating on Lake Hogan with his son Daniel and dog Pete around 1980. "Anyone older than 50 who grew up in Orange County knows Hogan Lake as the place they swam on weekends, had their first kiss, their first date, their high school graduation picnic. Every summer the lake drew people from miles around to fish and picnic," wrote Sally Hicks. (Both, courtesy of Rob Hogan.)

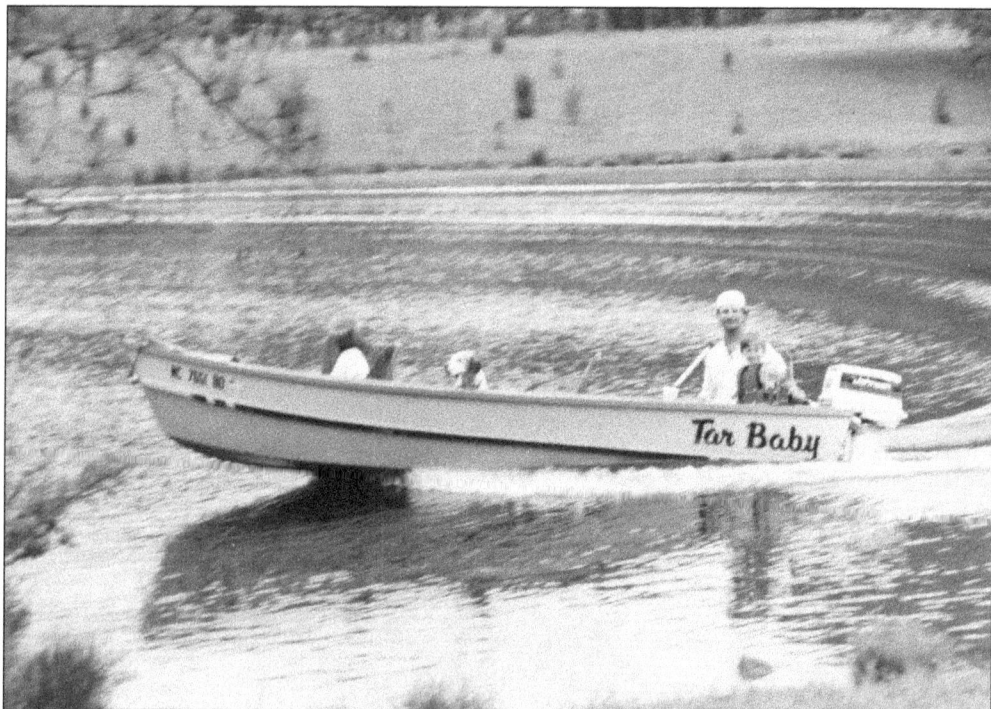

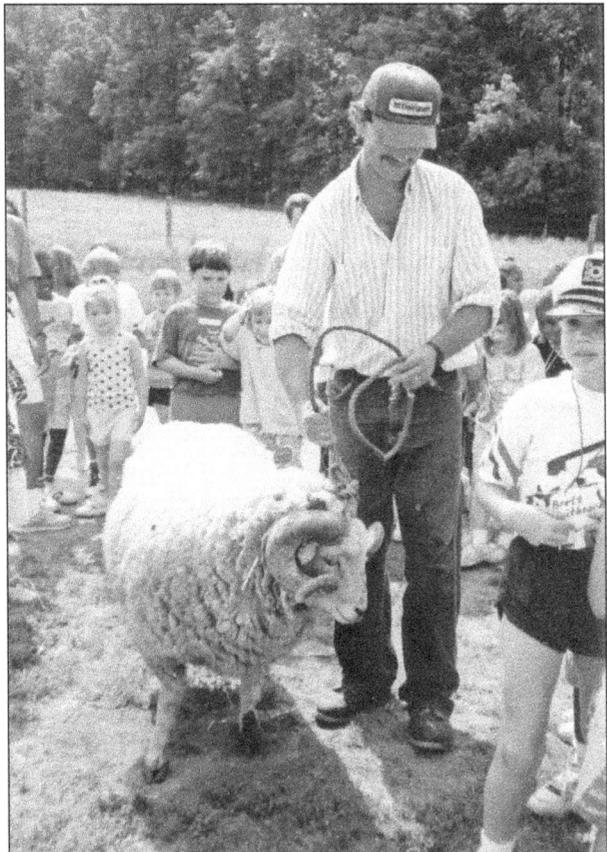

Rob (left) and his father Bob (above) are shown in the barn. The decision to sell the dairy farm in 1996 was wrenching for the Hogan family. Sally Hicks wrote, "If there was a defining moment for the Hogan farm, the decision [by Carrboro] to create the transition area was it. But the decision to sell was really built on a thousand small choices. . . . It's been a mighty good life. But it's time to go on to something else." Rameses, the University of North Carolina mascot ram, has been raised on the Hogan farm since 1924. Rob continued the tradition on his farm. In the photograph at right, Rob is showing Rameses to a group of visiting schoolchildren. (Both, courtesy of Rob Hogan.)

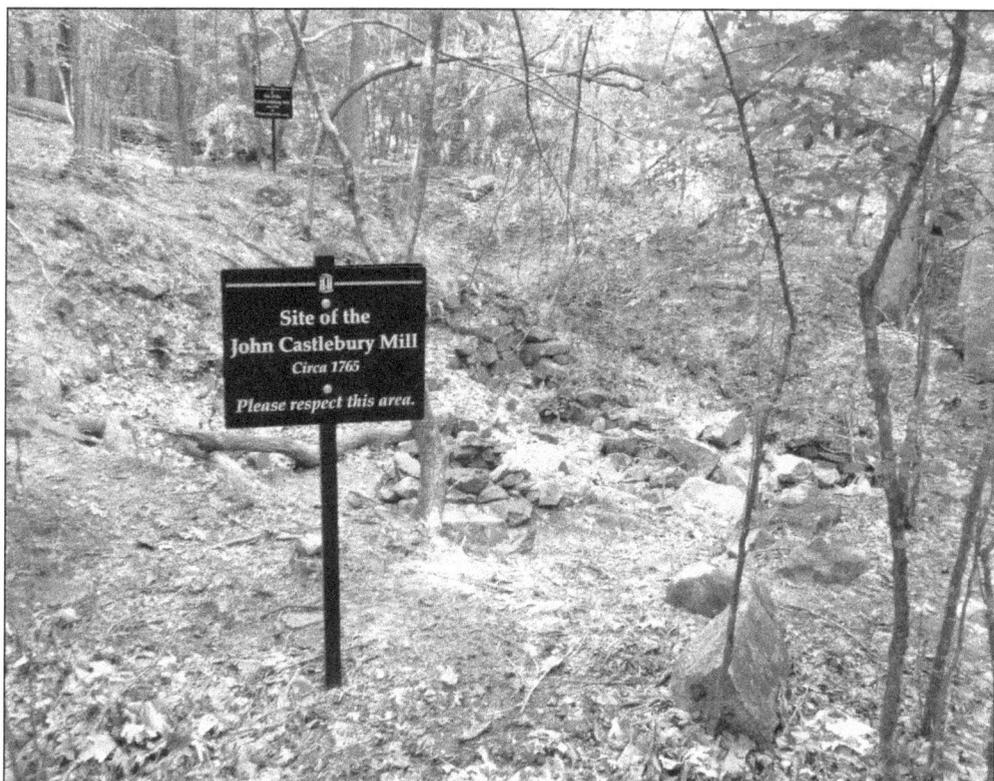

William Castlebury was granted permission to "erect a Water Grist Mill on Boling's Creek" on November 1, 1763, according to Orange County records. The ruins of the mill, including the foundation (above), millrace (below), and dam are located a few hundred yards upstream from the Spring Valley subdivision on Carolina North (UNC) property. The millrace is very well preserved. One can walk upstream along the millrace to where the ruins of the dam for the millpond are located. For many years the university rented garden space at the site of the millpond. (Photographs by Dave Otto.)

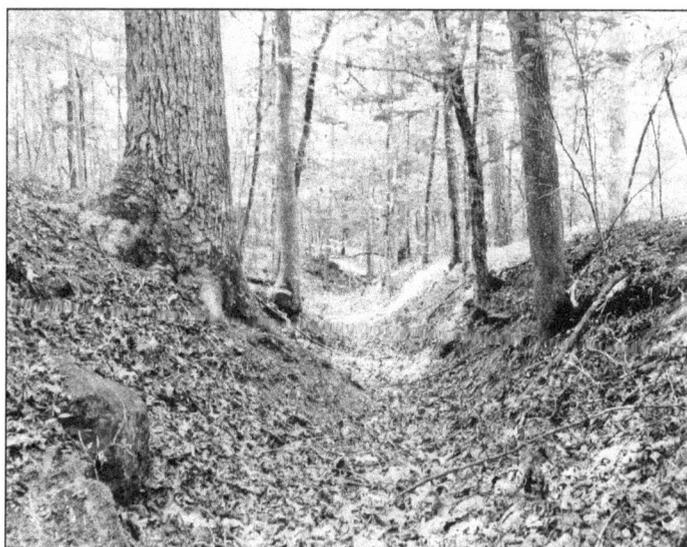

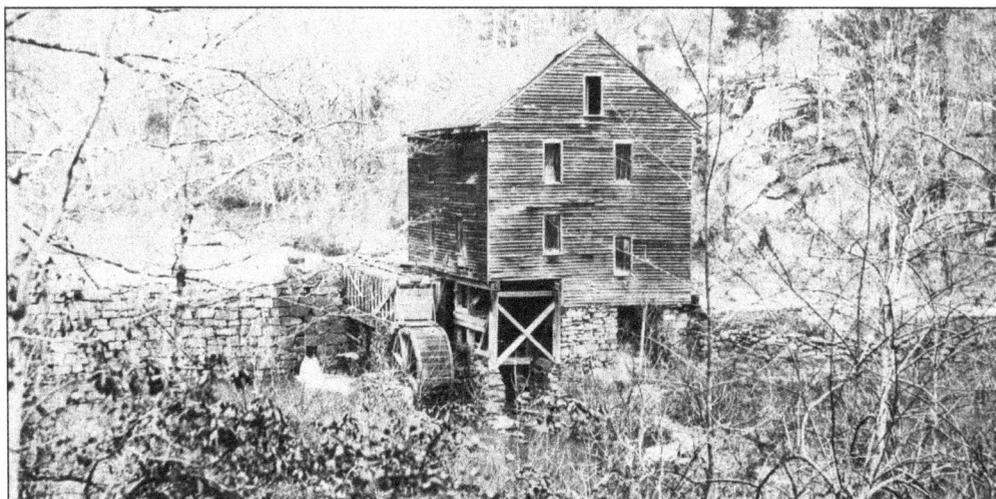

Pages Mill was located near Cary Road in Raleigh, North Carolina. This typical gristmill design is probably similar to the Castlebury Mill, which stood on Bolin Creek. There were three other mills on Bolin Creek—the Yeargin Mill where Umstead Park is today, the Waitt-Brockwell Mill where the creek flows under MLK Boulevard, and the Morgan-Jones Sawmill where East Franklin Street crosses the creek. (Courtesy of the North Carolina Archives Collection.)

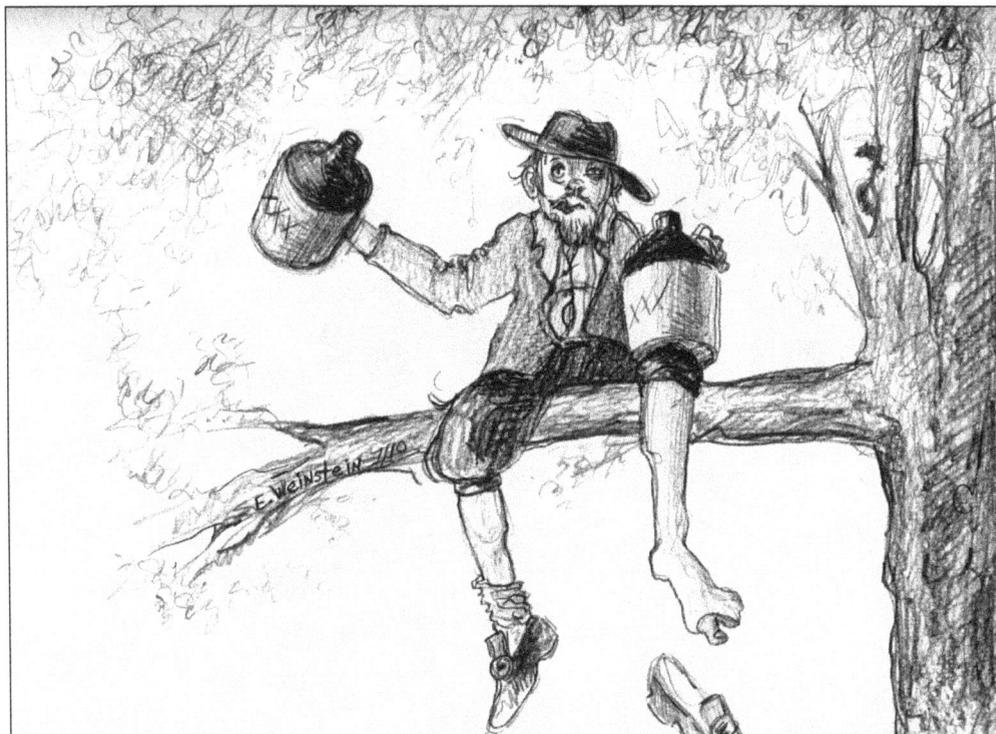

"Buck" Taylor owned the Castlebury Mill property in the 19th century. According to legend, he was buried with a jug of whiskey in each hand. His affinity for liquor is evidenced by November 1799, records of the Orange County court: "John Taylor Esq. appearing in open court intoxicated . . . and having shewn . . . great contempt to the authority of this court . . . be fined . . . 10 pounds and . . . confined to close custody in Gaol." (Drawing by Emily Weinstein.)

Bethel Baptist Church is located on Bethel Hickory Grove Church Road about 4 miles west of Carrboro. The church was established in 1851 to serve rural families who have farmed the land for centuries. Many families prominent in the history of Carrboro, particularly the Lloyds (below) are buried in the church cemetery. The inscription on the monument of Thomas Lloyd, who built Alberta Mill in 1898, summarizes his life: "Honesty, Thrift, Economy, and Sympathy with Distress Shone among his Virtues." (Photographs by Dave Otto.)

Two

Emergence of the Milltown (1880–1920)

The most important event leading to the founding of Carrboro was the completion in 1882 of a rail spur from University Station near Hillsborough to what is now downtown Carrboro. The rail line was originally built to transport ore from an iron mine located in the present-day neighborhood of Ironwoods. Although the mine soon closed, the rail spur provided a vital means to transport local goods to market. Thomas Lloyd realized the commercial potential and built a gristmill and cotton gin beside the railhead in 1883. These enterprises prospered, and in 1898, Lloyd built the Alberta Cotton Mill.

Another industry spawned by the railhead was the cross tie market. White oak, abundant in the Piedmont, was in demand by railroads for cross ties. In 1924, there were two lumber mills in Carrboro, according to Joanna F. Sturdivant. From 1880 to 1930, the community was the cross tie capital of the southeast.

The university also appreciated the railroad as a transportation link to remote parts of the state. A small locomotive, affectionately known as the "Whooper," made two daily runs to University Station near Hillsborough. Capt. Fred Smith and his loyal crew operated the train for nearly half a century until 1936, when faster automobile travel put the passenger train out of business.

The town was first known as "West of Chapel Hill," then "West Chapel Hill," and later just "West End." Around 1900, the area was briefly known as "Lloydville," acknowledging the contributions of the industrial pioneer. Much of the original Alberta Mill structure still survives as Carr Mill Mall, hub of the downtown business district.

In 1909, Julian Carr purchased the Alberta Mill from Lloyd and changed the name to Durham Hosiery Mill No. 4. In 1911, West End was formally incorporated as "Venable" in honor of University of North Carolina president Francis Venable. In 1913, the name was changed to "Carrboro" in recognition of Carr's contributions to the infrastructure of the town, including streets and electric power. Despite his important leadership role in the fledgling community, Carr never lived in the town that bears his name.

This drawing is part of the 1891 George Tate Map of Orange County. The location of present-day Carrboro is depicted as "depot," shown close to Chapel Hill. Just north of the depot is the iron mine. University Station is also shown at the northern end of the railroad spur. (Courtesy of Jean Earnhardt.)

Gen. Robert Hoke (above, left) was instrumental after the Civil War in bringing a spur of the North Carolina Railroad to present-day Carrboro. Hoke wanted the railroad to transport ore from a mine on Iron Mountain that he owned. University of North Carolina president Kemp Plummer Battle (above, right) was also interested in the railroad to provide transportation for students and staff to distant parts of the state. The trestle (below) crosses Bolin Creek west of Estes Drive. The iron mine was located in the hillside northeast of the trestle. By the time the spur was completed in 1882, the price of iron ore had plummeted, and the mine was closed. (Above, both courtesy of the North Carolina Collection; below, photograph by Dave Otto.)

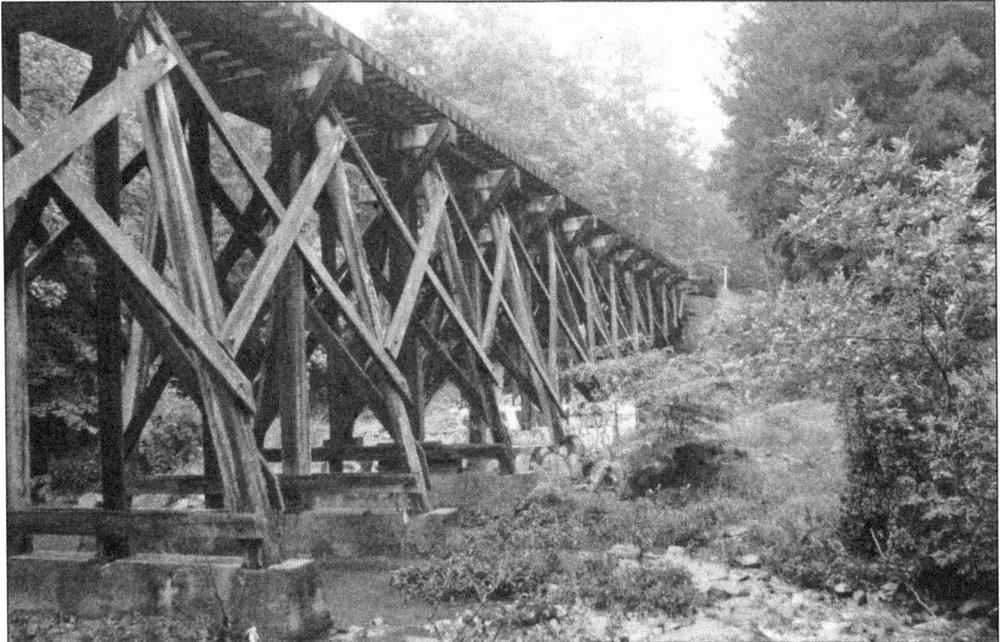

SITE OF OLD IRON MINE

A TEN FOOT VEIN OF RICH IRON ORE WAS
MINED ON THIS SITE FROM 1872 TO 1882.
THE MINE WAS OWNED AND DEVELOPED
BY GENERAL ROBERT F. HOKE.

THE ORE WAS SHIPPED TO PENNSYLVANIA
FOR SMELTING VIA A SPUR RAILROAD
WHICH WAS BUILT CONNECTING THE SITE
TO THE SOUTHERN R.R. AT A JUNCTION
LATER NAMED "UNIVERSITY STATION". THE
MINE WAS CLOSED IN 1882 DUE TO THE
DECLINING VALUE OF IRON ORE.

ERECTED BY THE CHAPEL HILL HISTORICAL SOCIETY
FOR THE CHAPEL HILL BICENTENNIAL OBSERVANCE-1993

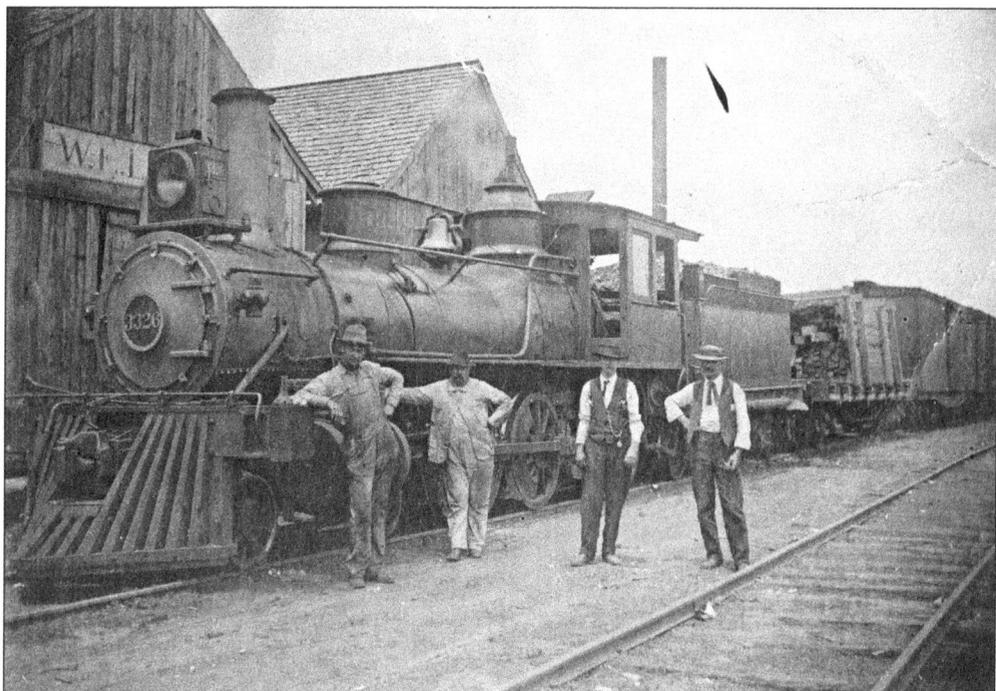

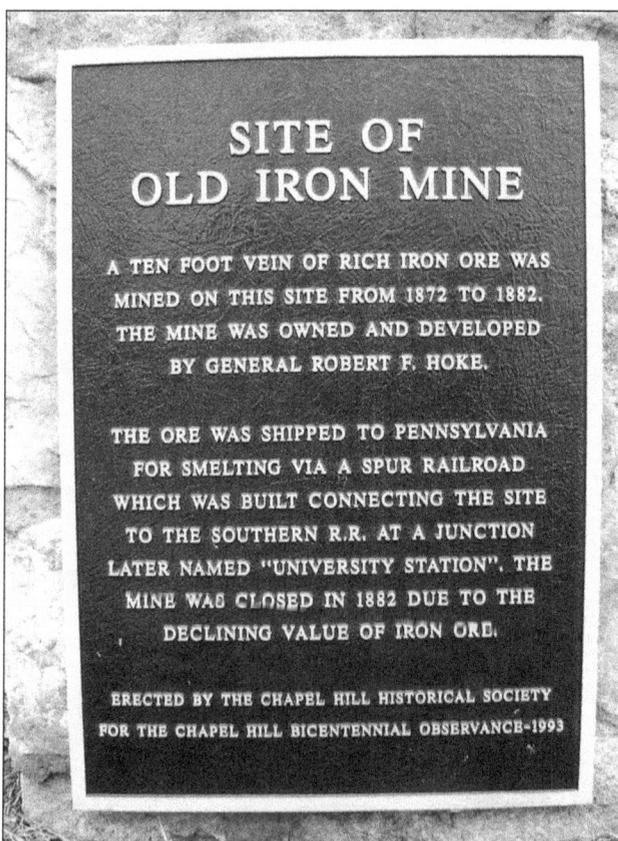

The "Whooper" made several runs each day from the West End depot to University Station. Capt. Fred Smith was conductor, brakeman, and flagman for almost 50 years. According to Holder in 1931, "University students submitted to the Captain's genial tyranny in all their comings and goings, for he was Lord Dictator of the sole means of transportation between the Hill and the outside world" until the early 1930s. The sheds beside the train are listed on 1911 Sanborn maps as "guano and cotton seed storage" (see page 44) but are not shown on 1915 Sanborn maps. Therefore, the sheds were removed and the picture was taken prior to 1915. The plaque (left) is located on Ironwood Drive at the site of the original iron mine. (Above, courtesy of the North Carolina Collection; left, photograph by Dave Otto.)

GEE AINT THIS A LONESOME PLACE, UNIVERSITY, N. C.

University Station (above) is southeast of Hillsborough, where the railroad spur to present-day Carrboro diverges. Passengers and cargo from Carrboro transferred to other trains at this station. University Station was also a popular destination for a day's outing in the late 19th and early 20th century (see page 44). The photograph below of the Carrboro depot was taken around 1920. The man on the right was identified as Tom Cole. The mill is visible to the left, and cotton bales are piled on the depot porch behind the men. (Both, courtesy of the North Carolina Collection.)

Thomas F. Lloyd was an entrepreneur and creator of the mill dynasty and industrial base of Carrboro's economy for the next 80 years. Lloyd and William Pritchard began in the early 1880s by building a gristmill and cotton gin, shown in the photograph below. Note the wagons of raw cotton waiting for processing. Lloyd later built the Alberta Mill (now Carr Mill Mall), which opened in 1899. Lloyd sold the mill complex to Julian Carr in 1909. Lloyd was considered to be the wealthiest man in the area when he died in 1911. (Left, courtesy of the North Carolina Collection; below, courtesy of the Watts Collection.)

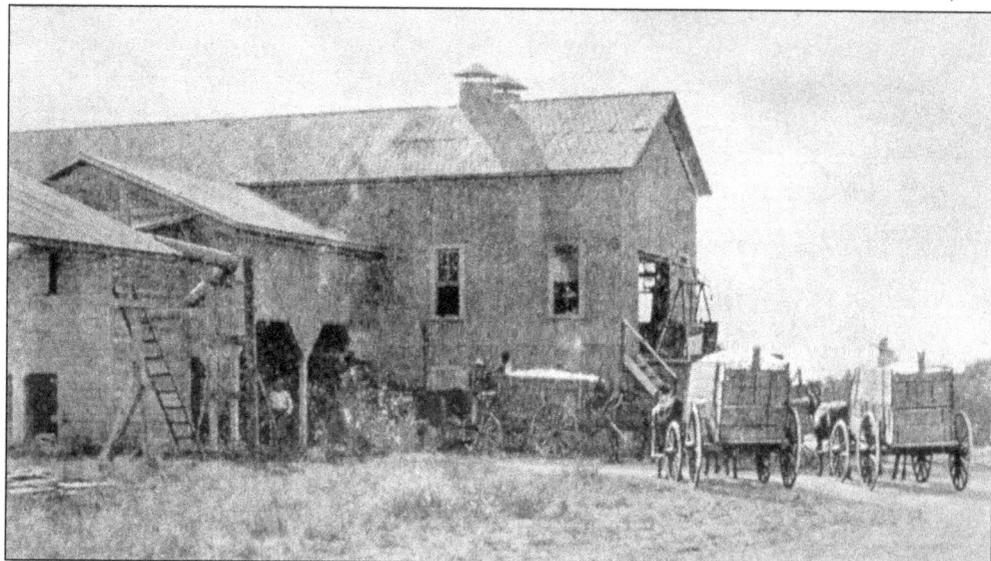

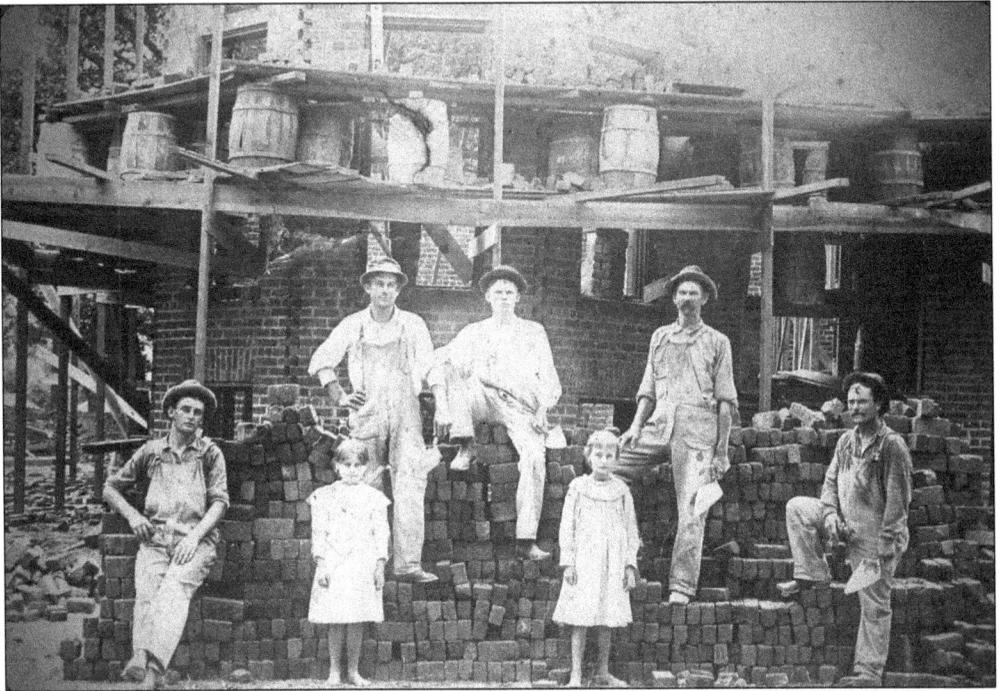

The photograph above is thought to be of workers during construction of Alberta Mill in 1898, although the exact location is unidentified. The children are probably bringing a meal to the brick masons so that they do not need to leave the job site and risk losing pay. The photograph below is what Carr Mill looked like in the 1960s, after Pacific Mills closed the plant. Note that the original windows had been bricked in when Pacific Mills installed air-conditioning in 1945. The small buildings on the yard are pump or well houses. (Both, courtesy of the Watts Collection.)

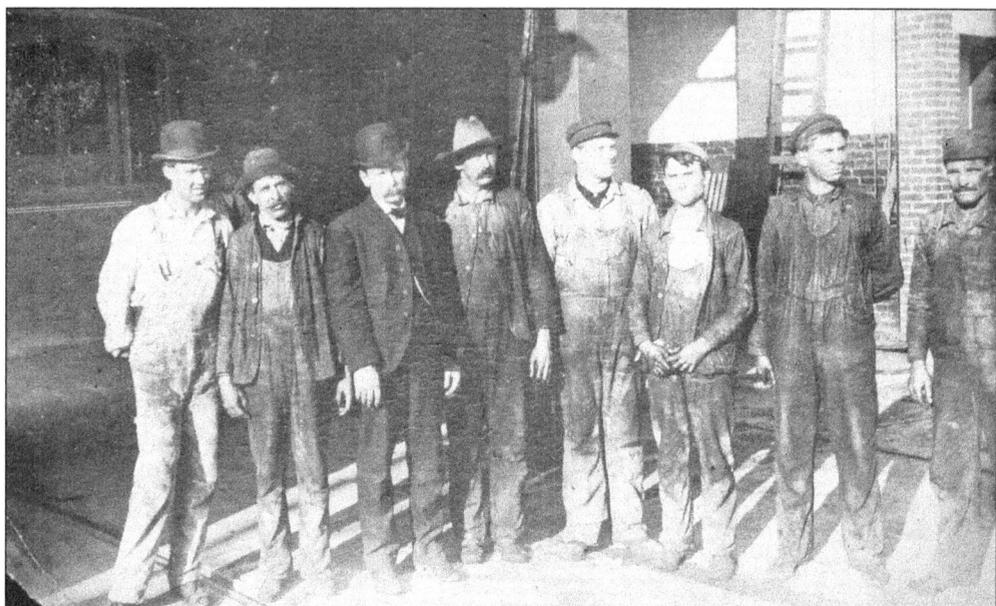

The men in the photograph above were identified only as mill employees. Most likely, they were steam plant workers, based on the coal dirt evident on their work clothes. The man in the bowler hat and bow tie was most likely an area supervisor. The women below were identified as spinners. The location was probably on the first floor of Carr Mill facing Weaver Street. Women were often employed, because they were paid less than men. (Both, courtesy of the Watts Collection.)

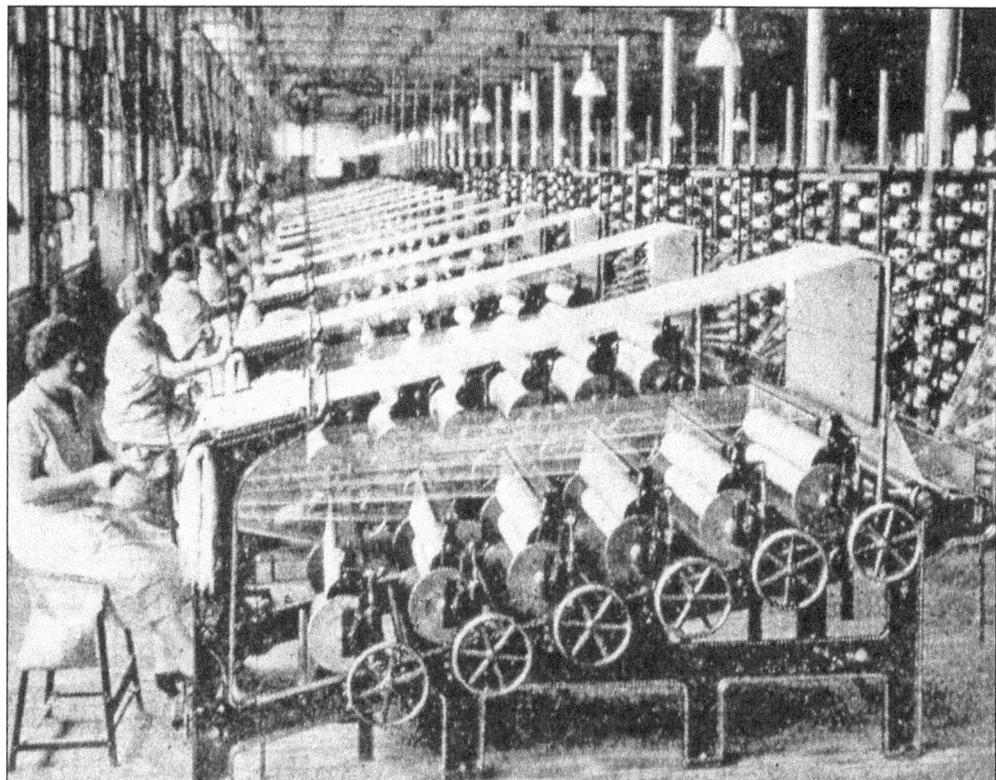

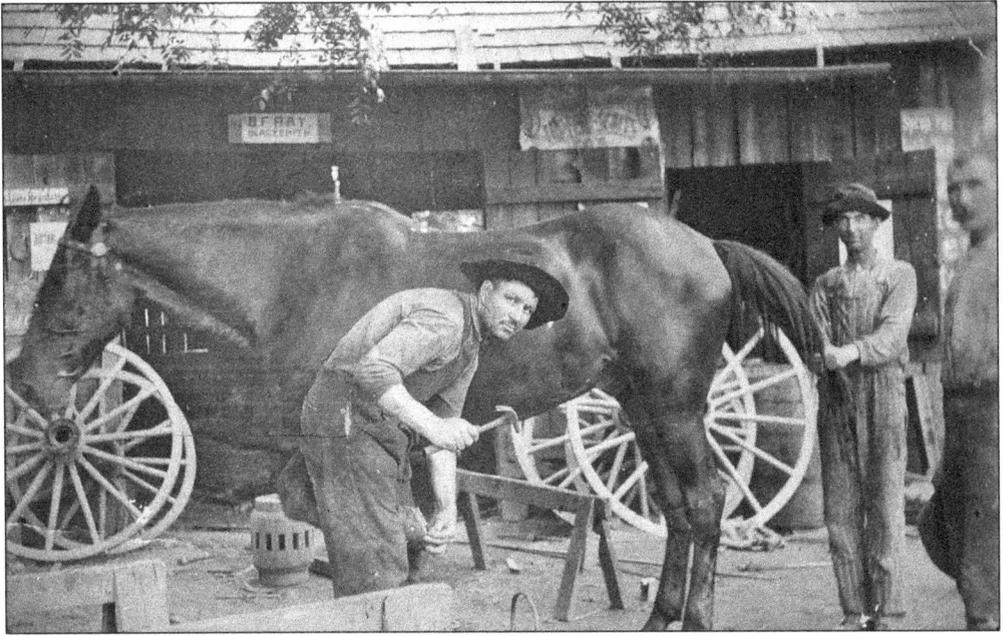

The blacksmith shop (above) stood on what is now Lloyd Street. It was operated by Bennie Ray (far right). His son Atlas Ray is shoeing the horse. Bennie's "quarter century of continuous service in the same capacity entitles him to lay claim in kinship to the immortal Village Blacksmith of Longfellow," wrote Sturdivant in 1924. The Ray family lived in a house on Weaver Street (page 54). Tom Farrington, standing in front, operated the hackney (below) or "hack" cab. Drivers would pick up and drop off train passengers at the depot. Hack drivers would race each other to see who could get to the depot and back to town the quickest. (Both, courtesy of the Watts Collection.)

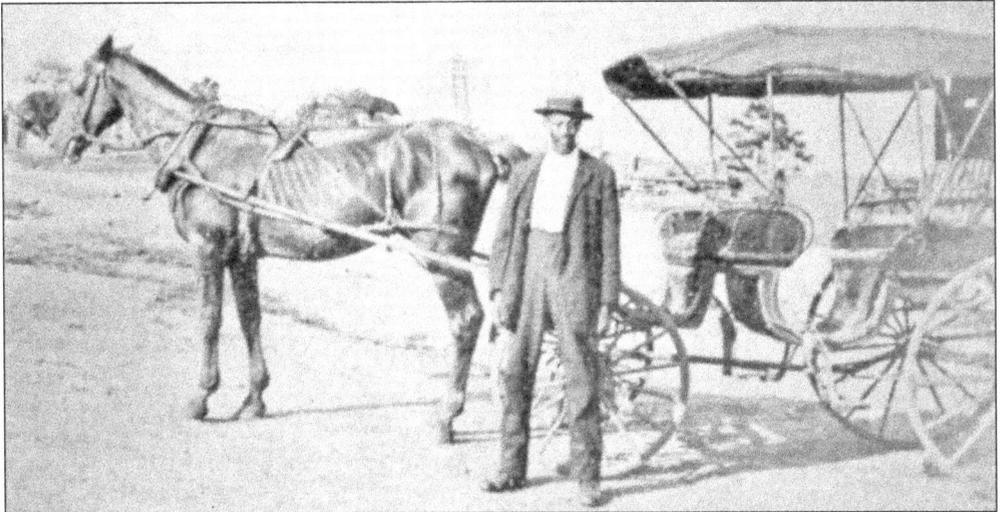

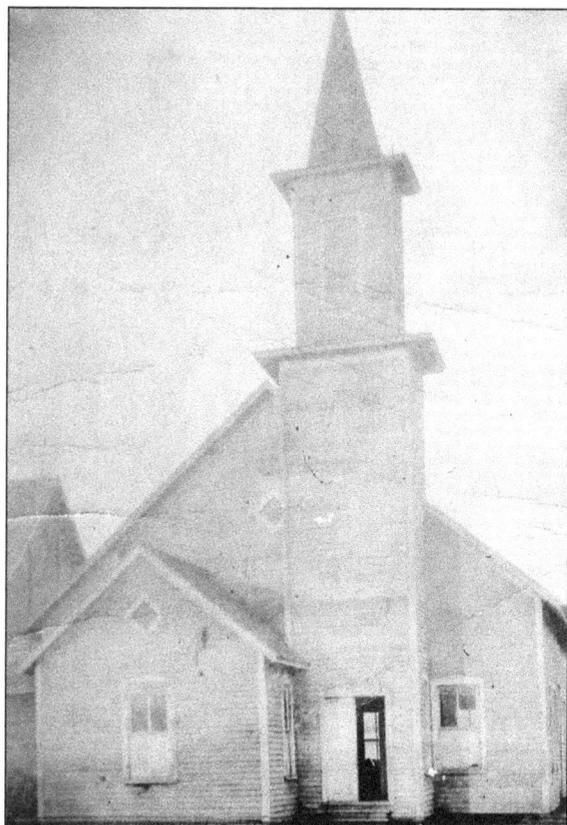

The Union Chapel (left) was built on land donated by Thomas Lloyd in 1898. Baptist and Methodist congregations initially met here, but the Methodists moved to another location on Main Street in 1902. The Union Chapel was dismantled in 1922 when the Baptists built a new church. The dismantled building was reconstructed as McDuffie Memorial Baptist Church (now North Chapel Hill Baptist Church) on North Carolina 86, north of Timberlyne. The photograph below shows Mae Mann with her Sunday School class at the Union Chapel around 1920. Mae Mann taught music at the Carrboro Elementary School and gave piano lessons in her home to several generations of Carrboro children. (Left, courtesy of the Watts Collection; below, courtesy of Wilbur Partin.)

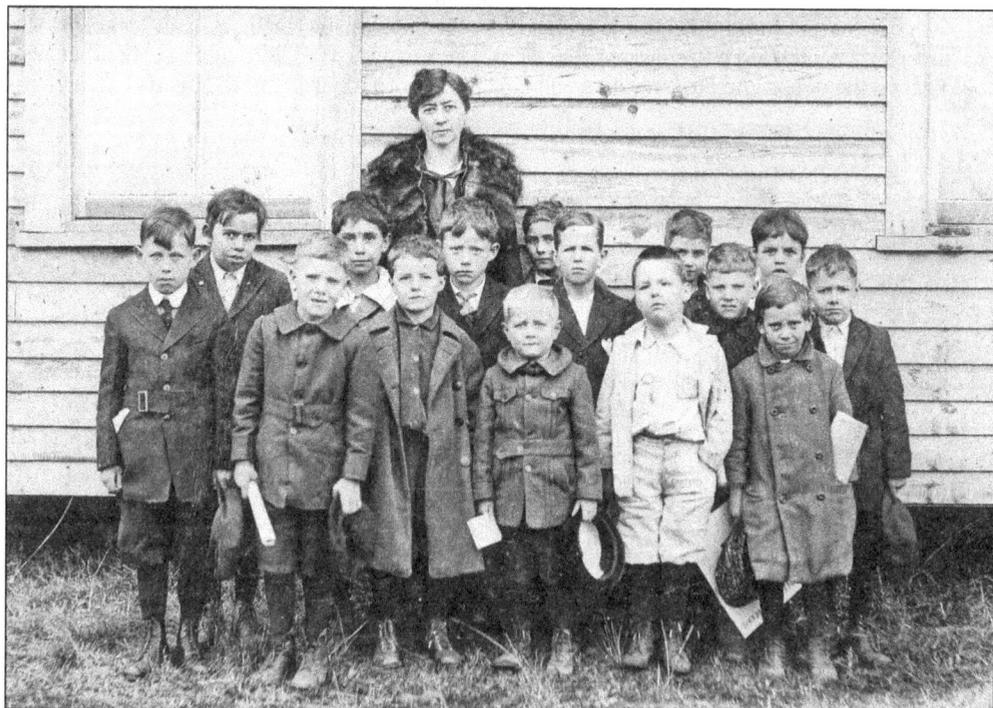

Rev. J. A. Hackney, an early pastor of the Carrboro Baptist Church, is shown in the picture above. Carrboro Baptist built another larger church in 1922, pictured below. The congregation continued to grow and moved to a new location on Culbreth Road in Chapel Hill. The Town of Carrboro purchased the former Carrboro Baptist Church building on Greensboro Street and converted it to the Century Center, which currently houses the Carrboro Police Department, Recreation and Parks Department, Cybrary, and an auditorium used for community events. (Above, courtesy of the Watts Collection; below, photograph by Dave Otto.)

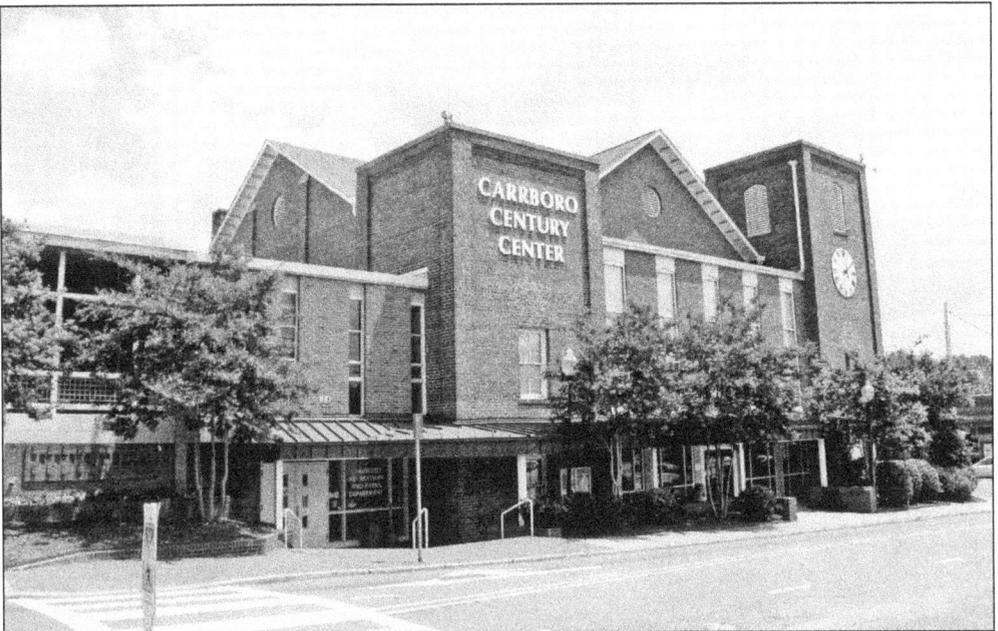

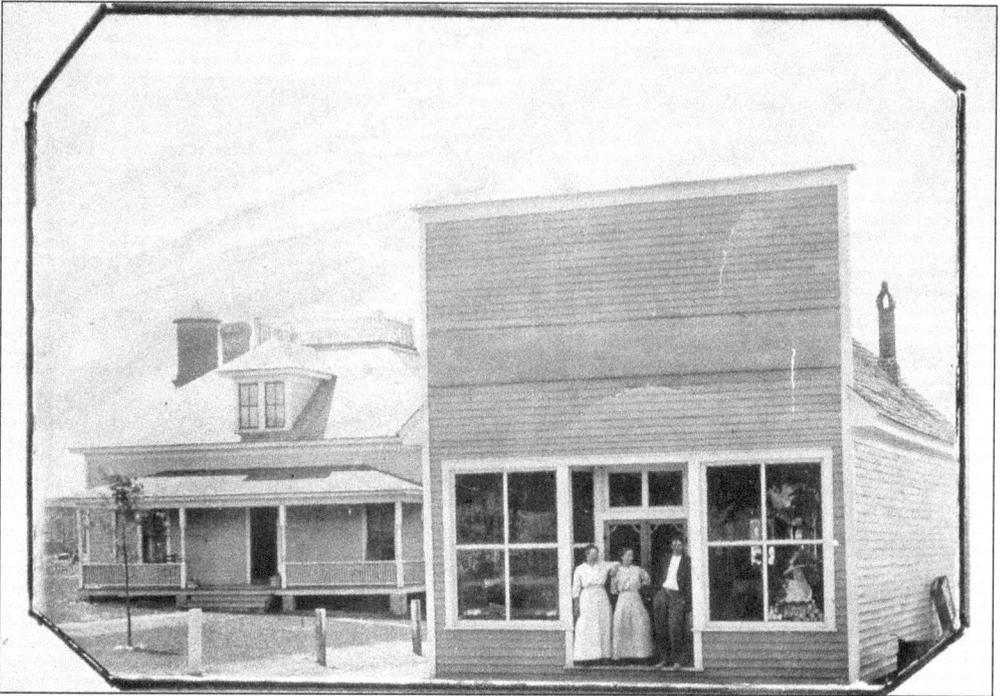

The building on the right in the photograph above was the first café in Carrboro, where the Bank of America is now located. Two people in the doorway are identified as Mrs. McDonald and Dick Andrews. Andrews was later a partner in several other business ventures, including Andrews-Riggsbee Grocery at 100 East Main Street, Andrews-Riggsbee Hardware, and Andrews-Riggsbee Tractor Company on South Greensboro Street, now the Open Eye Café. Jim and Maggie Neal owned the dry goods store in the picture below. The exact location of this business is unknown. (Both, courtesy of the Watts Collection.)

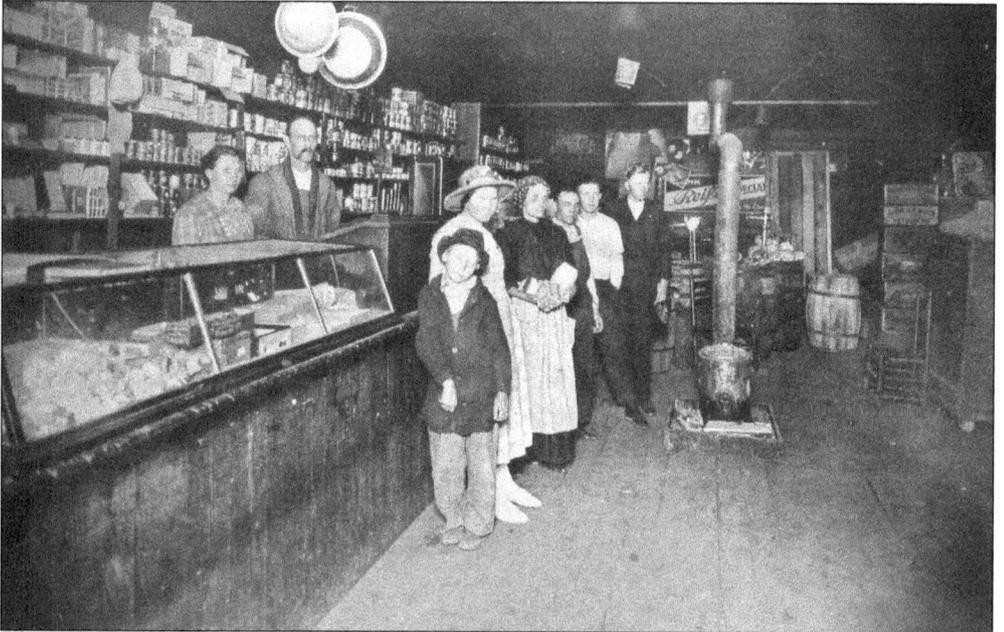

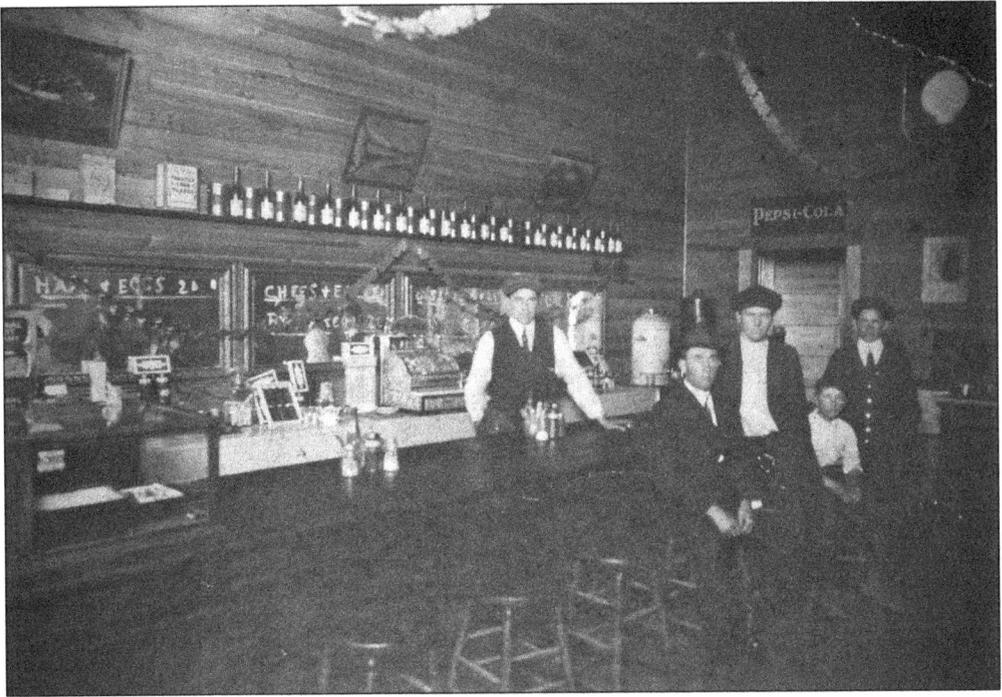

The photograph above shows the interior of a café or saloon in Carrboro during the 1920s. The menu on the mirror reads, "Ham & Eggs—20¢." Tiggis Andrews (below) made daily rounds in his ice wagon selling blocks of ice for 10¢ to 15¢. The ice plant was located behind the mill at the present site of Harris Teeter. (Both, courtesy of the Watts Collection.)

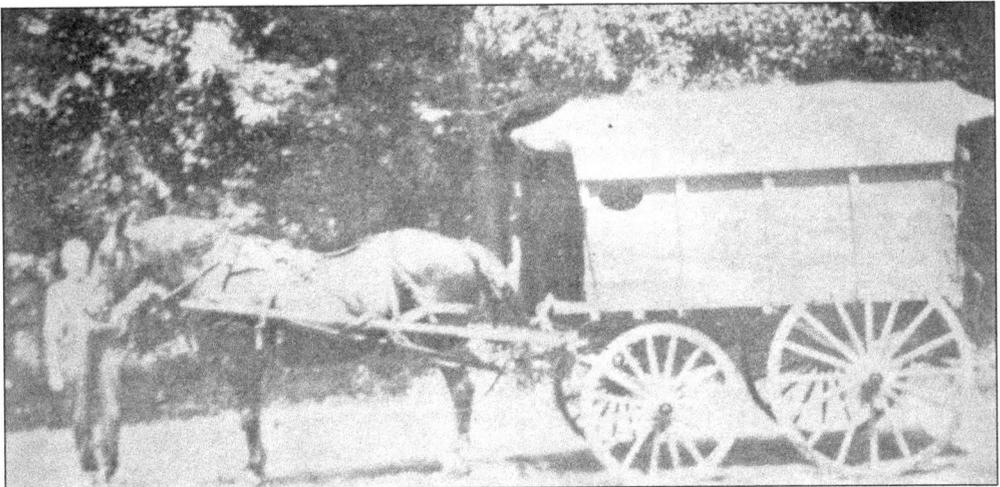

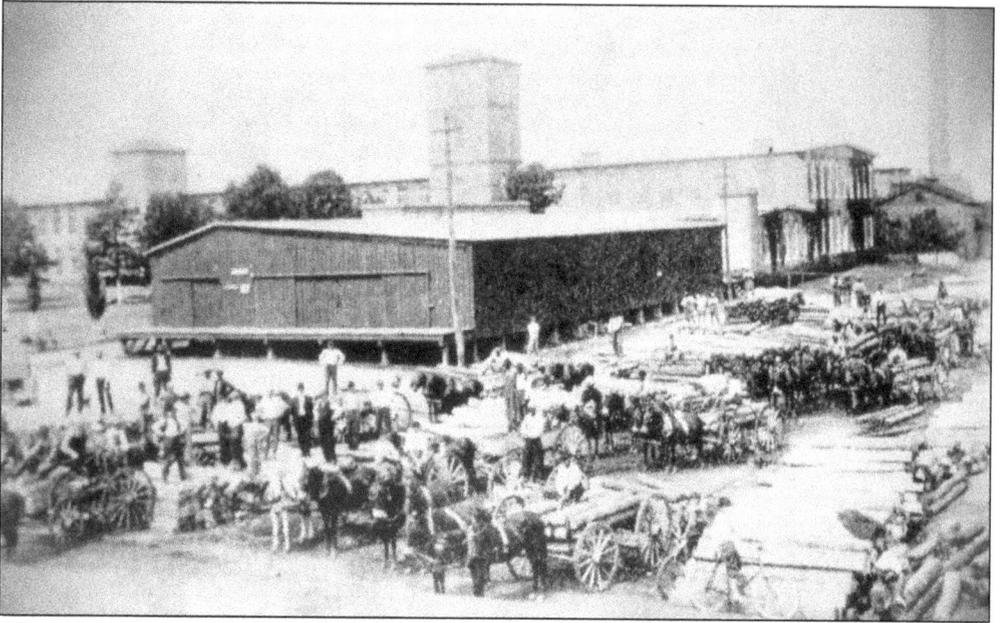

The wooden structure, which stood in the area now occupied by a parking lot between the mill and depot, was the cross tie market. Carrboro was reputed to have been the largest cross tie market in the world during the early 20th century. This market flourished from the early 1900s until about 1930. White oak, a very hard wood that would last a long time in contact with the ground if drained properly, was the preferred wood for cross ties. (Courtesy of the Watts Collection.)

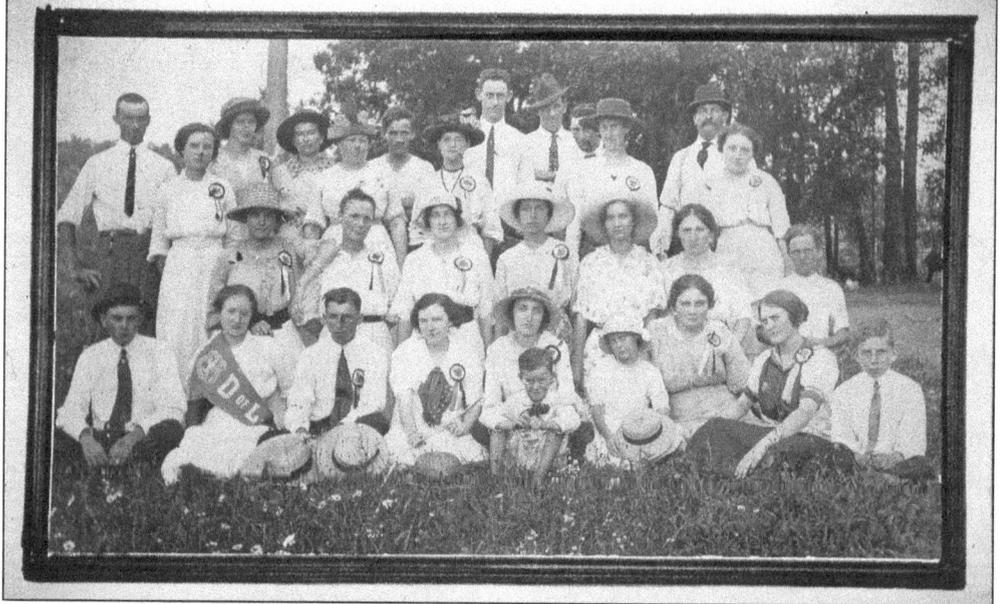

A GROUP OF CARRBORO CITIZENS, PICNICKING AT UNIVERSITY STATION, 1916

University Station was a popular destination to get away from town. These picnickers may have been mill workers. This location might also be at the Occoneechee Farm, owned by Julian Carr and close to University Station. Carr was reported to take mill employees to his farm for special occasions. (Courtesy of the Watts Collection.)

Julian Shakespeare Carr was born and raised in Chapel Hill and attended the University of North Carolina. After the Civil War, he became a partner in a tobacco business in Durham and became very wealthy. Carr then formed the Durham Hosiery Mills. In 1909, he purchased the Alberta Mill from Thomas Lloyd and renamed it Durham Hosiery Mill No. 4. In recognition of Carr's contributions to the infrastructure of the town, Venable was renamed Carrboro in 1913. The mansion in the lower picture was Carr's home in Durham. Although the town of Carrboro was renamed in his honor, Carr never lived there. (Both, courtesy of the Durham County Public Library, North Carolina Collection.)

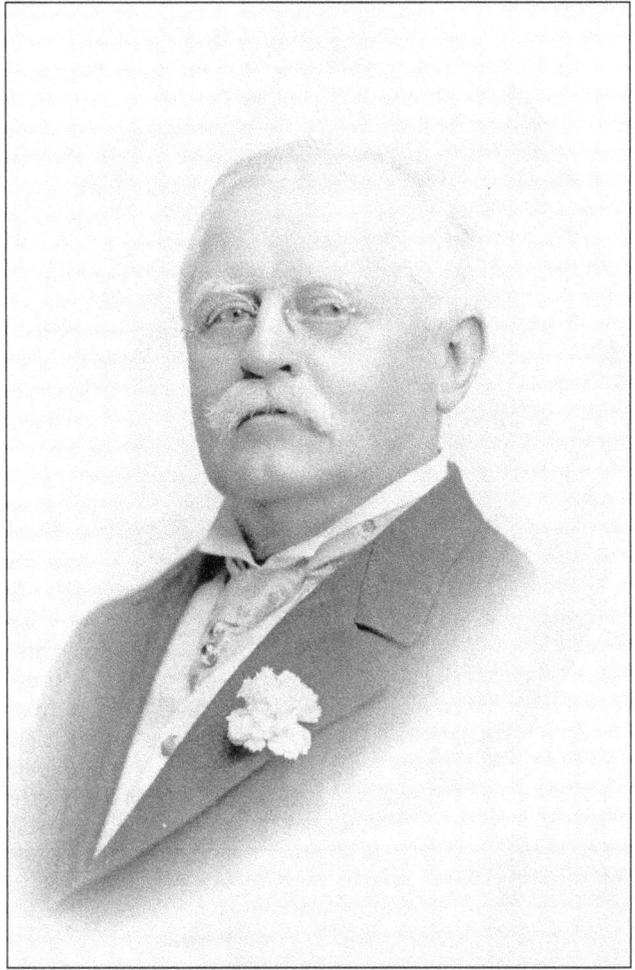

Residence of General J. S. Carr, Durham, N. C.

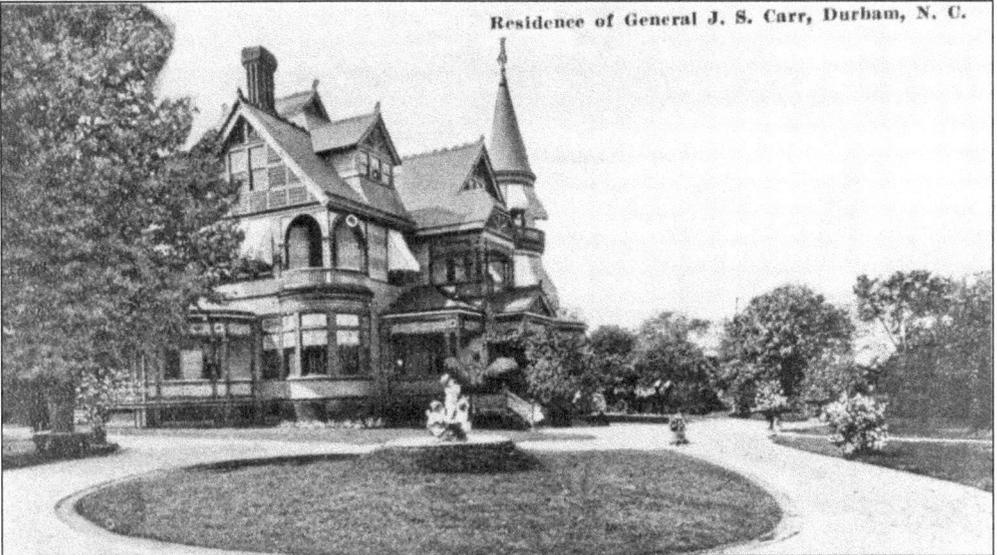

When the town was incorporated in 1911, it was named Venable after Francis Preston Venable (left), who was president of the University of North Carolina and professor of chemistry. The original Carrboro Town Hall, located on Lloyd Street, is shown in the lower photograph. This building held all the business offices for the town, as well as a garage for the fire truck. More fire truck bays and a small jail were added later. This building was used until the old Carrboro Elementary School on Main Street was purchased and remodeled in the 1960s. The small tower in back was a fire siren. The metal tower legs seen on the right held up the town water tank. This photograph dates to about 1950. (Left, courtesy of the North Carolina Collection; below, courtesy of the Watts Collection.)

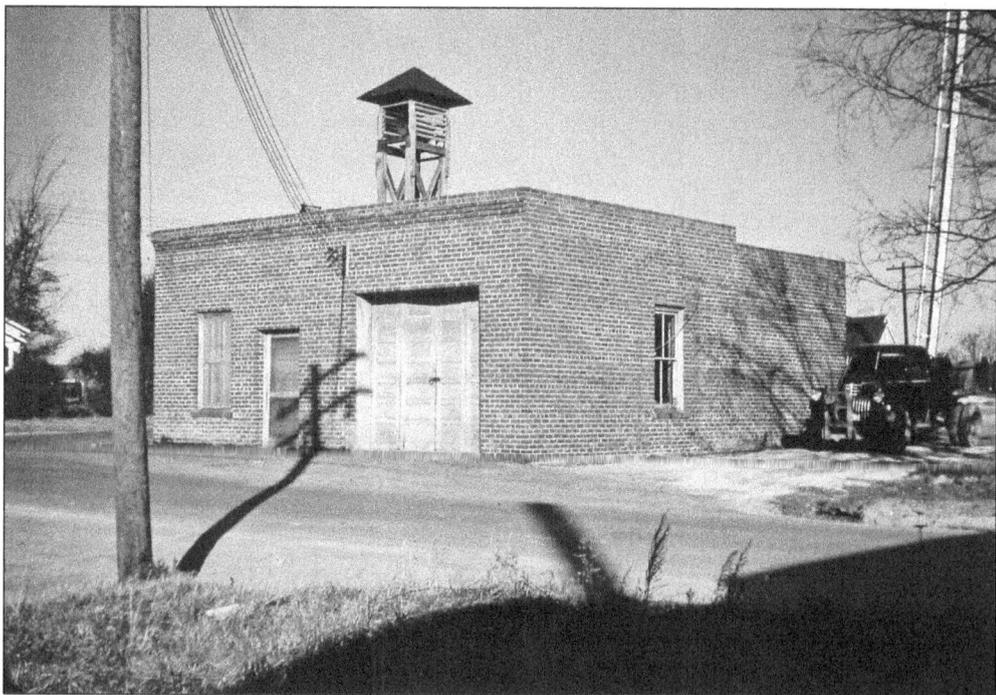

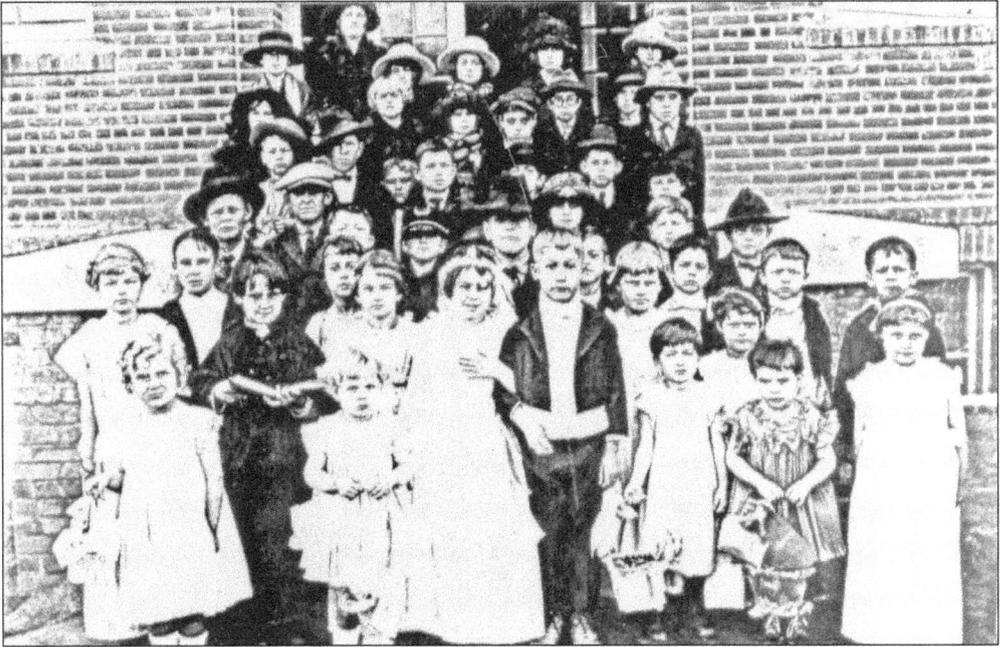

Mae Mann liked her students to perform in public productions to involve families and provide community entertainment. Many classes performed the "Tom Thumb Wedding." These young actors are gathered on the front steps of the Carrboro Graded School in the early 1920s. Although the "groom" may be Raymond Andrews, none of the other children can be identified. (Courtesy of the North Carolina Collection.)

Carrboro folk have always been innovative. Tommy Ragan is leaning on the fender of a Ford Model A truck that he converted into the first fire truck for the Town of Carrboro. Ragan, an auto mechanic, installed racks and frames on the truck to carry ladders and fire hoses. This picture was probably taken on Lloyd Street, where the town offices were located. (Courtesy of the Watts Collection.)

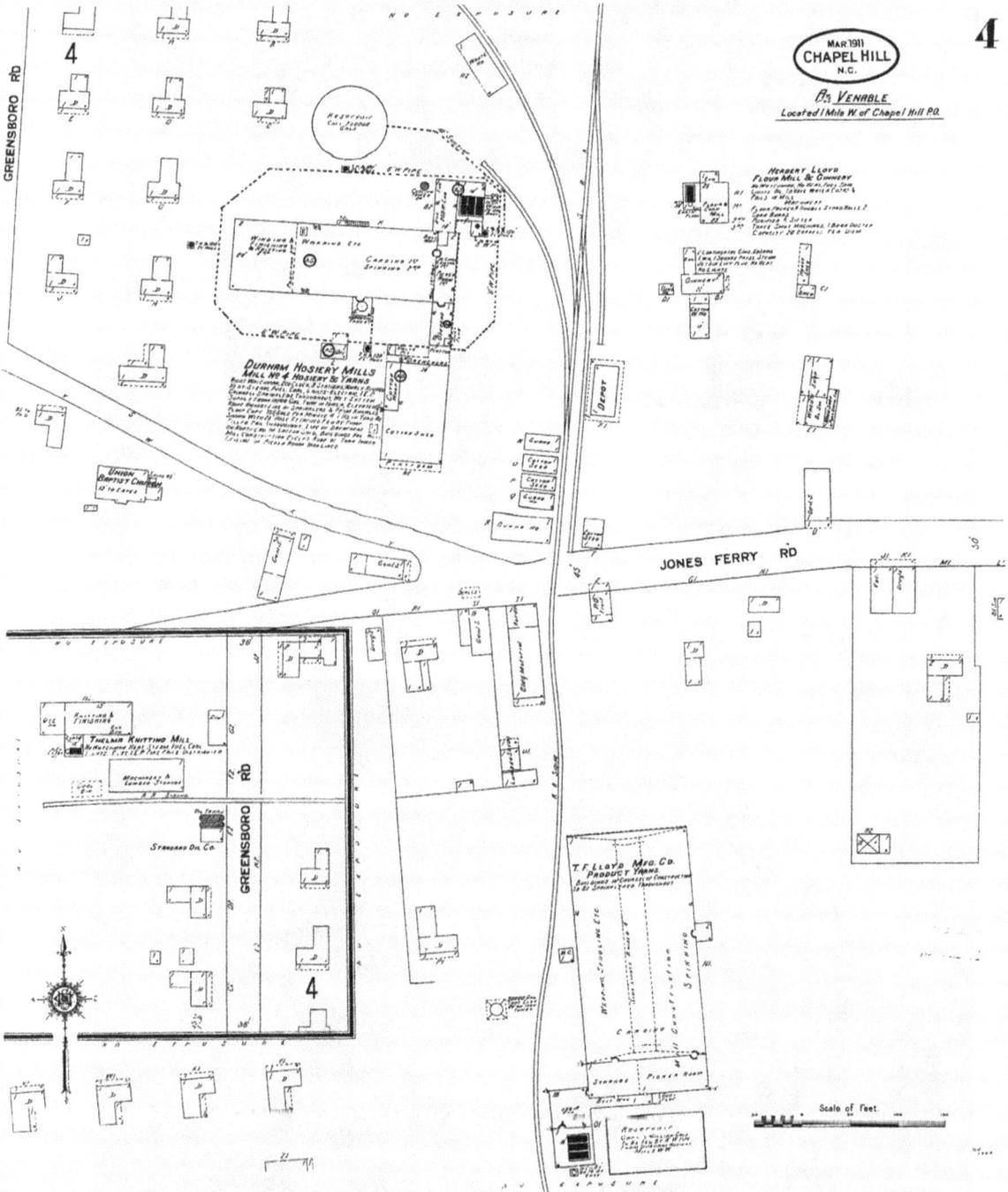

The 1911 Sanborn Insurance Company map of Venable provides a precise record of structures in the town when it was incorporated. Notice the Union Baptist Church across the street from Mill No. 4 and the T. F. Lloyd Manufacturing Company mill. Neither of these buildings exists today. Thelma Knitting Mill stood on the present site of Fitch Lumber Company. Today's Main Street was called Jones Ferry Road in 1911. (Courtesy of the North Carolina Collection.)

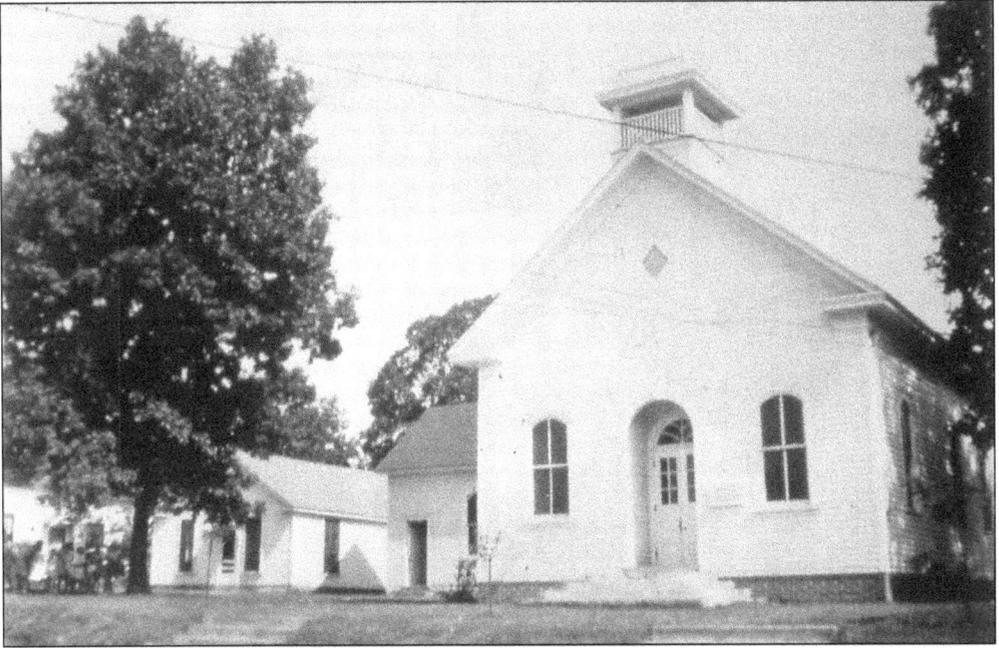

When the Carrboro Methodist congregation left Union Chapel in 1902, they first met in the Carrboro Graded School on Main Street. Julian Carr purchased land in 1911 for them to build a church, shown above. This building was located on West Main Street just east of where the Animal Hospital of Carrboro now sits. When Carrboro built a new graded school (the current Carrboro Town Hall) in 1922, the Methodists bought the old schoolhouse and used it for Sunday School and a parsonage until the mid 1950s. The present Carrboro Methodist Church (right) was built on Shelton Street in 1953. (Both, courtesy of the Watts Collection.)

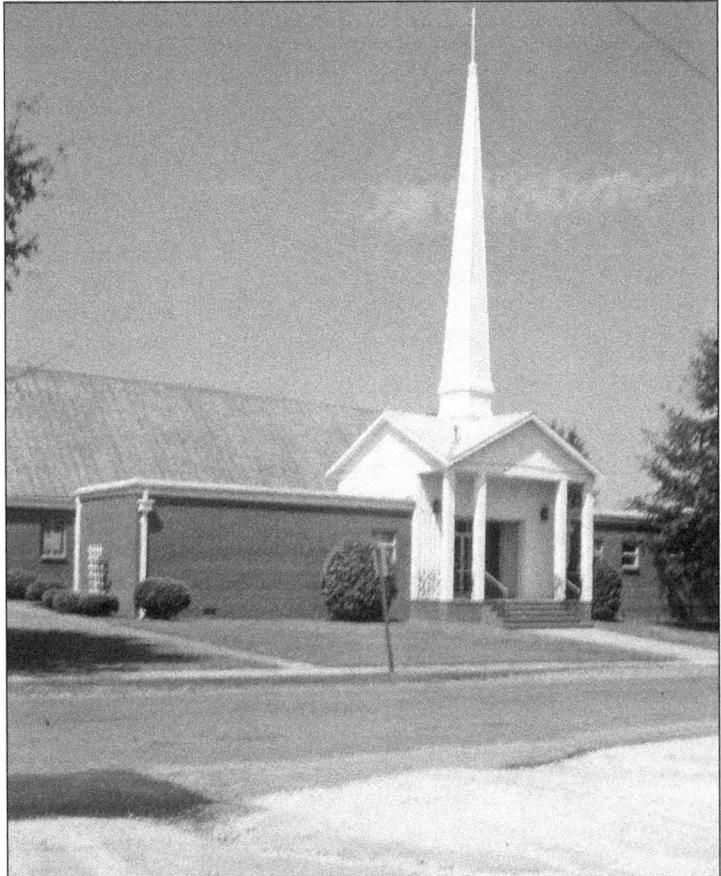

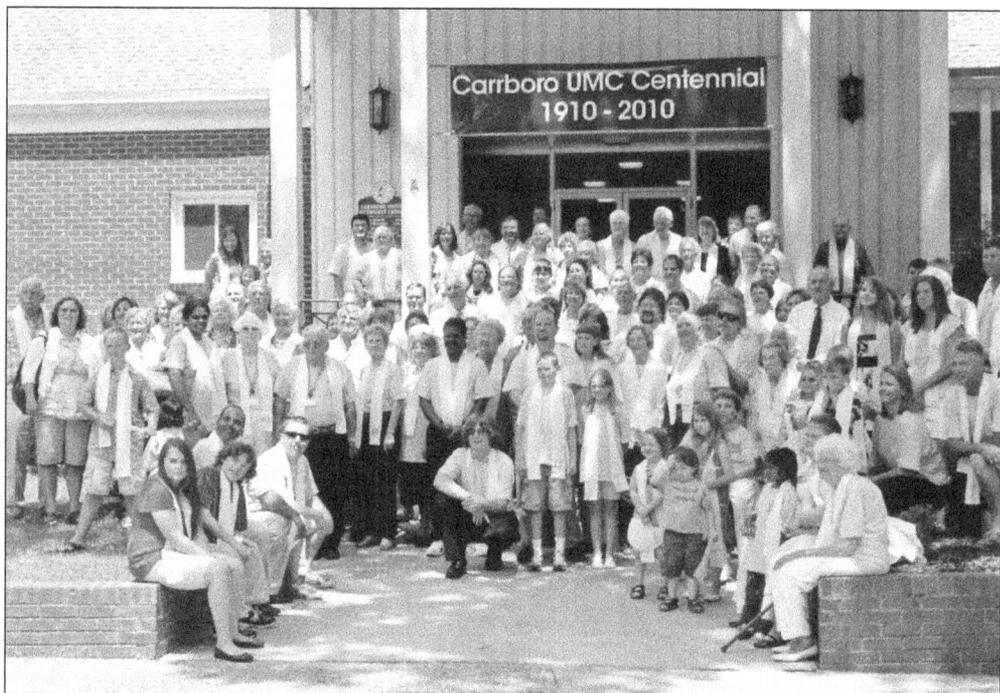

The Carrboro Methodist Church was established in 1910 and celebrated its centennial in 2010. This picture shows members of the congregation gathered for the 100th-anniversary portrait. The church began as a mission of the Chapel Hill Methodist Church, but by 1915, membership had increased enough to justify assignment of a ministerial student. From 1915 to 1949, the church was part of a circuit with one pastor serving two or more congregations. (Photograph by Richard Ellington.)

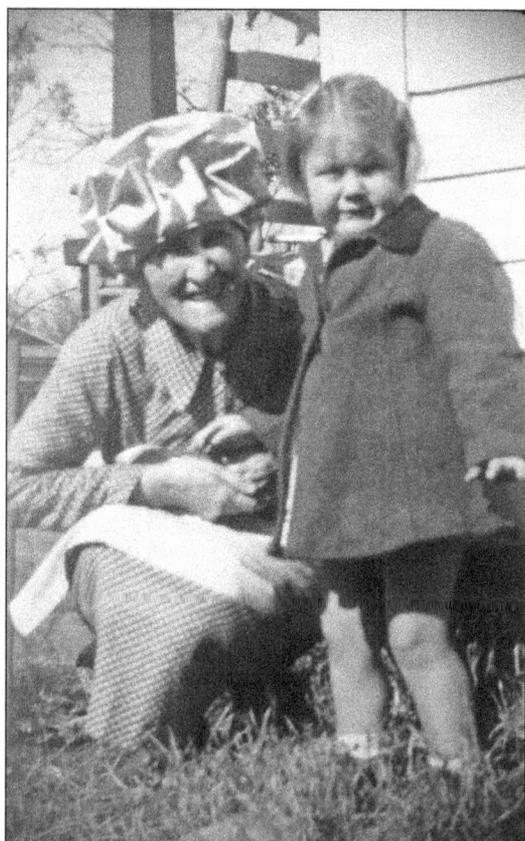

Cora Oakley was one of the prominent early citizens in Carrboro. She made a point of walking uptown every day to purchase something from a local merchant. On her death in the 1930s, all businesses in Carrboro closed in her honor during the funeral. She lived on the corner of Carr and South Greensboro Streets. (Courtesy of the Watts Collection.)

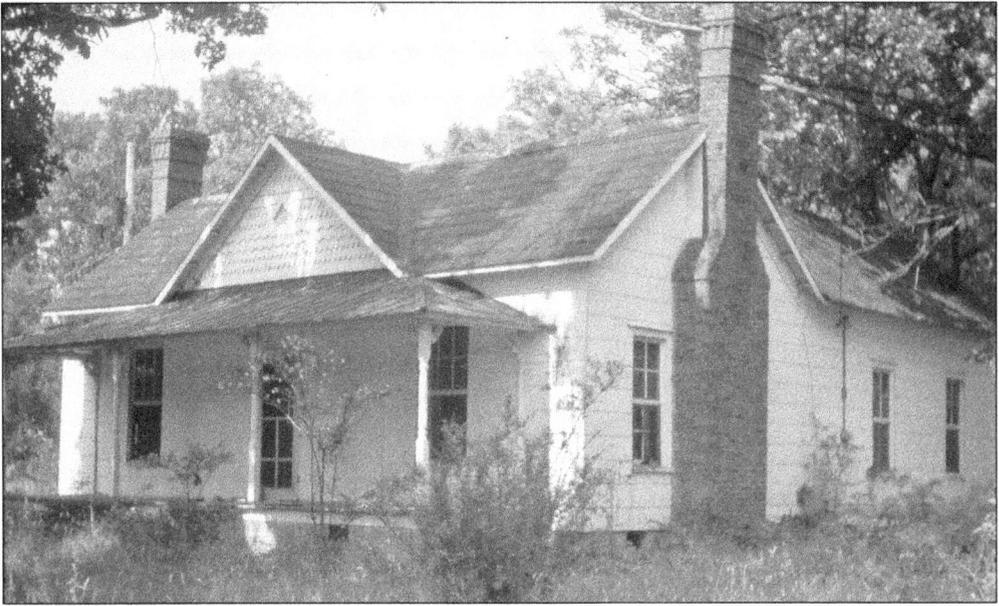

The Whitaker House, located at the corner of Shelton and Greensboro Streets, was one of the first residences built in the new town. Tom Whitaker was a carpenter and is believed to have built the house himself. It is one of the most ornamental 1900-era houses in Carrboro. Unlike other period houses, the Whitaker House has turned posts on the porch, delicate scroll spandrels, and decorative shingles on the front gable. (Courtesy of the Watts Collection.)

The men in this photograph, taken around 1900, were identified simply as "country folk" coming to town to do business. For the past century, farms that provide fresh produce, meat, dairy products, and firewood have surrounded Carrboro. Many of these farms have succumbed to the "progress" of development. These men represent a legacy that is rapidly disappearing. (Courtesy of the Watts Collection.)

Sheila Purefoy, described as a "school marm," was one of the first teachers in Carrboro. Requirements of a female school teacher at that time were, "you must not marry during the term of your contract; you must not go out with any man, except your father or brother; you must not cuss, smoke, or drink any kind of intoxicating beverage; you must be at home between the hours of 6pm and 8am, unless you are at a school function; you must not wear a dress shorter than two inches above the ankle in the classroom or out in the community; you must not slap a school youngin. If he or she needs a whooping, get a switch and wear 'em out." (Courtesy of the Watts collection.)

This building on Center Street was the first school in town, used from about 1900 until 1910. The structure, reportedly used as a small milling facility when the school moved to Main Street, has been a residence for most of its life. This photograph was taken in the mid-1960s. (Courtesy of the Watts Collection.)

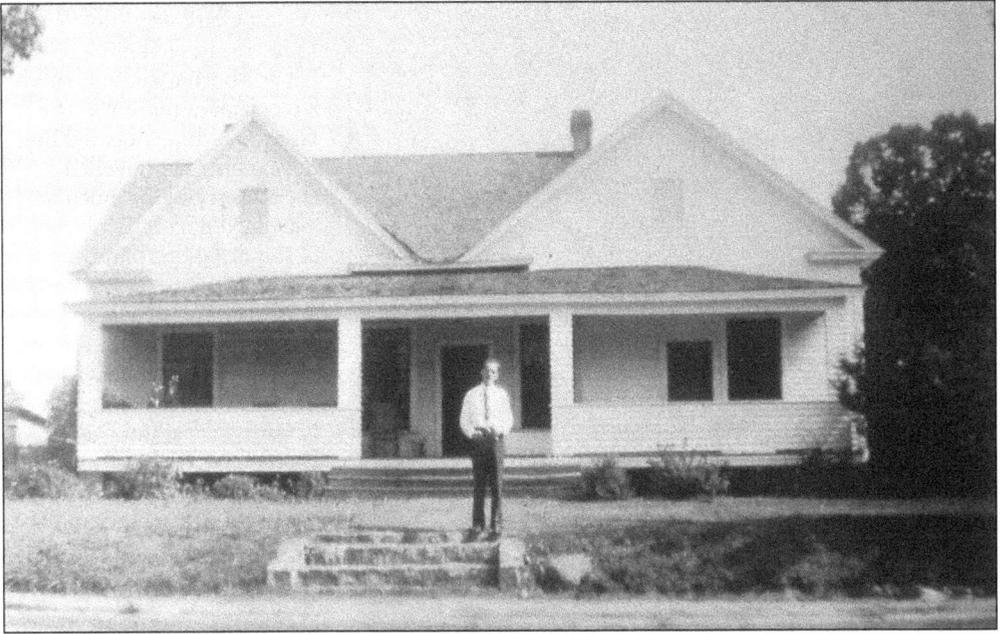

The second school building (above) opened in 1910. Ben Williams, a longtime resident of Carrboro, remembered that there were three classrooms. Some students had to come to school early in the winter to start a fire in the wood stove in each classroom. Julian Carr started evening classes in this building for mill employees who wanted to continue their education. J. F. McDuffie, a Baptist preacher, taught evening classes there. When the new Carrboro Graded School opened in 1922, the old school building was converted to a residence. The picture of students and teachers standing in front of the old school (below) was taken about 1920. (Both, courtesy of the Watts Collection.)

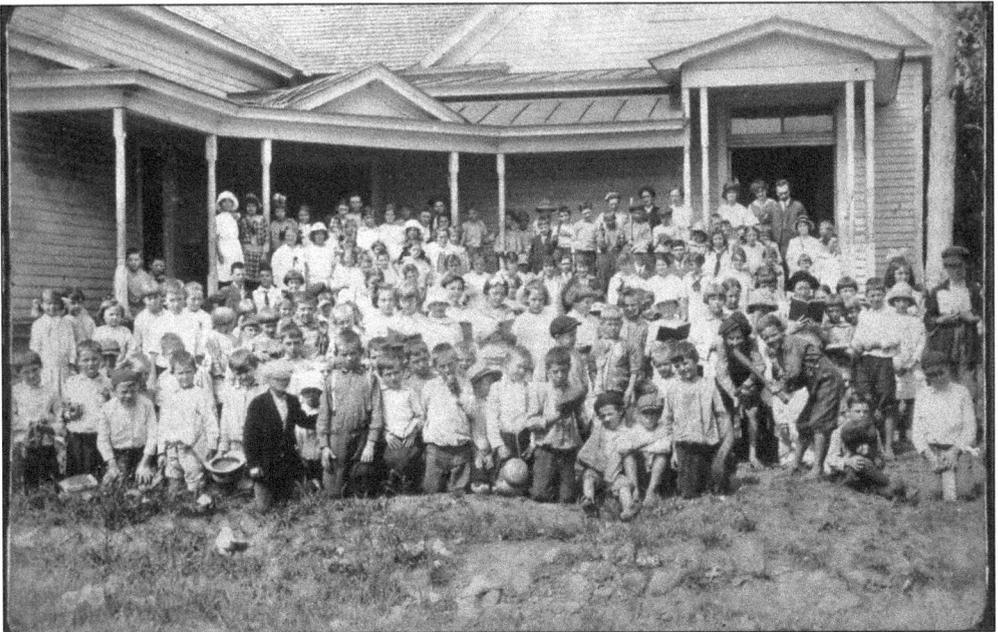

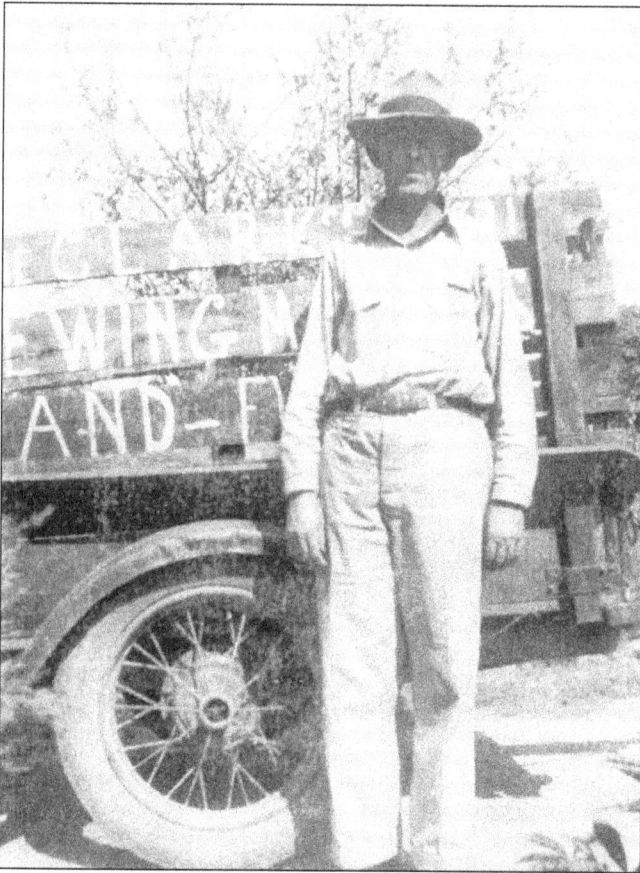

Walter Clark was known as "The Sewing Machine Man." He was both a salesman and a repairman, but it was the latter role that endeared him to women. "He travelled the countryside as much as a medical doctor. Looking at the situation from the viewpoint of need, he was one. Every housewife in Carrboro, and as far away as Hillsborough, depended on his skill," wrote Frances Tripp. (Courtesy of granddaughter Diane Clark Echols.)

This gathering of folks dates to about 1915. The location is believed to be on Weaver Street or Center Street. The lady, second from left on the porch step, was Effie Cole Dillehay. The two youngest girls to her left are her daughters, Hettie and Beulah. (Courtesy of Richard Ellington.)

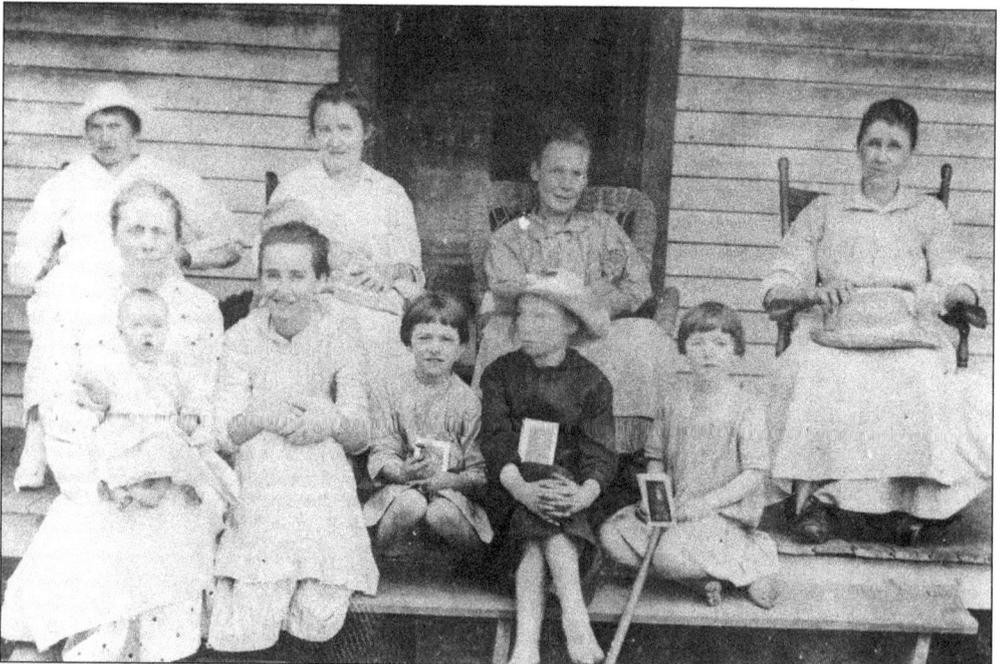

This floor plan is typical of mill houses built in Carrboro between 1900 and 1920. Thomas Lloyd and Julian Carr built many of the houses for mill workers; private citizens built others. The mill house pictured here is located on Shelton Street. Many old mill houses can be seen in downtown Carrboro today and are highly prized as private residences. (Above, courtesy of the Watts Collection; below, drawing by Scott Simmons from Brown et al [1983].)

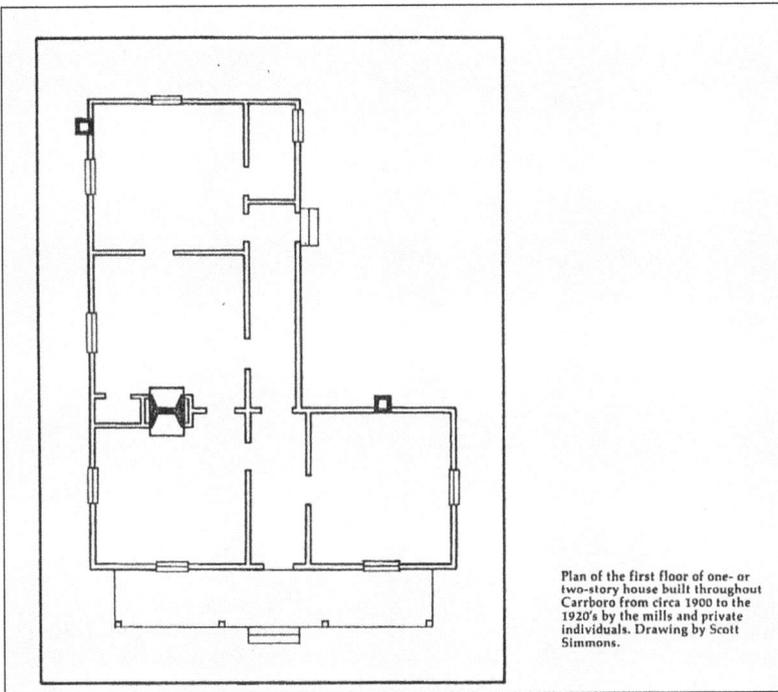

Plan of the first floor of one- or two-story house built throughout Carrboro from circa 1900 to the 1920's by the mills and private individuals. Drawing by Scott Simmons.

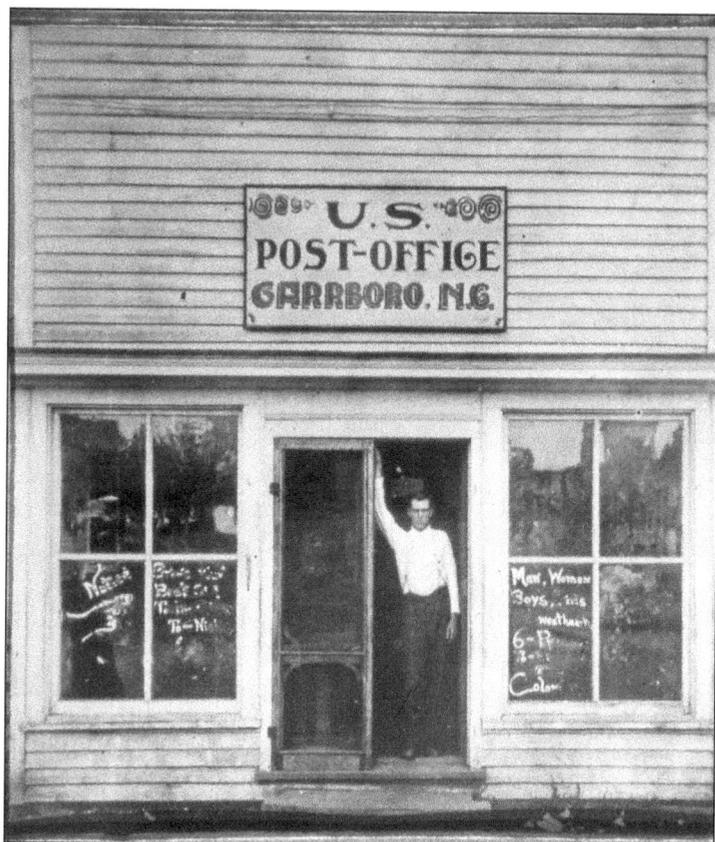

According to the 1911 Sanborn map (page 44), the first post office (left) was located across from the depot on present-day Main Street. The name of the village at that time was Venable. This photograph was taken after 1913, when the name was changed to Carrboro. The second post office (below) was in the flatiron building located where Weaver and Main Streets diverge. The flatiron building has served many functions, including a shoe repair shop, florist shop, and several eating establishments. The current occupant is the Spotted Dog restaurant. (Both, courtesy of the Watts Collection.)

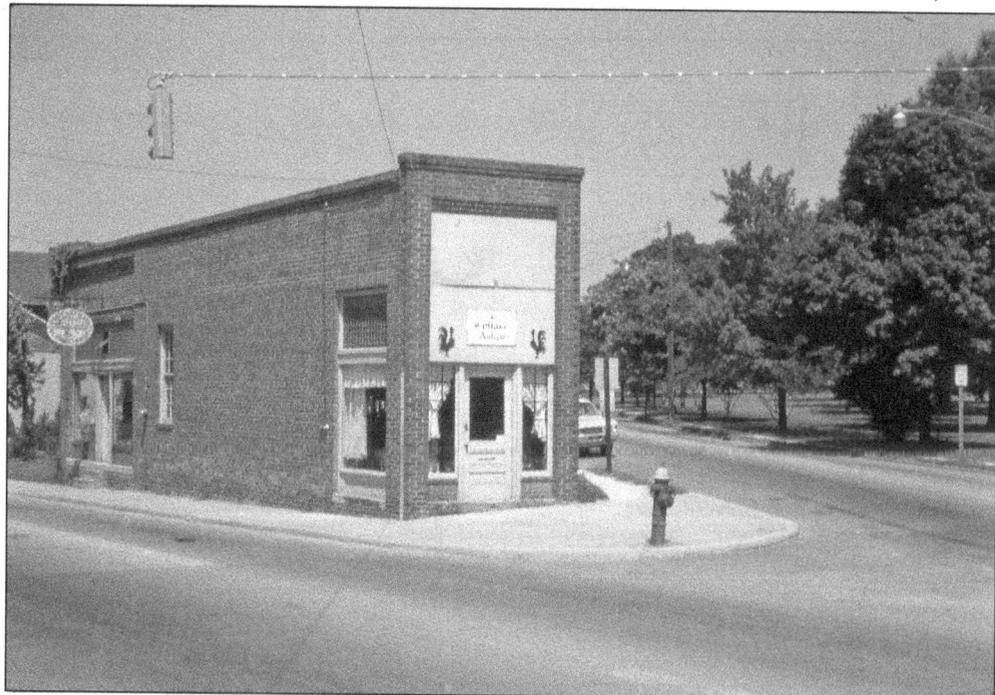

Beatrice Upchurch, better known as "Miss Beaty," was the mother of a riddle. Three of her children were born in the same house, in the same room, in the same bed. However, each child was born in a different year in a different town (West End, Venable, and Carrboro), and the house never moved. Beaty's house (below), where her children were born, is still standing on the corner of Oak and Poplar Avenues. (Both, courtesy of the Watts Collection.)

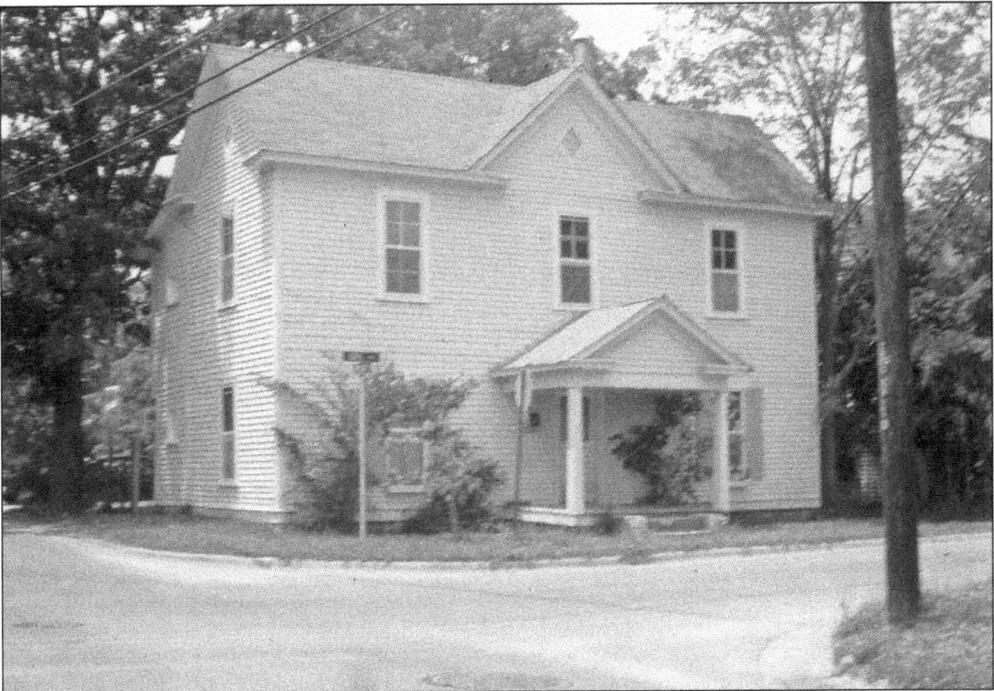

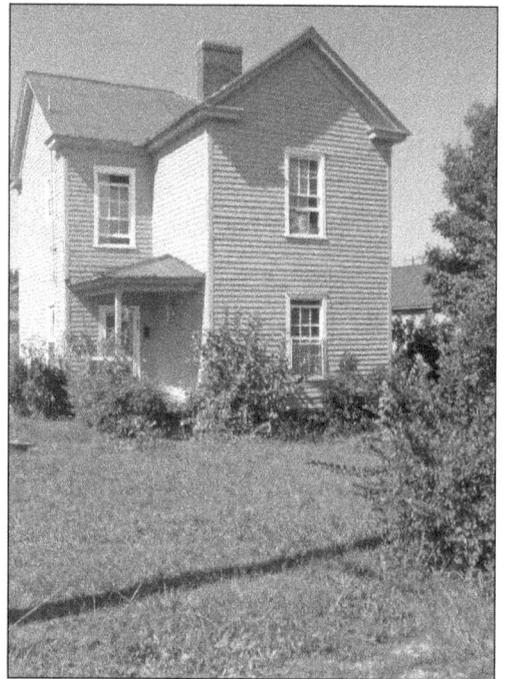

On the top left is a well. Most families in early Carrboro obtained water from wells. At first, Carrboro bought water from the university, which owned the utility until the mid-1970s. The home of Bennie and Lillie Ray on Weaver Street is shown in the photograph above, right. This building now houses the Wellness Alliance. (Both, courtesy of the Watts collection.)

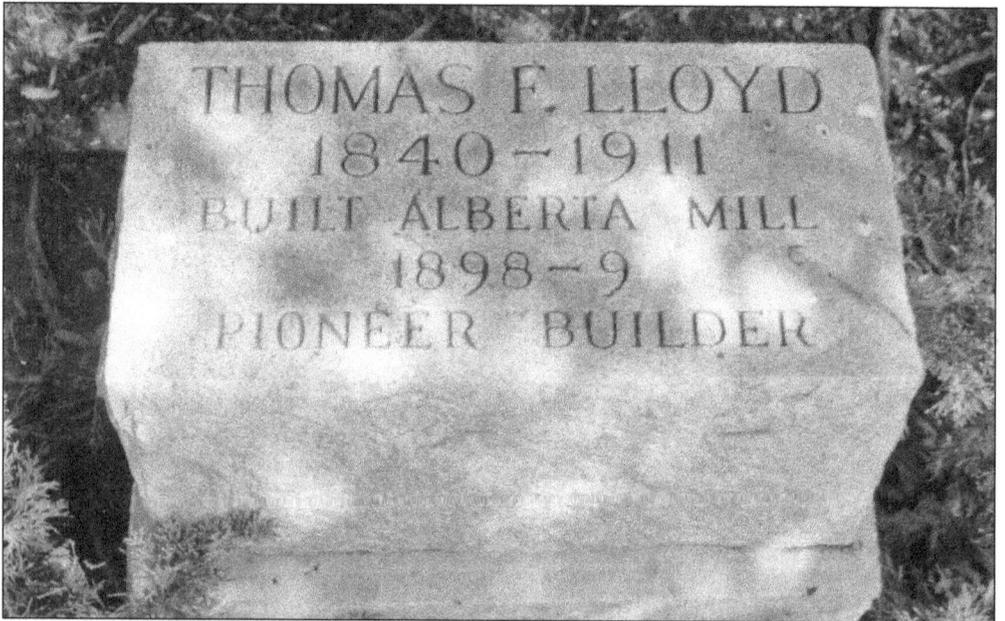

This humble stone marker honoring Thomas Lloyd can be found in the corner of the Carr Mill parking lot and the sidewalk along Weaver Street. Most people walk by and never notice the marker. It is puzzling why Carrboro has never erected an appropriate monument to celebrate the man most responsible for creating the town! (Photograph by Richard Ellington.)

Three

LIFE IN THE MILLTOWN (1920–1960)

According to the 1920 census, the population of Carrboro was 1,129. In addition to two textile mills, there were two lumber plants, a gristmill, a cotton gin, a laundry, a barbershop, a bank, and 10 grocery stores, wrote Sturdivant in 1924.

The first school in Carrboro was located on Center Street in a wooden house. Only seven grades were taught, because most children began working in the mills by age 12. The curriculum included reading, writing, arithmetic, history, and geography. If students wanted to attend high school, they went to Chapel Hill. A few tried, but they usually quit because of the chilly reception: "Don't get close to him, you will get lint on you," recalls Quinney in 1980. Most students considered themselves fortunate to complete seventh grade.

In 1921, Carrboro built a brick school for grades one through eight that was administered by Orange County. Several generations of children were educated in the Carrboro Grade School from 1922 to 1958. In 1959, Carrboro merged with the Chapel Hill School System, and the school closed. Today the building serves as the town hall.

The fortunes of Carrboro varied with the demand for textiles. In their heyday, the mills employed more than 500 workers and paid more than $1 million in salaries annually. Business flourished during World War I but declined in the 1920s. Mill No. 4 closed in 1930, and Mill No. 7 closed three years later. The university eased the hardship by hiring some former mill workers for construction and maintenance.

Mill No. 7 was converted to a munitions plant in 1942. Antiaircraft ammunition was manufactured there for three years. After the war, the munitions plant closed.

Pacific Mills purchased and modernized both buildings in 1945. The mills then produced worsted cloth for suits, dress material, and auto upholstery until the early 1960s. The final closing of the mills dealt an economic blow to the town and challenged its identity as a mill town, but it was now time for Carrboro to shake off the lint and move forward.

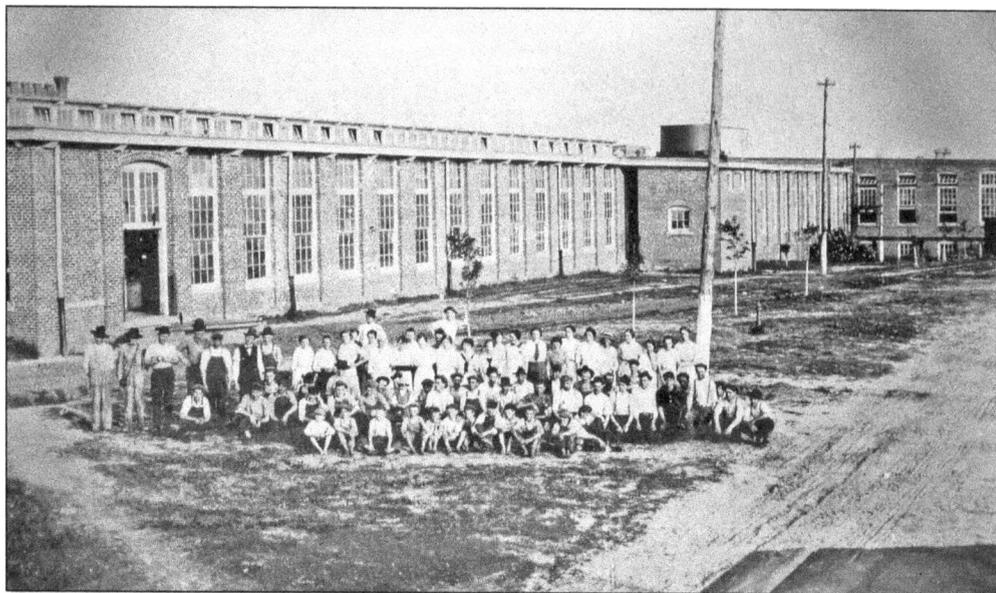

Thomas Lloyd began construction of a second cotton mill in 1909 but died before it was completed. Julian Carr purchased the mill and renamed it Durham Hosiery Mill No. 7. Note the young boys in the front row of the c. 1920 photograph above. Lloyd permitted children to begin working at age six, but Carr increased the minimum age to 12. The mill was demolished in the late 1960s. The bricks from this mill were donated for use in constructing the new South Orange Rescue Squad building, located on Roberson Street on property once occupied by Mill No. 7. (Courtesy of the Watts Collection.)

Mrs. Cates lived on Oak Avenue and was known to most only as "Aunt Sis." (Courtesy of Carley Pardington.)

56

Orange Electric Shoe Shop was located on Main Street. Electricity was such a novelty when this picture was taken around 1915 that "electric" was used in advertisements to inform customers that equipment in the shop was powered by electricity. (Courtesy of the North Carolina Collection.)

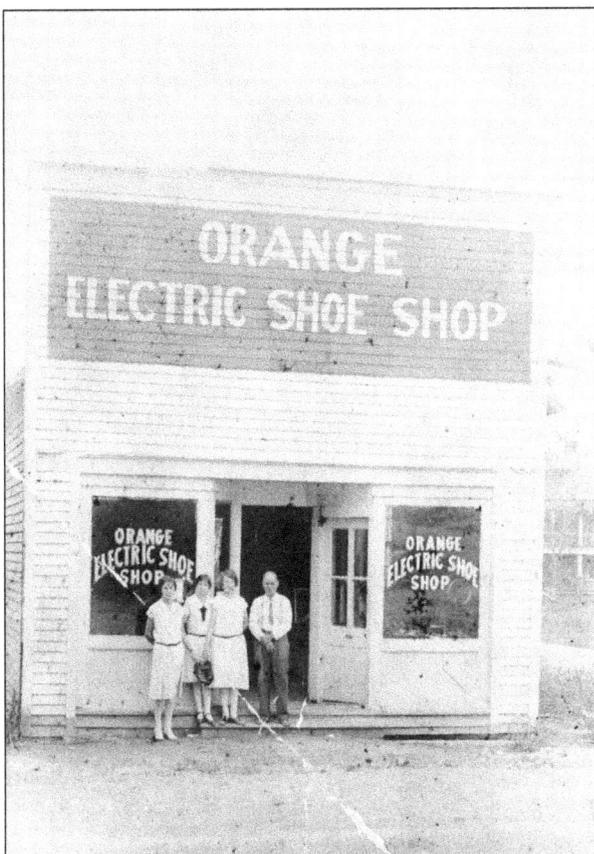

This picture of Main Street was taken in 1924. The street was not paved at that time. The Ford Model T belonged to Dr. Braxton Lloyd. Nellie Strayhorn can be seen leaving one of the buildings. The young man walking down the street is Willis Barbee, Nellie's grandson. (Courtesy of the Watts Collection.)

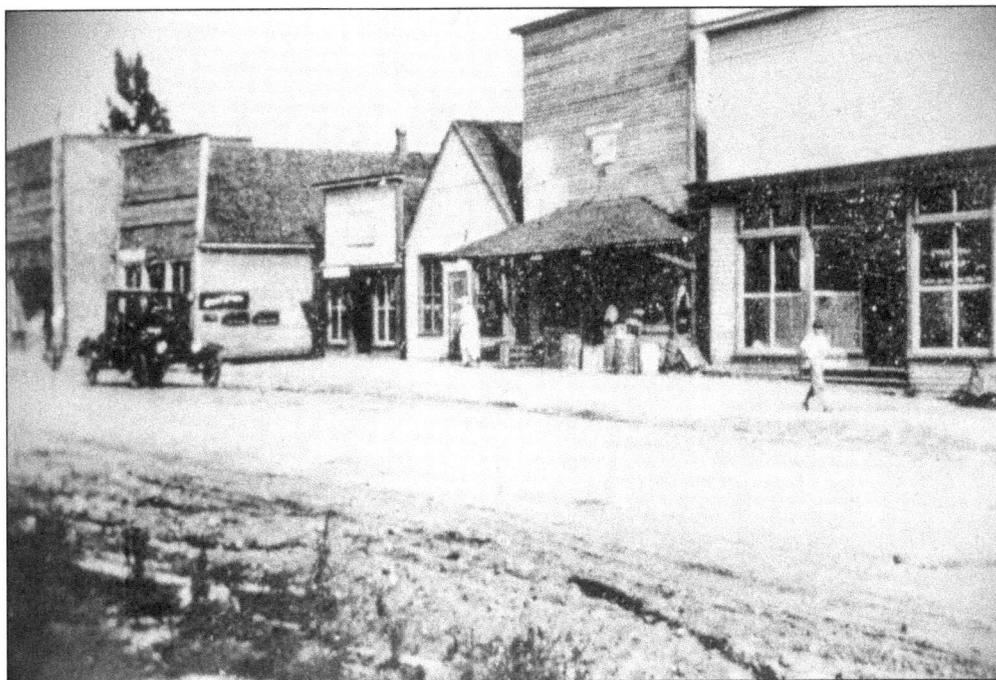

Josie Sturdivant began teaching at Carrboro Elementary School in 1913. She was an excellent teacher and a respected leader in the community. In 1927, she became principal of the school, a job that she performed with dignity and honor. She retired in 1943 after 30 years of service to the cultural and spiritual life of the town. (Courtesy of the Watts Collection.)

"That sure was an odd-looking bunch of children parading down the street, not one of them decently dressed. Any other time of the year than Halloween they wouldn't have been let out of the house fixed up like that. These children were going to a 'tacky party,'" according to a Frances Head Tripp article. (From the Watts Collection.)

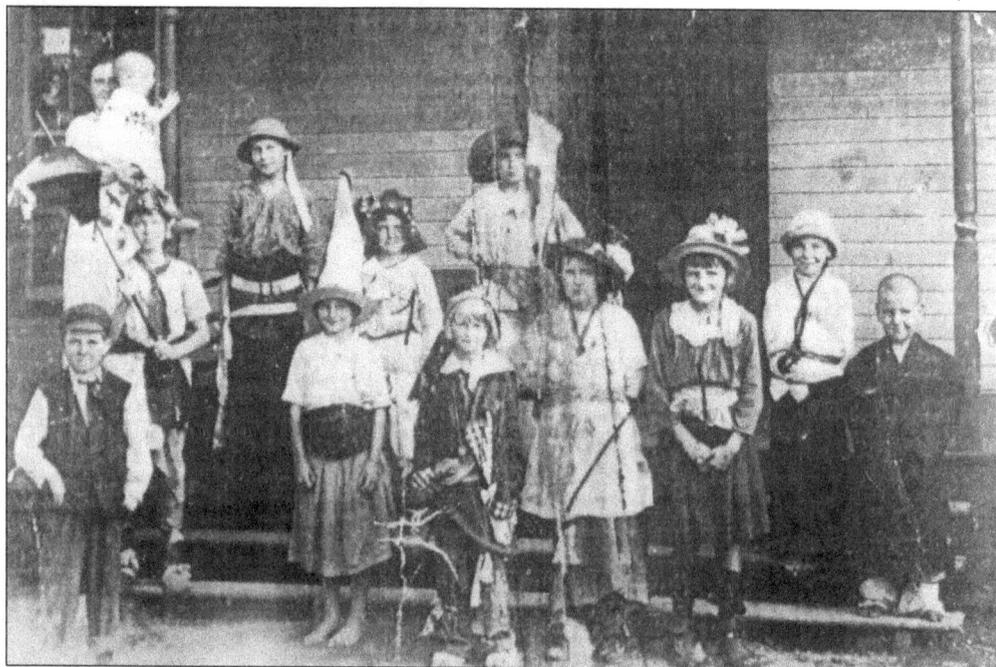

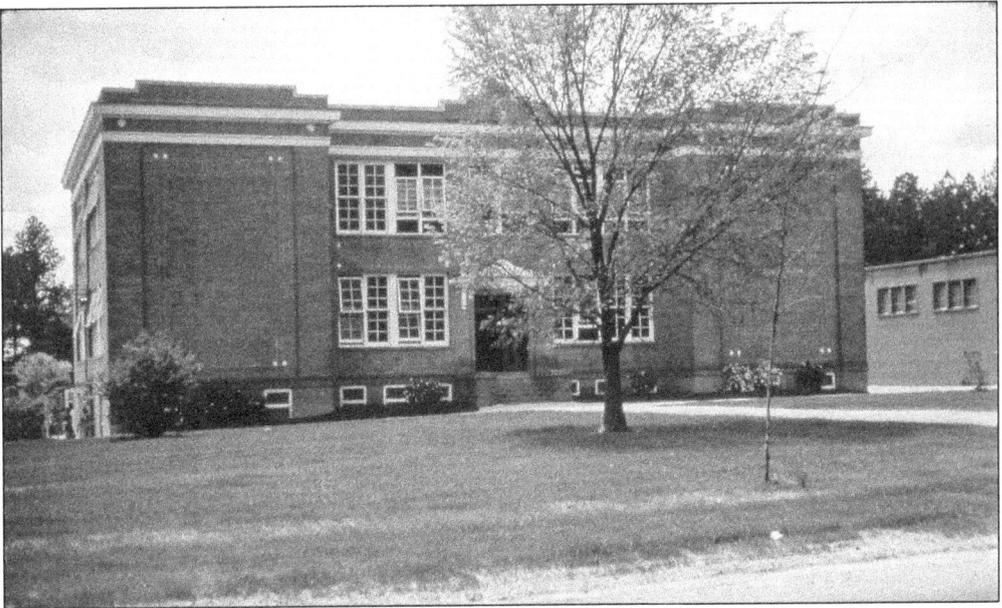

The Carrboro Graded School (above) was built in 1922. Note the elm tree beside the walkway in the front yard. This elm tree has grown tall and full in the ensuing years and has been designated a historic landmark to be honored and preserved for future generations. The building has continued to serve Carrboro as the town hall. (Courtesy of the Watts Collection.)

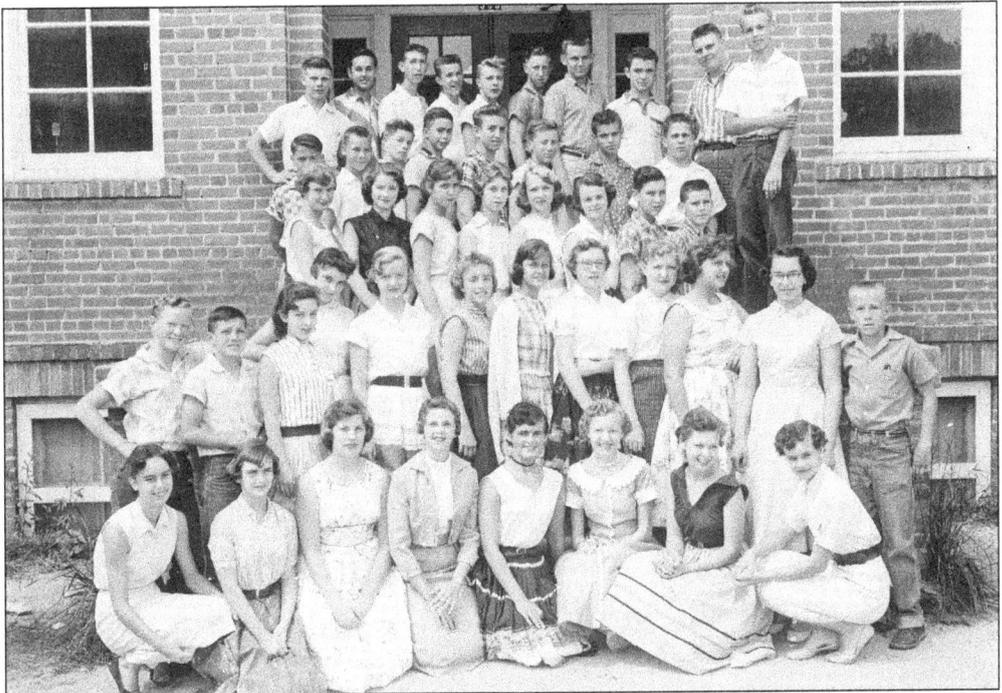

The eighth-grade graduating class of 1957 is shown here. Terry Todd, third from left in the first row, was the daughter of Mayor R. B. Todd. John Blackwood (far left, fifth row) went on to become the Carrboro police chief for a short time. (Courtesy of the Roland Giduz Collection, North Carolina Room, Wilson Library.)

Mae Clark Mann (left) moved to the community in 1894, where she lived for the rest of her life. "Miss Mae" taught music for many years to area children. One of her music classes is shown below around 1930. Pictured are, from left to right, (first row) Frankie Durham, ? Dean, ? Pendergrass, ? Dean, Lois Starnes, Phyllis Durham, and Hazel Ferrell; (second row) Margaret Clark, Lucille Perry, Lois Ray, Elizabeth Womble, Mabel Dean, June Hogan, and Ruth Ferrell; (third row) two unidentified, Christine Mann, Addie Dean, Pearle Hackney, Glen Starnes, and Walter Clark; (fourth row) Andrew Cannada, Julia West, unidentified, Maude Mann, Mae Mann, Gertrude Pridgen, Lois Andrews, and Sidney Wall. Mae Mann died in 1976. (Both, courtesy of the Watts Collection.)

Beulah Dillehay (above) is standing in the yard of her home on the corner of Weaver and Greensboro Streets, across from Mill No. 4, around 1926. Note the mill houses along the side of the street. Mill owners sold the houses for $600 each during the 1930s, when the mills closed. Pictured below, from left to right, are "Lum" Oakley, Jesse Oakley, and Tom Goodrich around 1930. The Oakley brothers worked in the mills—Lum as a twister and Jesse as a spooler. Tom Goodrich was the first employee of Fitch Lumber Company when it opened in 1923. Tom boarded with the Oakleys for several years. Many Carrboro families provided room and board for mill employees so they could walk to work. (Above, courtesy of Richard Ellington; below, courtesy of the Watts Collection.)

Fitch-Riggs Company was founded in Mebane in 1907 and opened in Carrboro in 1923. It became Fitch Lumber Company in 1927. It is the oldest business in Carrboro. Three generations of Fitches are pictured above. From left to right are Homer (son), Miles (son), Abner (father), R. B. (son), and R. B. Jr. (grandson). Pictured below is an aerial view of the Fitch Lumber sawing and planing operation on Lloyd Street around 1950. (Both, courtesy of the Fitch family.)

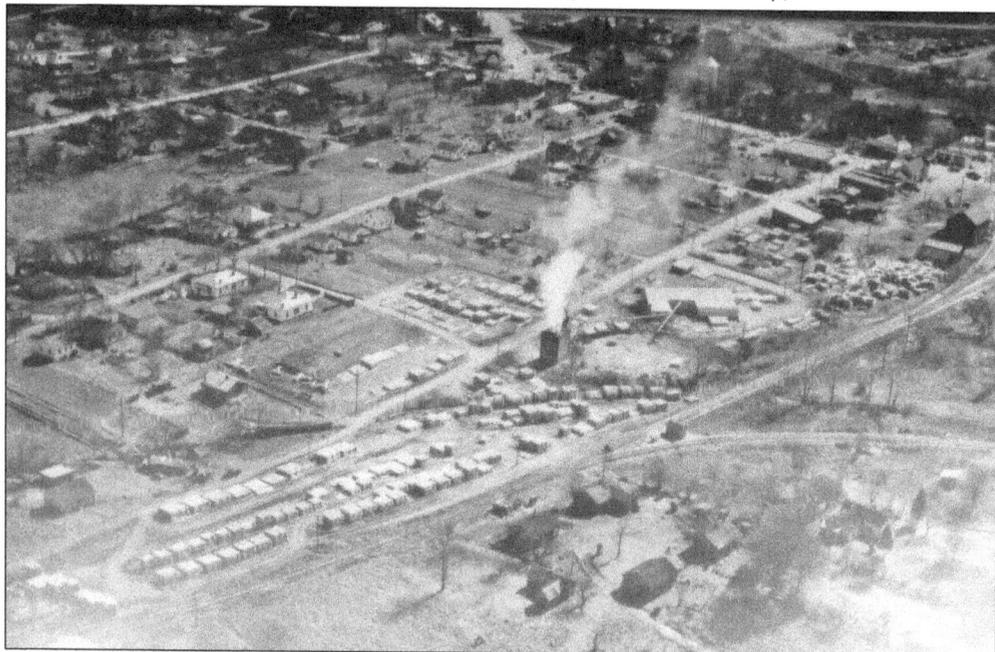

Another family-owned Carrboro business that has been in operation for more than 60 years is Sparrow and Sons Plumbing on Weaver Street. Carl Sparrow (right) and sons Martin and Braxton started the company in 1946. Martin and Braxton managed the business after Carl's death. Martin's wife, Emily, helped in the office for many years. Martin and Emily are shown in the picture below. Families in the Chapel Hill–Carrboro area have depended on the Sparrows for plumbing repairs for four generations. (Both, courtesy of the Sparrow family.)

Talley Hardee's grocery store was at the corner of present-day Main and Greensboro Streets. Hardee (left) sold groceries, seafood, and firewood. According to Tripp in 1981, "For 25 years, Mr. Hardee was well known around Carrboro for his generosity, not only giving a heaped-up measure in his store to specially needy people, but actually carrying groceries to any family suffering from want." Hardee's son Bill continued to operate the store until the 1970s, when Cliff Collins bought the business, known today as Cliff's Meat Market. The picture below shows the Hardees turning the shop over to Cliff. From left to right are Kathy Collins, Helen Hardee, Bill Hardee, Randy Robinson, Carl Stone, Larry Billingsley, and Cliff Collins. (Left, courtesy of the Watts Collection; below, courtesy of Jake Hardee.)

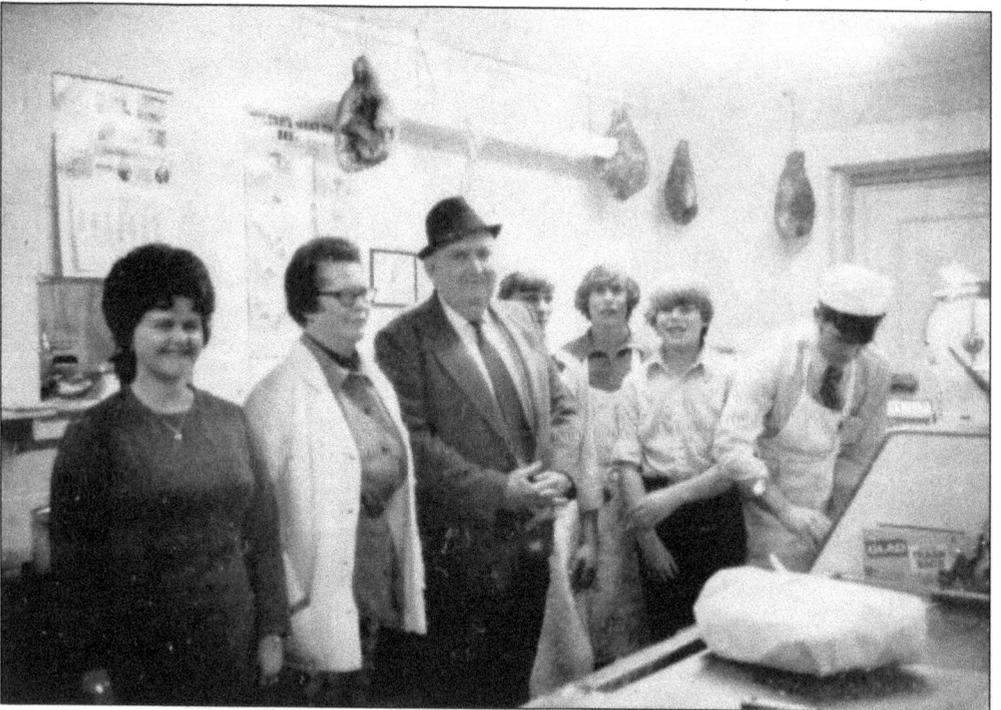

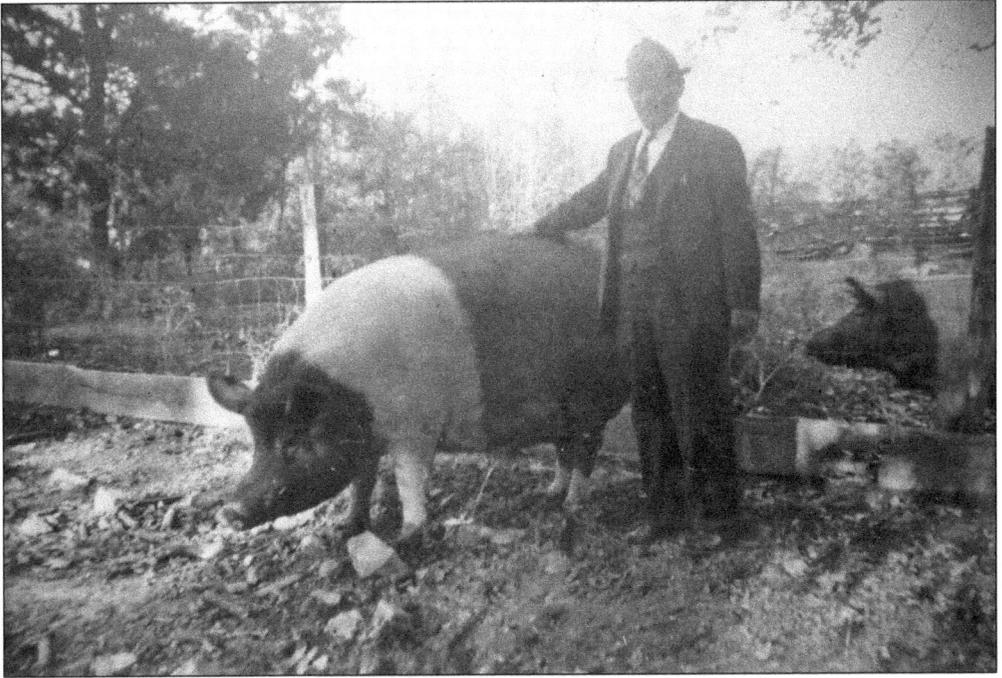

Dr. Braxton Lloyd (above) was known as a fancier of hogs. Many folks said that it was uncanny how much Doc Adams on the 1960s television show *Gunsmoke* resembled Dr. Lloyd, down to his hat and personality. The pen was at the end of Lindsay Street, where many families kept hogs. Matilda Pickett, a blind woman, lived near the present location of the PTA Thrift Shop on Jones Ferry Road. Her house is shown in the picture below. Many children born in Carrboro in the early 20th century were said to have been delivered in this neighborhood, suggesting that a midwife lived here. (Both, courtesy of the Watts Collection.)

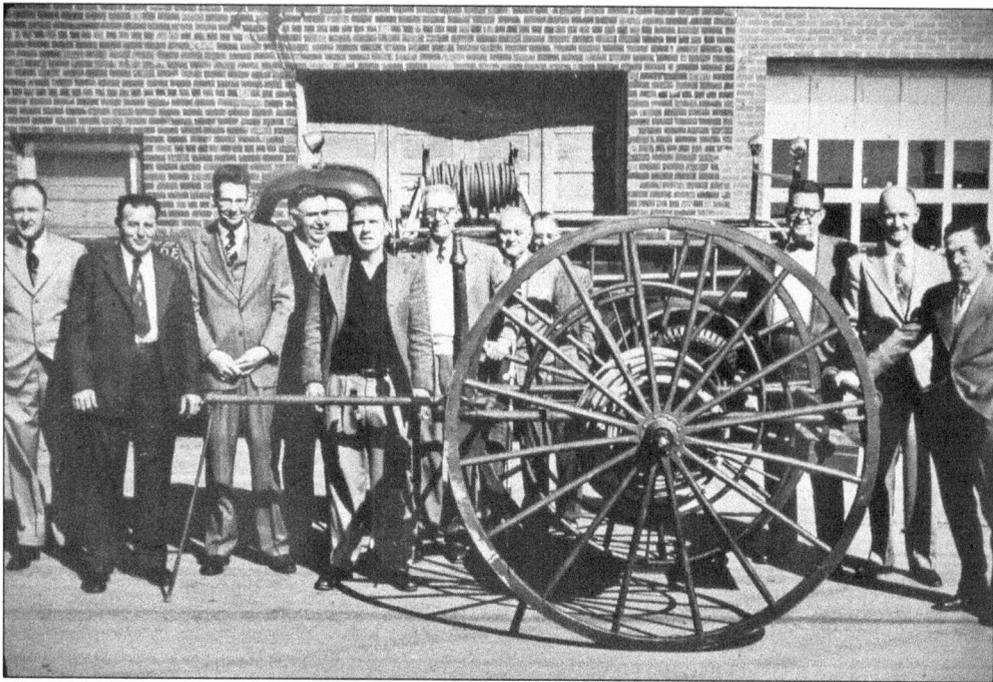

For many years, volunteers manned the fire department in Carrboro. Hose reel carts (above), stationed at several locations around town, were the first fire-fighting equipment in Carrboro. When a fire alarm sounded, volunteers would come running with a hose cart. Firemen boasted that they usually managed to save the lot and the chimney! The picture below, taken in 1954, illustrates the evolution of fire-fighting trucks from the first (lower right). Charlie Ragan, a mechanic who had a shop on Elm Street, outfitted the first truck with fire equipment. (Courtesy of Jake Hardee, the last volunteer fire chief.)

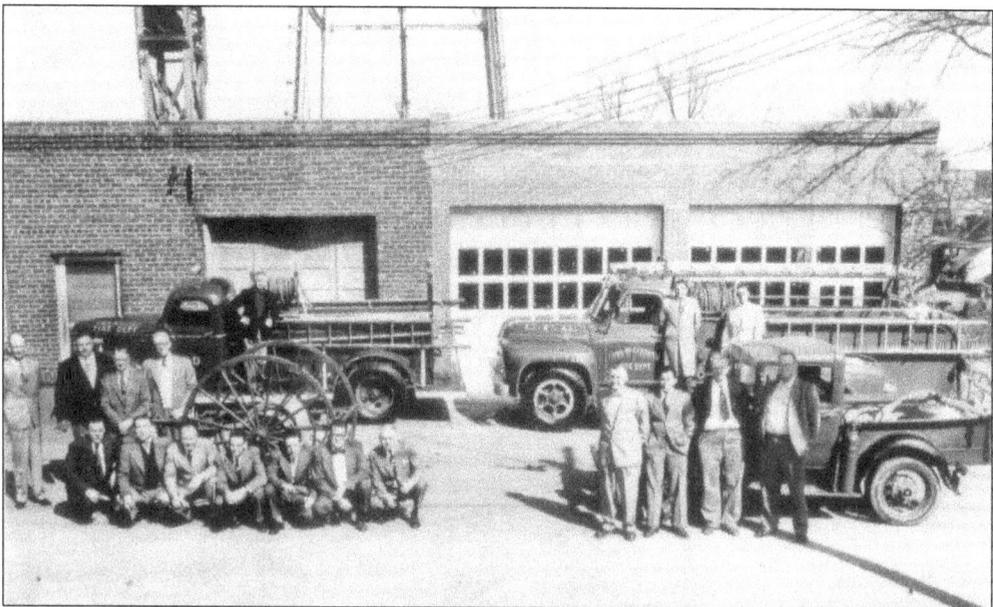

As a teenager, Mary Lloyd Head (right) decided to create a newspaper, the *Carrboro Courier*, about the town and its people. The first edition appeared in February 1934. A year's subscription to the four-page paper was only $1. A local barbershop owned by Jessie Hackney and Alan White advertised haircuts for 25¢. The February 16, 1934, edition (below) describes how the water jacket on Mrs. S. C. Hunley's stove exploded, almost killing her; Mae Mann was having a recital on Friday evening in the Carrboro School; and a fire in a lane off Cameron Avenue killed four people and drew a crowd of 200. The paper survived only a short time during the Great Depression. (Both, courtesy of the Watts Collection.)

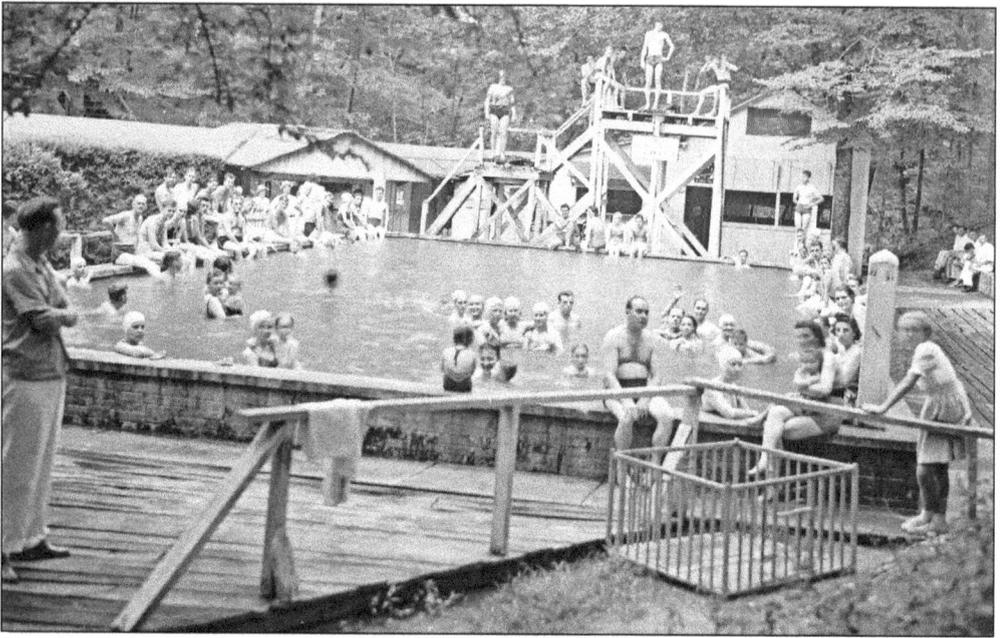

Sparrow's Pool on Old Pittsboro Road was a popular retreat on hot summer days. Jody and Mattie Sparrow built the pool around 1920 and opened it to the public for 25¢ admission. The pool closed in 1958. Jane and Logan Kendall purchased the property in 2008. The Kendalls plan to obtain a conservation easement to preserve the property and to make it available for educational purposes. (Courtesy of the North Carolina Collection.)

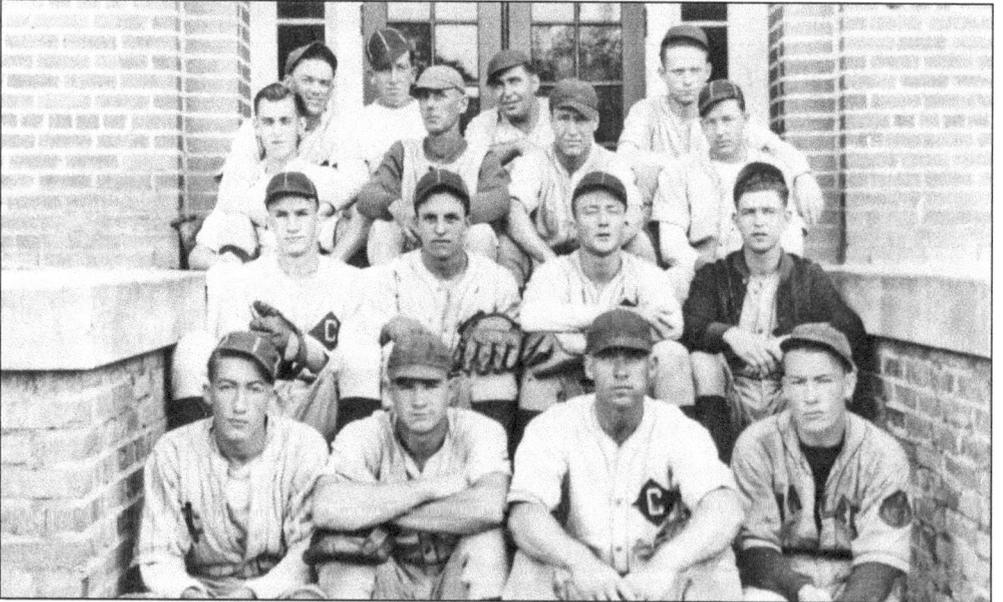

Baseball has long been popular in Carrboro. The 1935 Carrboro Cubs included, from left to right, (first row) Raymond "Wimpy" Andrews, Bob Ray, Joe Parker, and Ernest Riggsbee; (second row) Herman Lloyd, Baymon Upchurch, Bruce Riggsbee, and Brack Riggsbee; (third row) James Horne, Sy Smith, Odell King, and Warren Thrift; (fourth row) Homer Fitch, Griffin Clark, Bill Hardee, and Woody Williams. (Courtesy of the Raymond Andrews family.)

Charles Ellington took some lady friends out for a drive in the country in his Ford Model A around 1930. Berta Dillehay is on his right and Myrtle Dillehay is the girl in front. Charles worked many years as a yard supervisor for Fitch Lumber. Ellington served on the board of aldermen and as mayor from 1960 to 1966. (Courtesy of Richard Ellington.)

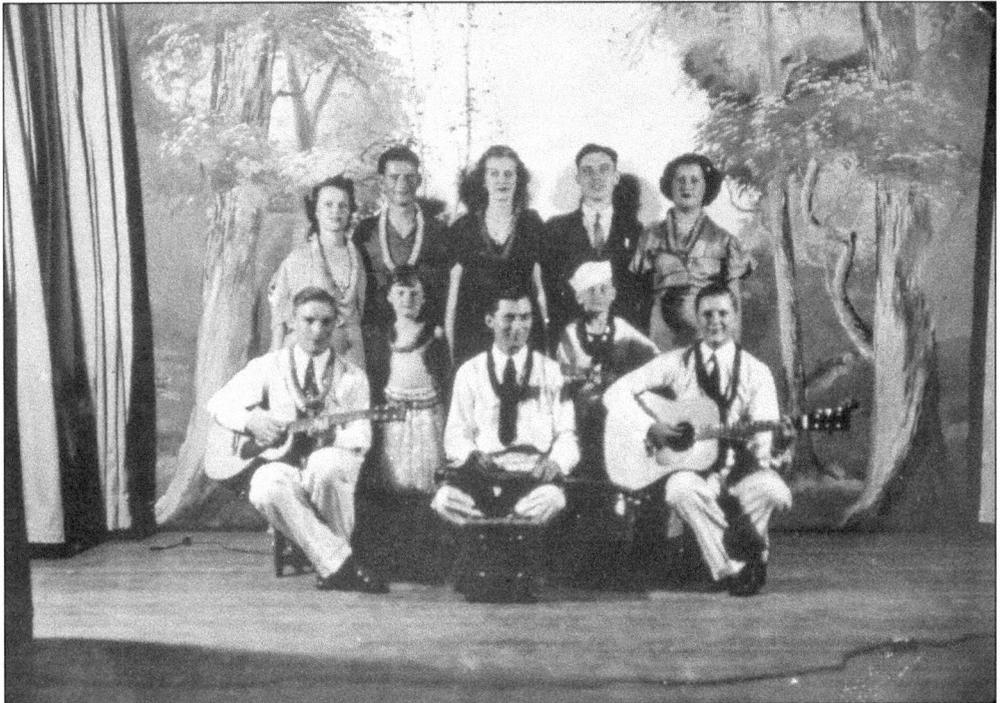

Mack Watts, in the center of the first row, organized a band that played for house parties and other Carrboro events. Watts loved Hawaiian music. This picture was taken in the auditorium of the old Carrboro Graded School. (Courtesy of the Watts Collection.)

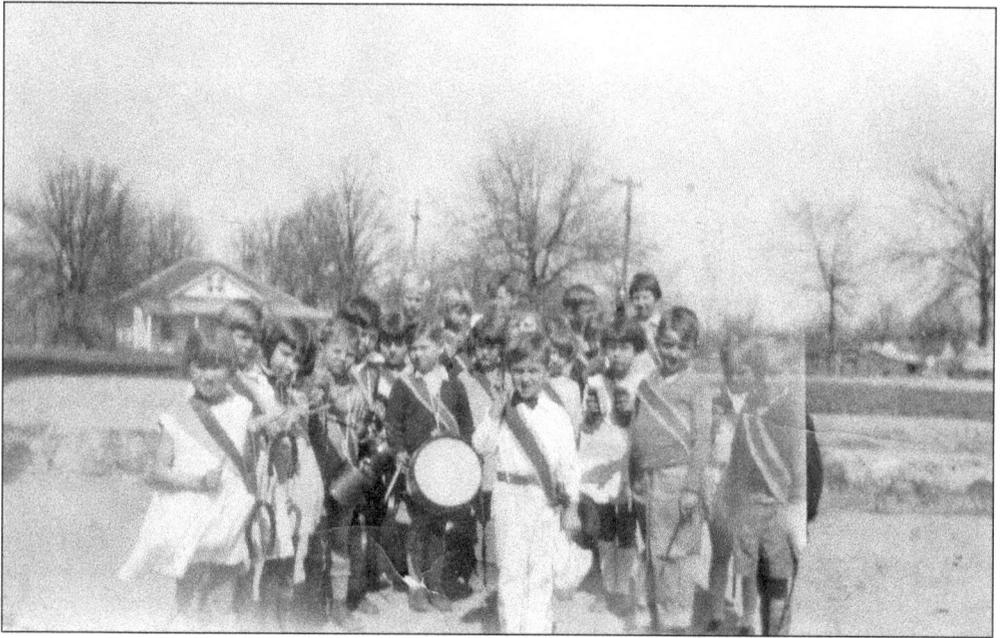

Students in the rhythm band around 1931 (above) are standing in front of Carrboro Graded School. For many years, the Maypole Dance (below) was an annual rite of spring at the Carrboro Graded School. (Both, courtesy of Carley Pardington.)

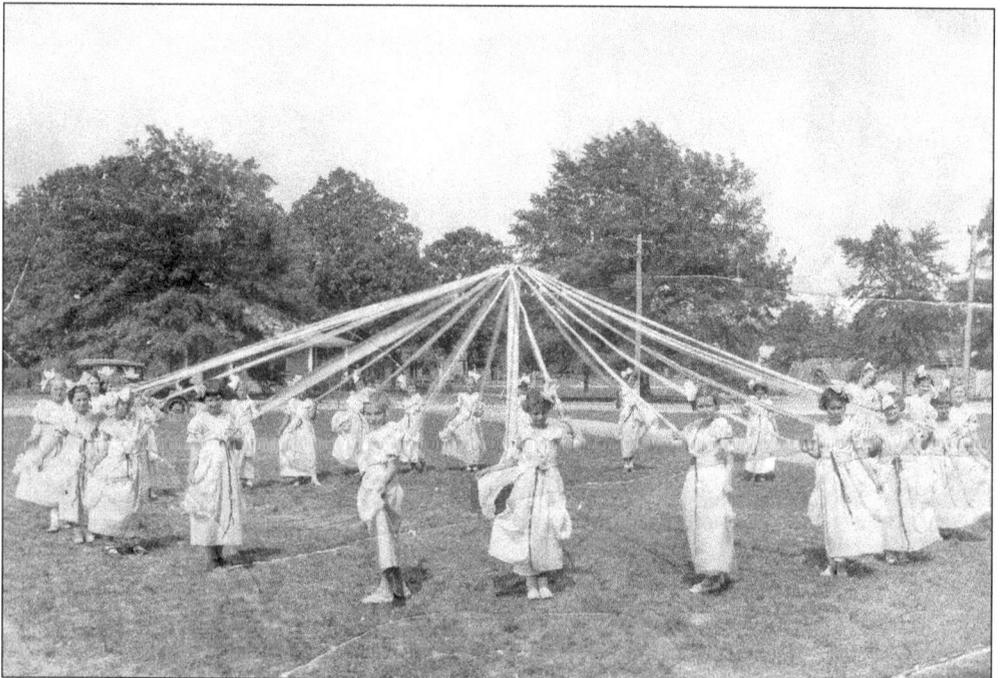

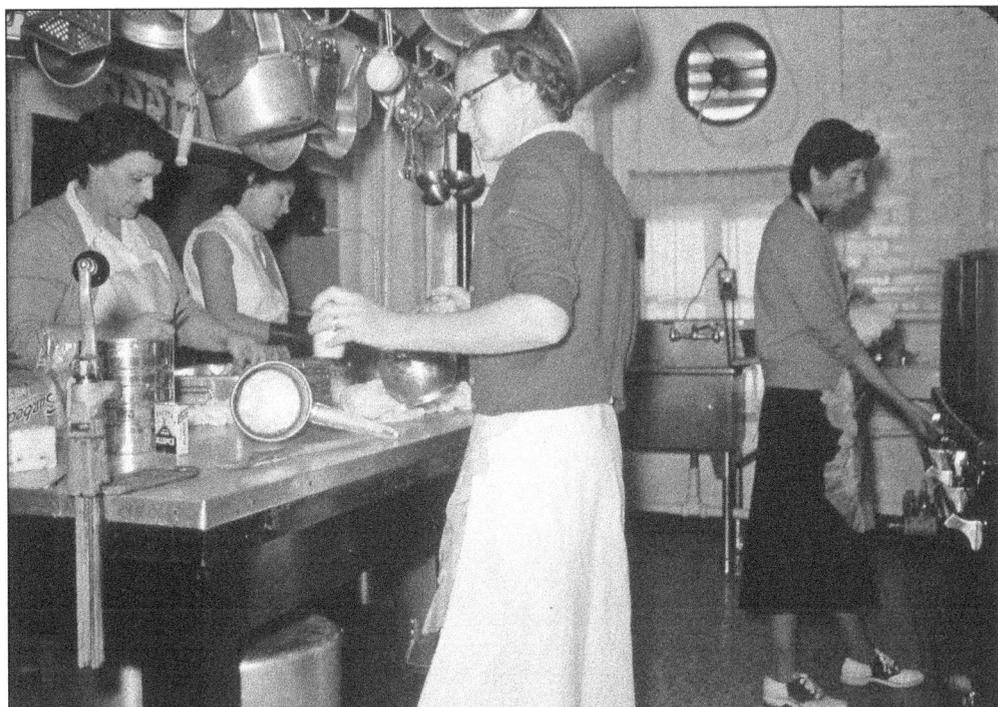

In the picture above, from left to right, Mildred Barker, an unidentified worker, Beulah Watts, and Britty Page are preparing school lunch in the kitchen located in the basement of the Carrboro Elementary School in 1955. The second-grade class of Ola Maddry is eating lunch in the school cafeteria in the photograph below. There was no cafeteria when the school opened. Children brought their lunch to school or walked home to eat. In the late 1930s, Beulah Watts and Beulah Ellington decided that the children needed a hot lunch and worked with the school to clear out space. The county school system later hired cafeteria workers. (Both, courtesy of the Watts Collection.)

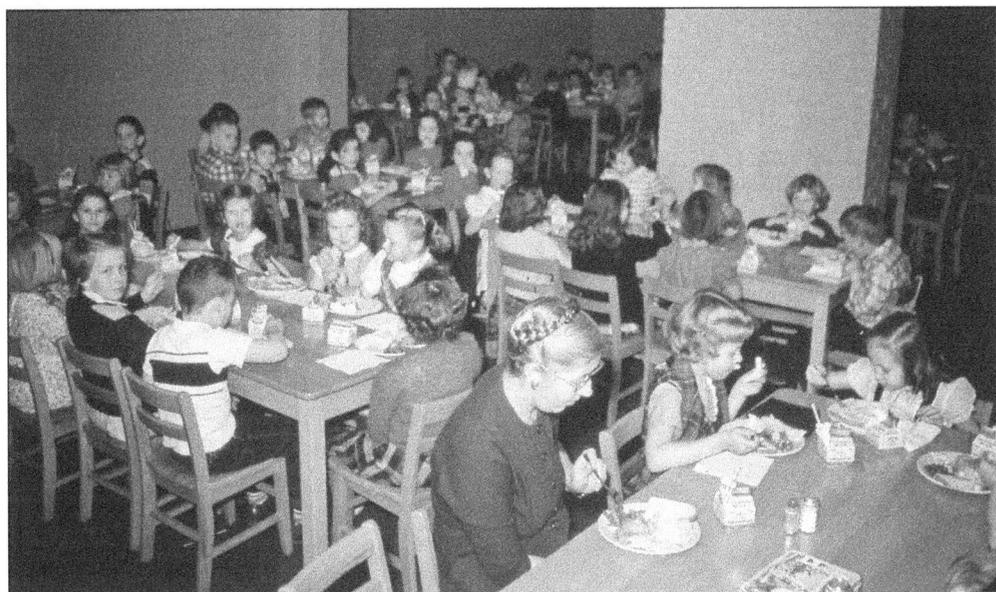

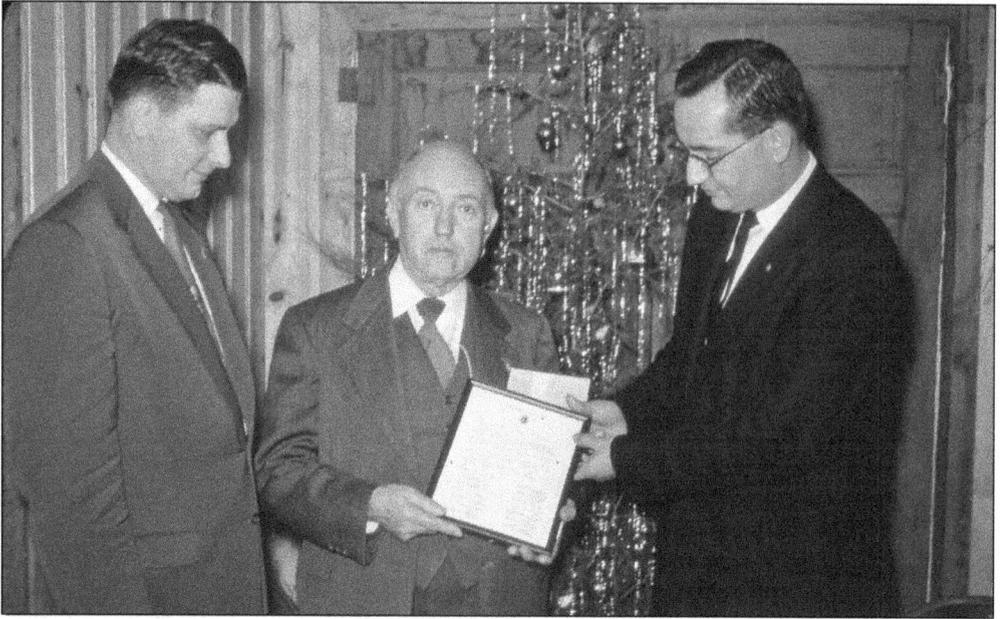

Pictured from left to right in the photograph above are Lloyd Senter, former mayor R. B. Studebaker (1941–1943), and Ashwell Harward at a Lion's Club meeting in the mid-1950s. In the photograph below, outgoing mayor J. S. Gibson (1951–1955) is presenting incoming mayor R. B. Todd (1955–1960), in the center, with the key to the town hall, while former mayor Roy Riggsbee (1935–1937) observes the 1955 ceremony. Seated around the table are members of the board of aldermen. From left to right are Bill Hardee, Paul Sturdivant, Offie Durham, unidentified, Teet Lloyd, and Wilson Lackey. (Both, courtesy of the Watts Collection.)

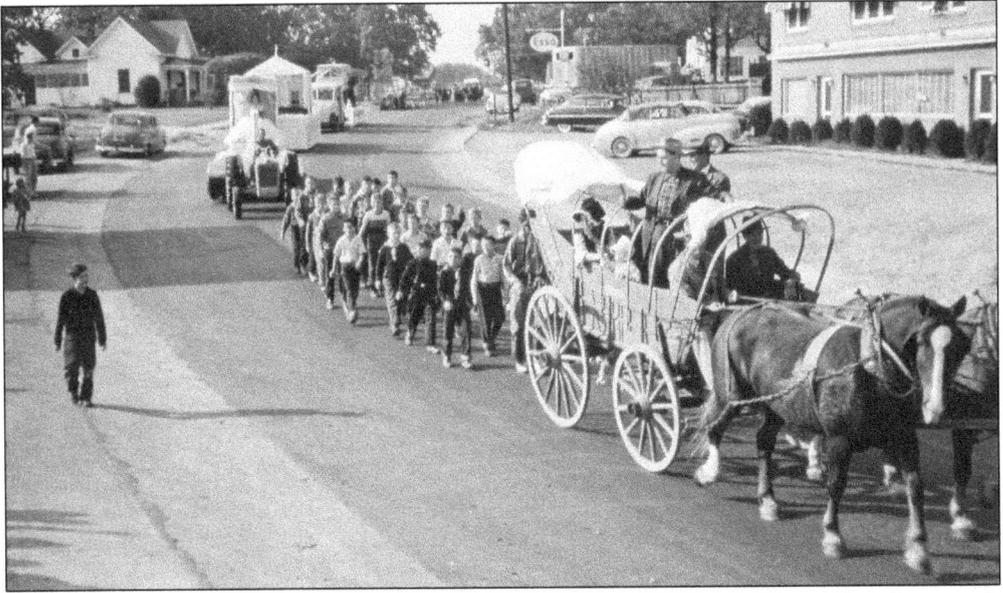

Orange County celebrated its bicentennial in 1952. The Conestoga wagon in the photograph above was part of the bicentennial parade that travelled the county. Many businesses used this as an opportunity to advertise on floats decorated with shiny bangles and pretty girls. The picture below is an aerial photograph of Carrboro taken in the late 1940s. Note that Weaver and Greensboro Streets and others were unpaved. (Above, courtesy of the Watts Collection; below, courtesy of the North Carolina Collection.)

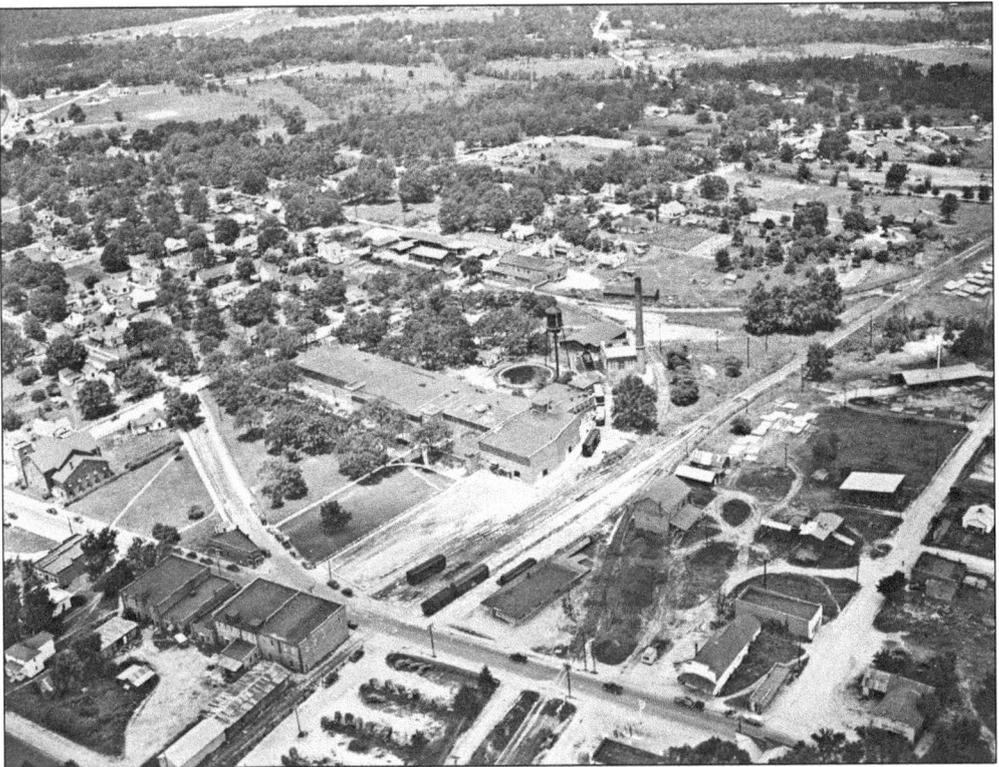

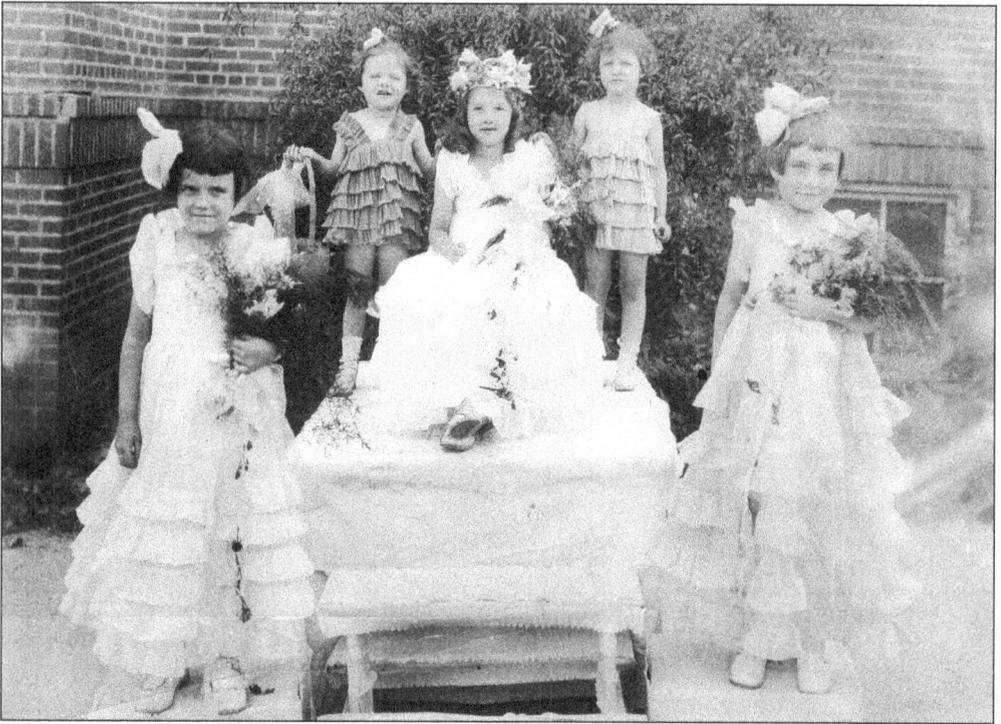

The May Queen and her court are, from left to right, (first row) Rachel Bland, Carley Williams (May Queen), and Jane Riggsbee; (second row) Janet Ellington and Lenore Tripp. They are all pictured on the front steps of the Carrboro Graded School around 1933. Mothers of the girls made the dresses from crepe paper. Another popular activity in the 1950s was the cute baby contest, shown in the picture below. The contest was held in the Carrboro Graded School auditorium. From left to right are unidentified, Frances Watson with daughter Kathy, Virginia Grantham holding her daughter Mary Lib, unidentified, Zolena Watts and son Richard, and Eleanor Harward with daughter Mary Nell. (Above, courtesy of Carley Williams Pardington; below, courtesy of the Watts Collection.)

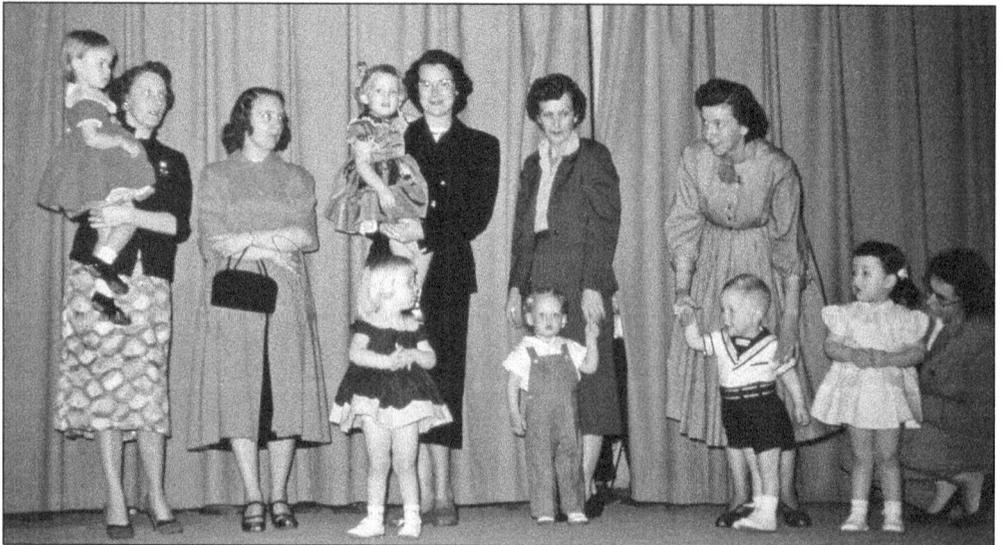

Carrboro folks often organized community activities to bring citizens together. They did this when times were good, but also when economic conditions were not the best. Sometimes activities were done as a fund-raiser for a special project. Two examples of community activities in the 1950s are illustrated here. The selection of Miss Carrboro Cub (above) was a favorite. Participants were local high school students. Another was the "Womanless Wedding" (below). From left to right are Mark Whitaker (bridesmaid), unidentified (groom), Harry Andrews (bridesmaid), and unidentified (bride). (Both, courtesy of the Watts Collection.)

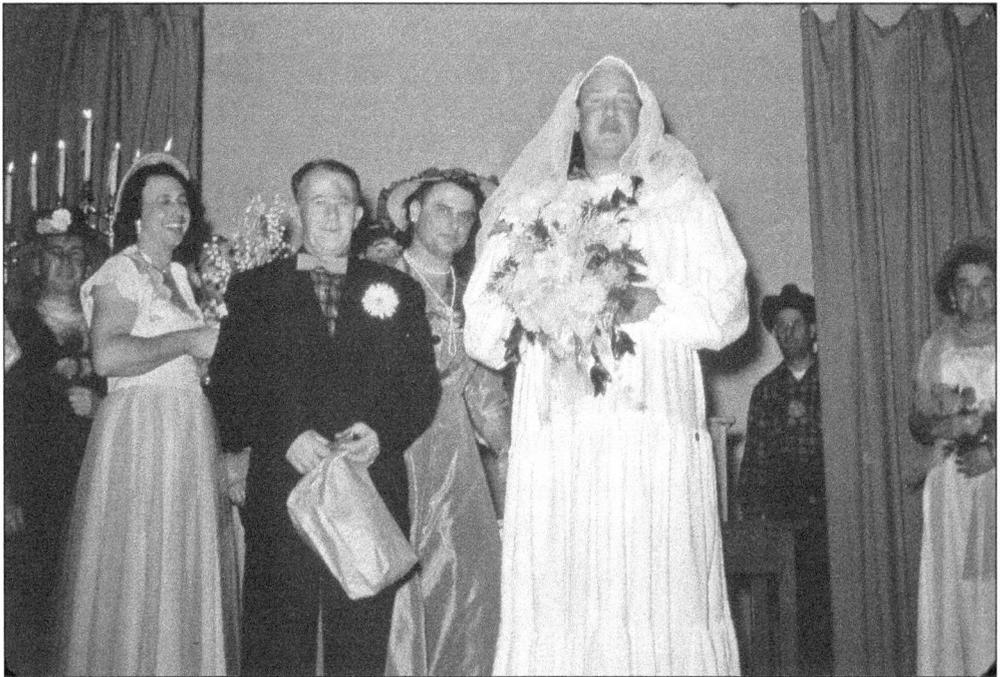

George "Cat Baby" Cannada (above, in 1954) graduated from Chapel Hill High School at age 21 without opening a book. He was a beloved and passionate sports fan who became an unofficial Chapel Hill High football team mascot. He would often lead the team onto the field for home games. "Cat" was an expression used then like "bro" is used now. One day, George called Bob Rosenbacher, who owned the Hub clothing store, "Cat." According to Charly Mann, the next time Bob saw George, he hollered out "Cat Baby," and the name spread until everyone called George "Cat Baby," to which George would reply "Wha-say Caaat'!" Luther Sturdivant (below) was Josie Sturdivant's husband. Luther ran a grocery store on Main Street as well as this popcorn stand across from present-day Jade Palace. The popcorn stand was removed about 1960. (Both, courtesy of the Watts Collection).

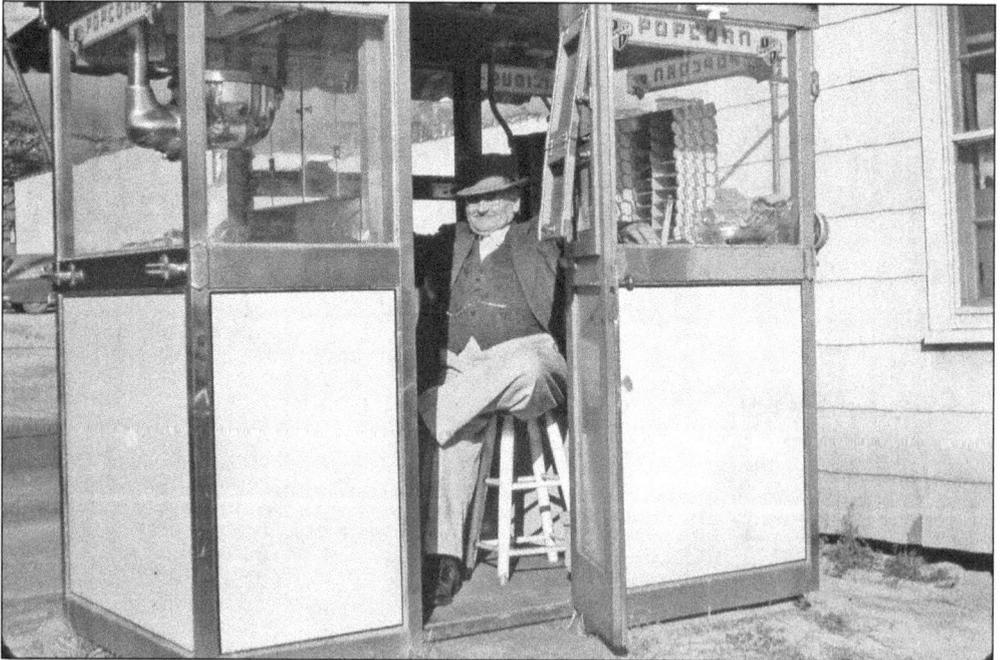

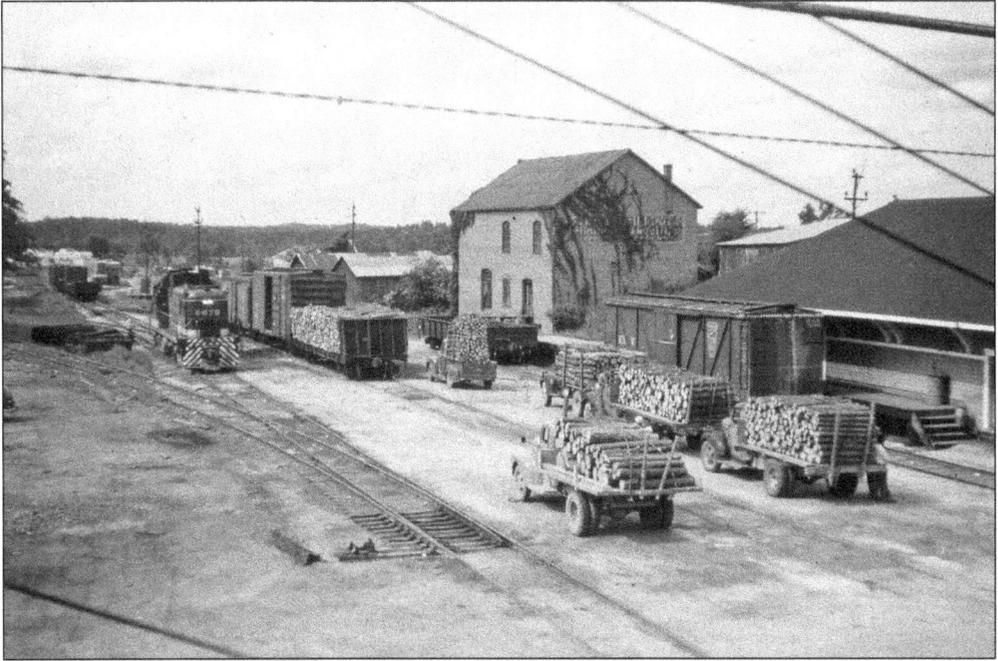

Trucks (above) are waiting to have cargos of pulpwood loaded on the train around 1950. Carrboro was an important pulpwood shipping center until the 1960s, when regular train service was discontinued. In the 1930s, brothers Eric and Stacey Neville opened a Texaco Station (below) on the island east of the Carrboro School. In the 1940s, the Nevilles moved across the street to a larger lot and opened an Esso Station where the North Carolina Crafts Gallery is currently located. John Cate and then Jack Riggsbee continued to operate the Texaco Station until it was torn down in the 1960s. (Both, courtesy of the Watts Collection.)

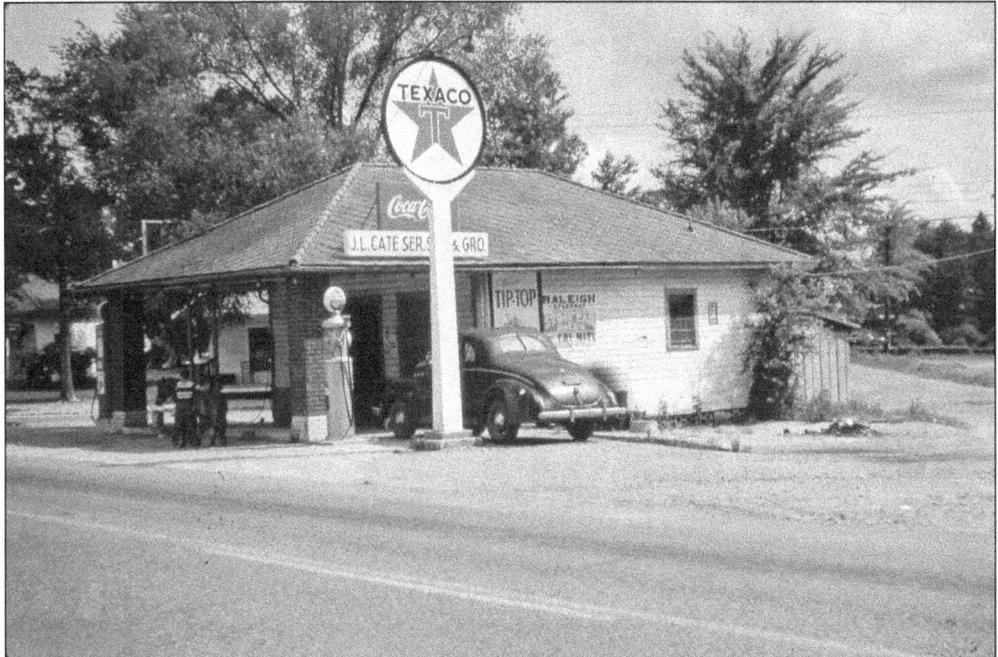

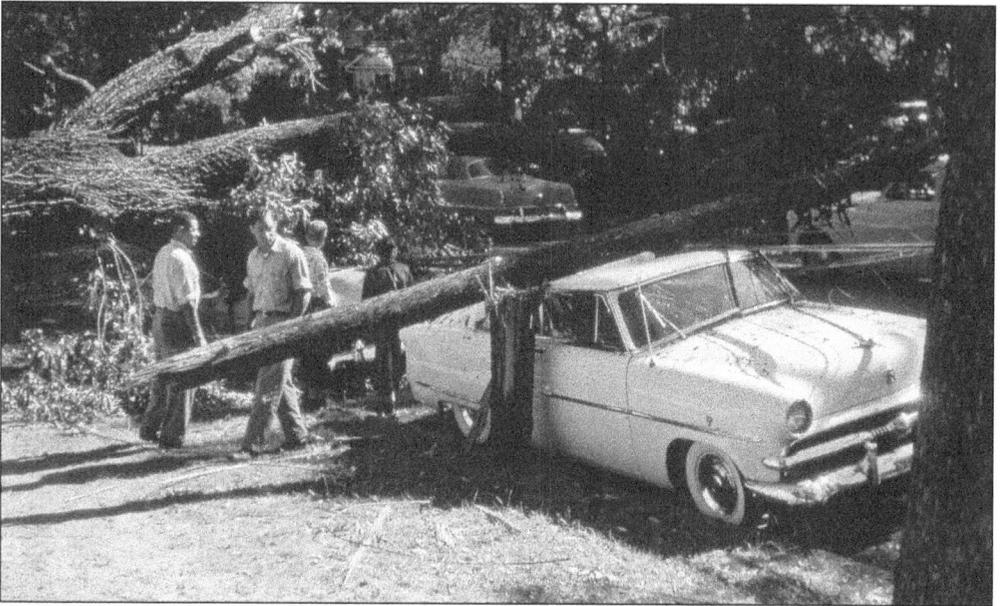

Hurricane Hazel ravaged North Carolina on October 15, 1954. The storm killed 19 people and did $1.1 billion of damage in the state. Although the worst damage occurred on the coast, hurricane-force winds reached far inland and caused extensive damage in Carrboro (above). Power was out for several days. (Courtesy of the Watts Collection.)

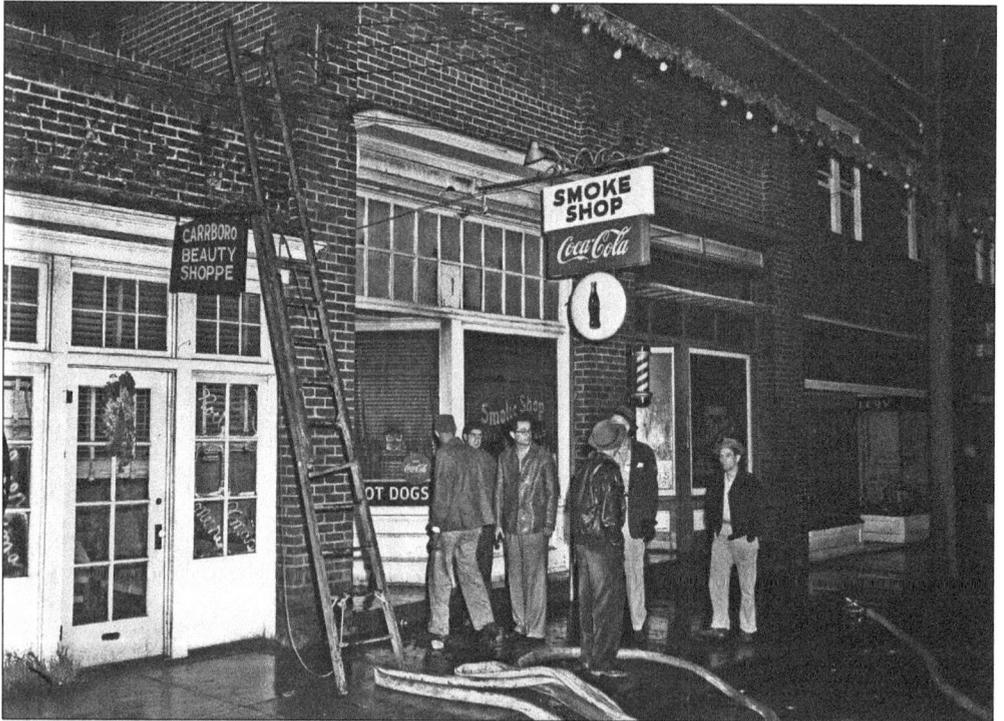

Fire damaged the Smoke Shop on Main Street on December 30, 1953. Volunteer fireman Ashwell Harward (third from left) and others helped to fight the fire. (Courtesy of the North Carolina Collection.)

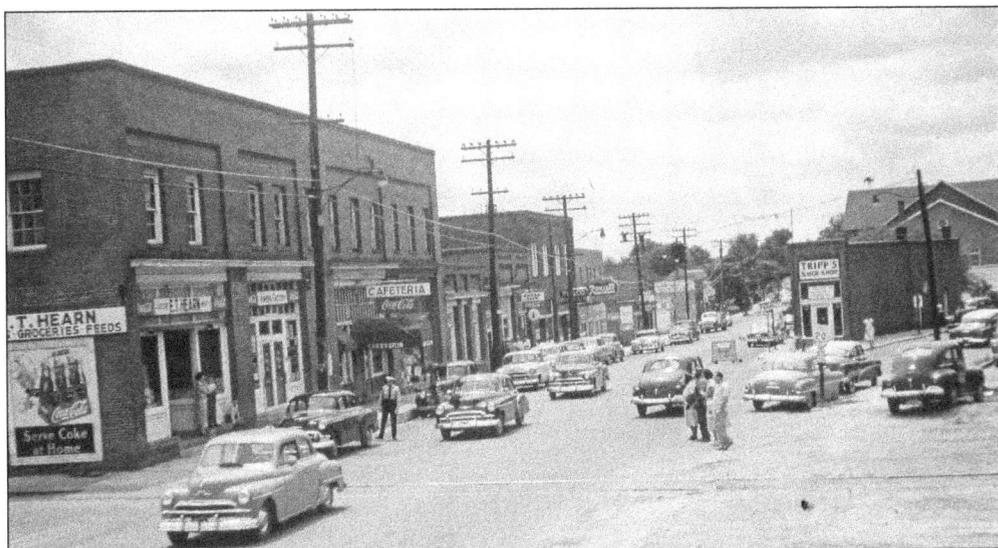

Downtown Carrboro in 1953 offered almost anything that families needed, including seven grocery stores. One of these was L. D. Hearn's, now Tyler's Taproom. A Frances Tripp article fondly remembered Harvey Boone, who worked there many years. "We cherished his helping us at the candy case and would wait for him . . . We had learned long before that the heavy-browed Mr. Harvey would drop an extra piece or two into our tiny brown bag." (Courtesy of the Watts Collection.)

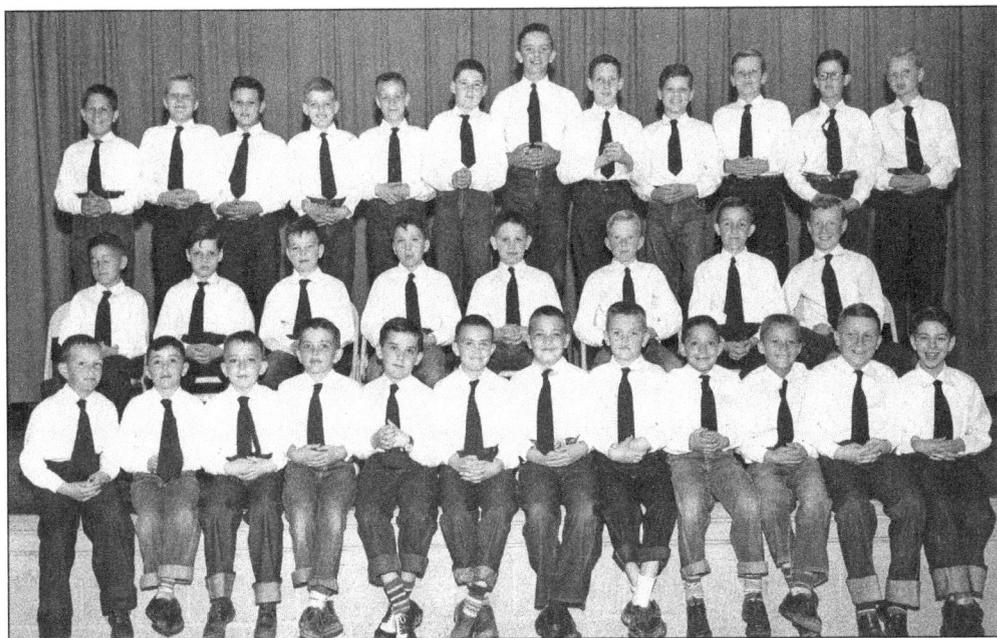

The "Blue Jeans" was a boys' chorus sponsored by the Carrboro Lions Club and made up of boys who lived in the town in the 1950s. Jan Schinhan was the director when this picture was taken. Boys aged 7 to 14 auditioned to become members and considered it an honor to be selected. This group garnered awards in several choral competitions. Concerts were given in the Carrboro Elementary School Auditorium, where the Carrboro Fire Station is currently located, as well as several local television appearances. (Courtesy of the Watts Collection.)

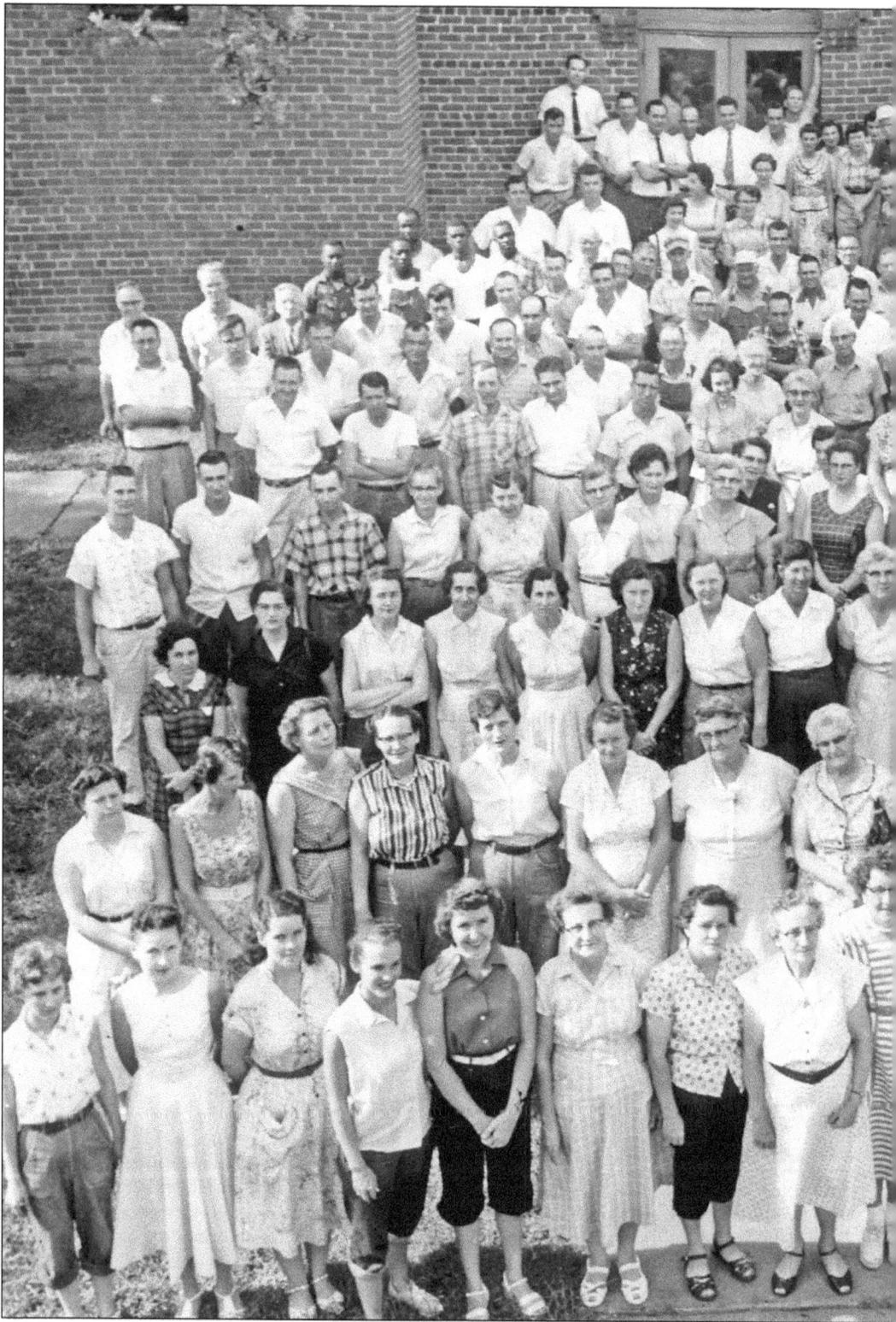

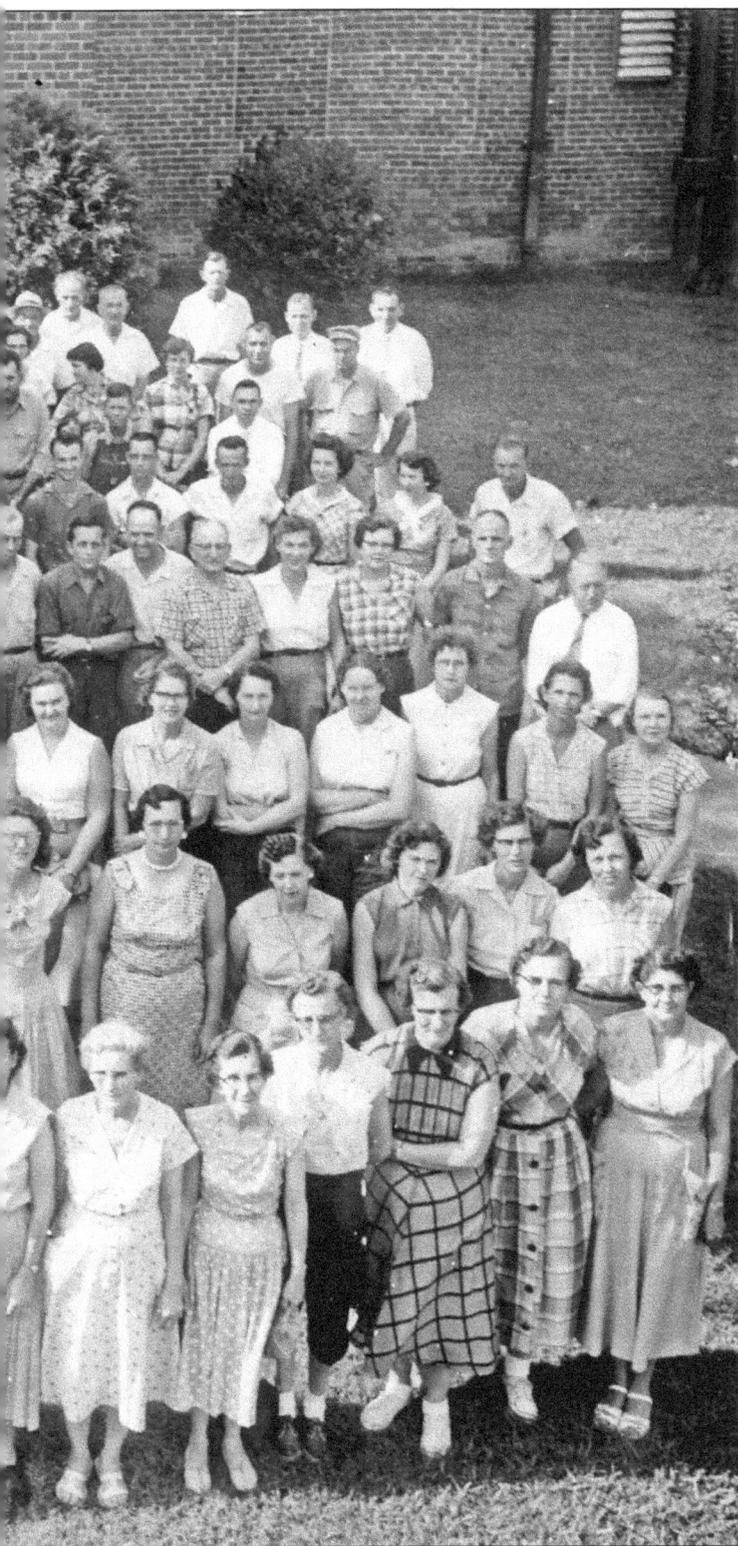

The group portrait of Pacific Mill employees was taken on June 18, 1957. Operation of the mill ceased in the early 1960s, although Burlington Mills continued to assemble men's underwear in the building until 1966. It is hard to imagine the impact on the economy and psyche of a small Southern town when the employment of so many people was suddenly terminated. (Courtesy of Lloyd Senter.)

This view of the entrance to the manager's office was taken around 1965, shortly before the mill closed. Today this doorway opens into Townsend-Bertram and Company Adventure Outfitters. (Courtesy of the Watts Collection.)

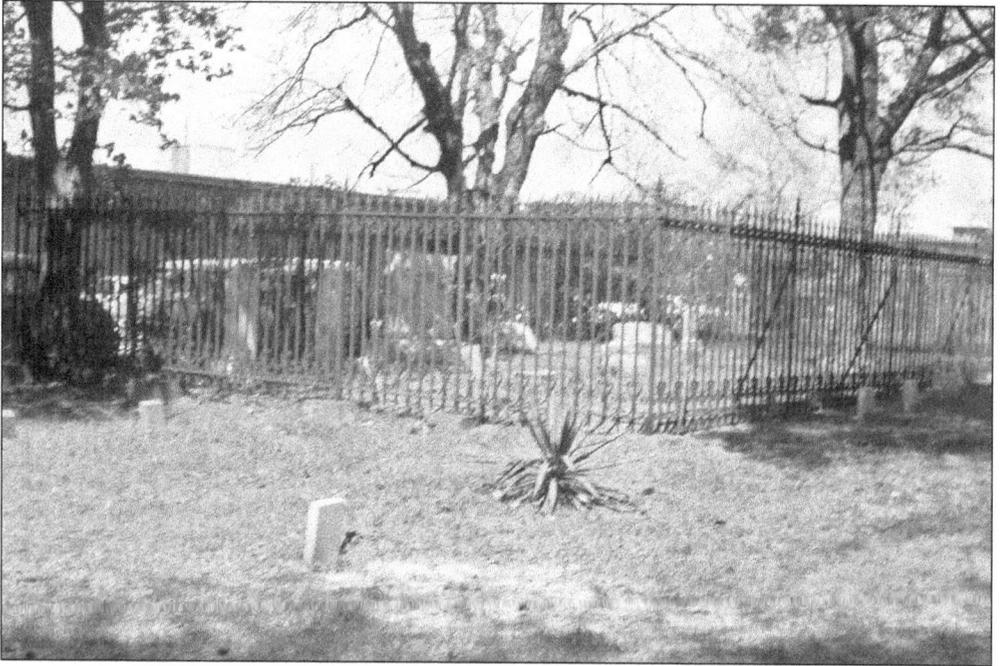

The Old Carrboro Cemetery is located south of the Libba Cotten Bikeway near Robeson Street. The cemetery was opened around 1860. In the past, there were separate African American (South) and white (North) sections. With stately oak and maple trees, the cemetery is an island of beauty and serenity near downtown Carrboro. According to a 1973 survey, there were 151 marked and about 135 unmarked graves. Dr. Foy Robeson donated land for the cemetery to the town. (Courtesy of the Watts Collection.)

Four

Transformation of Carrboro (1960–Present)

The cotton mills in Carrboro closed for the last time in the early 1960s and stood idle for a decade. Mill No. 7 was demolished, and the owner decided in 1975 to raze the remaining mill and build a shopping center. This decision jolted the sleepy town and galvanized a movement to save the old mill.

Another catalyst was the 1968 decision of the university to limit on-campus housing for students. This decision stimulated construction of apartment complexes along the North Carolina 54 bypass. Students flocked to the new apartments but were frustrated by the lack of transportation to campus. Impatience with the old-fashioned ways of Carrboro gave rise to the Carrboro Community Coalition, a group intent on modernizing the town. A majority of coalition members were elected in 1975 with the help of disgruntled students living in the new apartments.

The new board initiated an extensive reform program. Mayor Robert Drakeford and Alderman Doug Sharer were experienced planners who convinced the board to establish a planning department and create a new vision for the future. A revised Land Use Plan was adopted in 1977, and funding was obtained to pave roads, renovate neighborhoods, build parks and greenways, and renovate the old mill. Carr Mill Mall opened in 1978.

Another transformative event was the arrival in 1975 of Jacques Menache, a dynamic French artist, who opened an "ArtSchool." Menache moved to Carr Mill Mall in 1978 and then to the ArtsCenter beside Cat's Cradle. The program was extremely popular and expanded to include theater, music, photography, and ceramics for people of all ages and skill levels.

Not everyone was happy with change, and coalition candidates were defeated in 1981. Mayor Ellie Kinnaird and the new board undertook an aggressive program of neighborhood restoration and downtown revitalization. A loan program to encourage entrepreneurs was introduced in 1986. The first recipient was Weaver Street Market, a community-owned natural food store and café, which opened in 1988. The grassy courtyard between the market and Weaver Street has become the social center for a large number of downtown Carrboro residents.

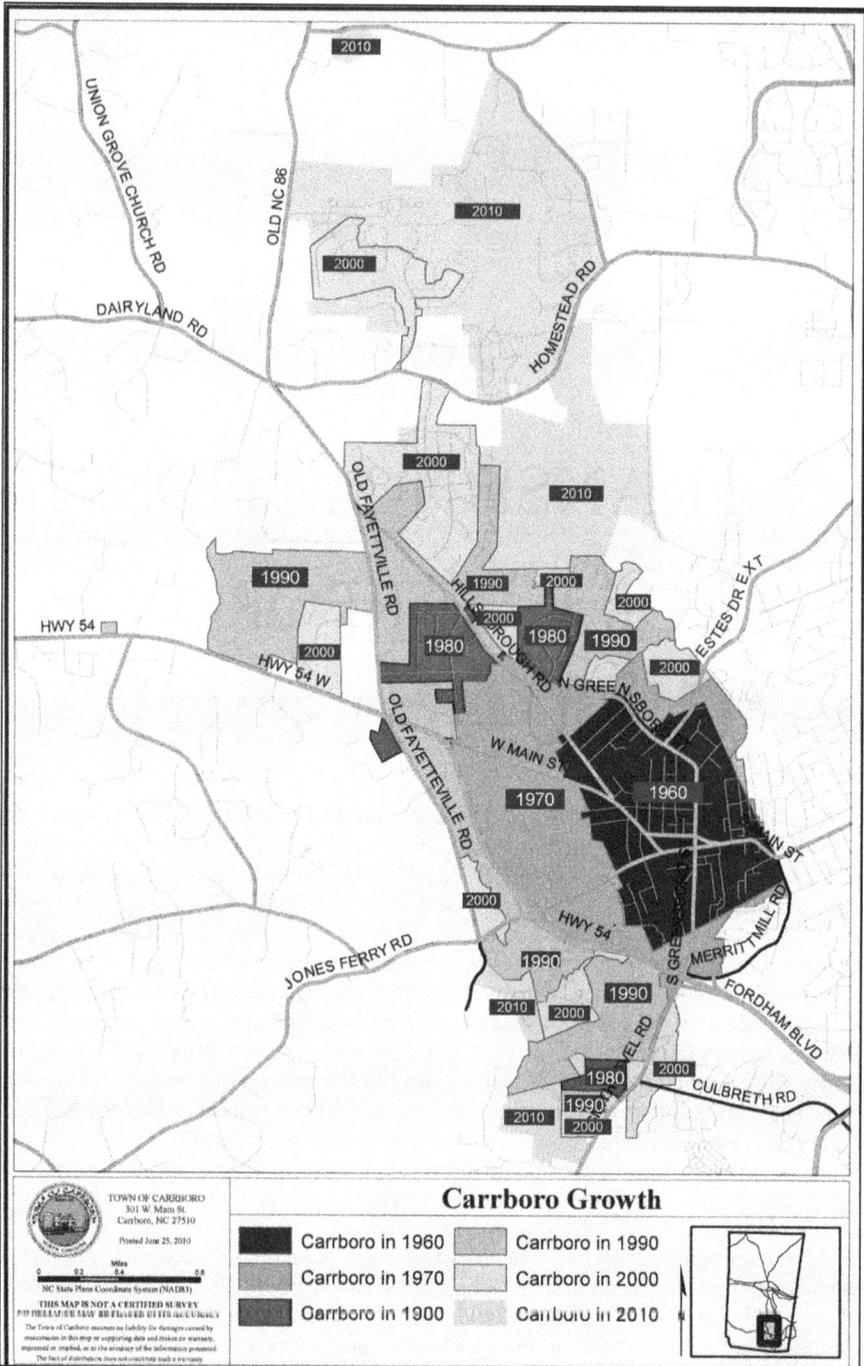

TOWN OF CARRBORO
301 W. Main St.
Carrboro, NC 27510

Printed June 25, 2010

Miles
0 0.2 0.4 0.6

NC State Plane Coordinate System (NAD83)

THIS MAP IS NOT A CERTIFIED SURVEY
NO RELIANCE MAY BE PLACED ON ITS ACCURACY

The Town of Carrboro assumes no liability for damages caused by
misconstrue in this map or supporting data and makes no warranty,
expressed or implied, as to the accuracy of the information presented.
The lack of distribution does not constitute such a warranty.

Carrboro Growth

■ Carrboro in 1960		Carrboro in 1990	
Carrboro in 1970		Carrboro in 2000	
Carrboro in 1900		Carrboro in 2010	

This map illustrates the growth of Carrboro each decade from 1960 to 2010. The population of the town increased from 1,997 in 1960 to about 20,000 in 2010, and the size of the town doubled from 3.1 to 6.4 square miles during the same period. Most of the growth during the past 20 years has been in the Northern Transition Zone. The town expects to be built-out by 2020, meaning all available undeveloped land will be occupied by then. (Courtesy of the Carrboro Planning Department.)

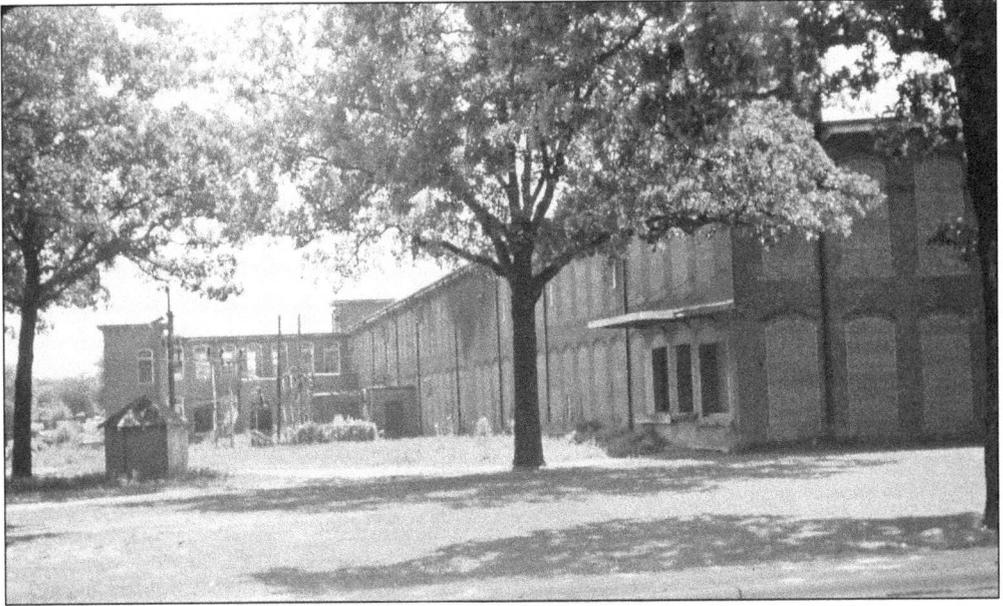

Production ceased at Durham Hosiery Mill No. 4 (the original Alberta Mill) in 1966. The building stood empty for a decade and began to deteriorate. The picture above was taken in the late 1960s. Ed Yaggy, owner of the building, decided to tear the building down and build a new shopping center. Many townsfolk were upset and formed the Friends of Old Carrboro to preserve the mill. Funds were obtained to renovate the building and convert it to a specialty shopping mall. Efforts to preserve the mill were successful, and Carr Mill Mall opened in 1978. The picture below shows a similar view of the back of the mall as it looks today. (Above, courtesy of the Watts Collection; below, photograph by Dave Otto.)

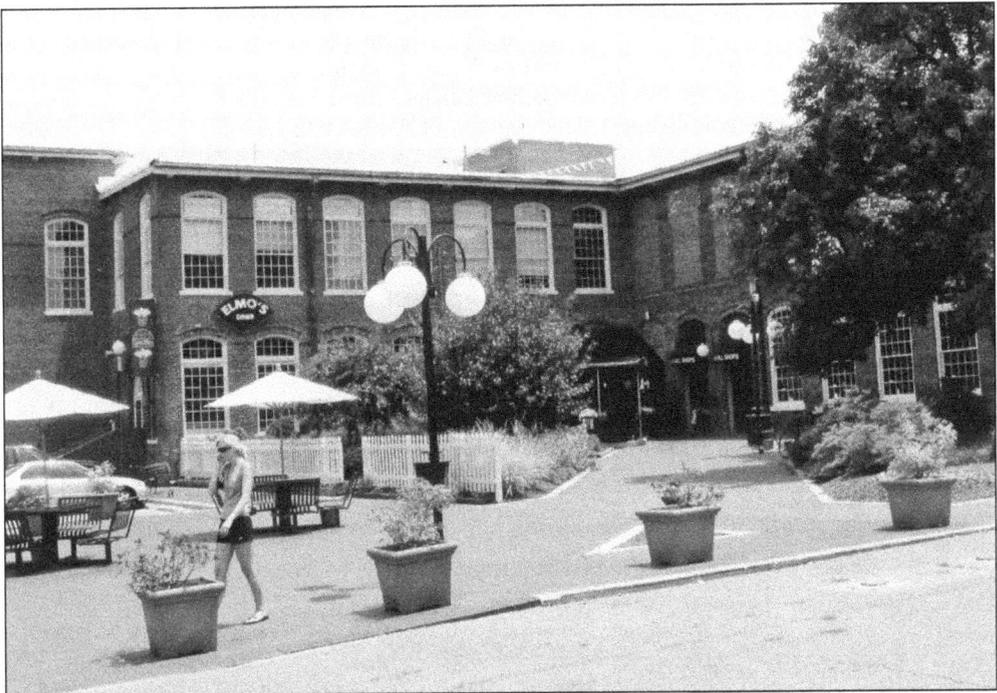

Grady Sturdivant opened the Friendly Barbershop in 1960. Grady had a warm smile and kind word for everyone. The barbershop quickly became a popular meeting place for locals. But Grady was more than a barber. He was a volunteer fireman for many years, and when the Orange County Rescue Squad opened in 1971 (below), Grady joined the daytime team. When a call came in, Grady and his partner Clyde would run across the street, where an old Cadillac ambulance was parked. Many notables had their hair cut at Friendly Barbershop, including UNC president C. D. Spangler and UNC basketball star Eric Montross. Young men from around the state would come in to get a "Montross" cut. Grady's son Russ now carries on the Friendly Barbershop tradition. (Above, courtesy of Jane Sturdivant; below, courtesy of Watts Collection.)

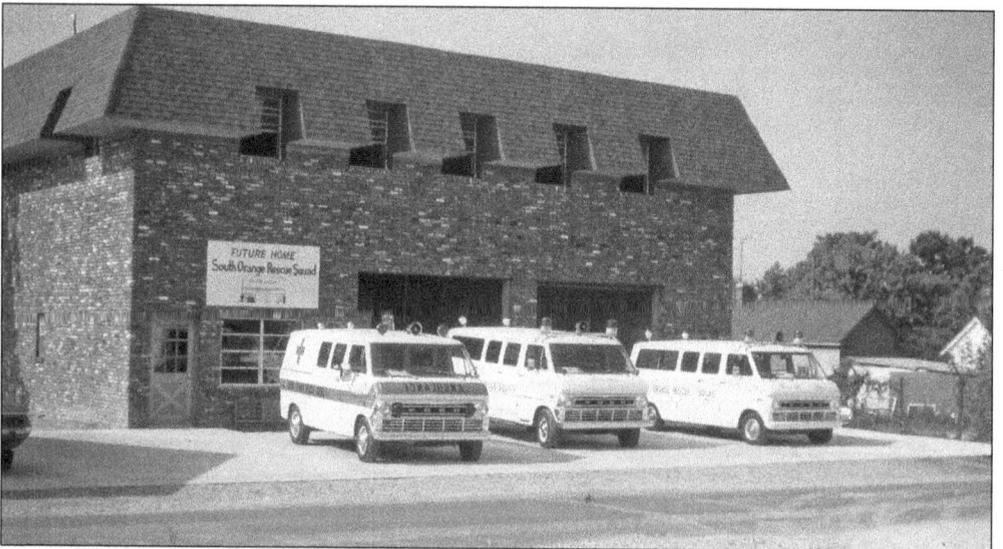

The decision of the university in 1968 to encourage students to live off campus spurred the construction of many apartments in Carrboro, particularly along the North Carolina 54 bypass, to house students. Two of the first complexes built were the Old Well (above) and Royal Park (below) Apartments. The Old Well Apartments have been renamed Abbey Court. University students continue to live in apartments along the bypass and elsewhere in town, although the residents today are more diversified and include many Hispanics. (Above, photograph by Richard Ellington, below, photograph by Dave Otto.)

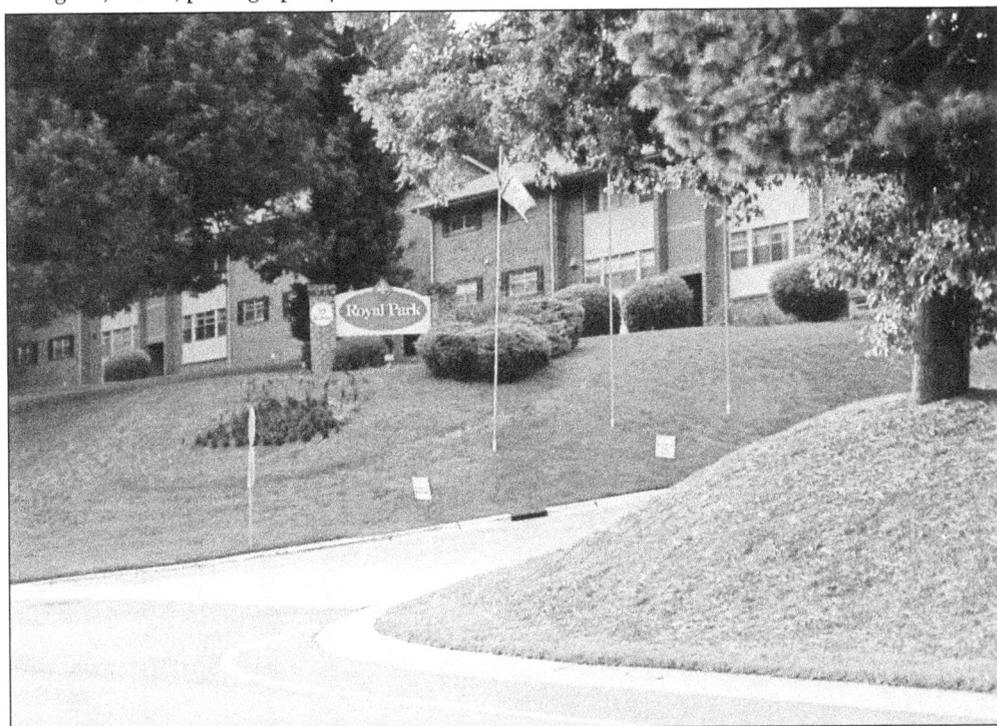

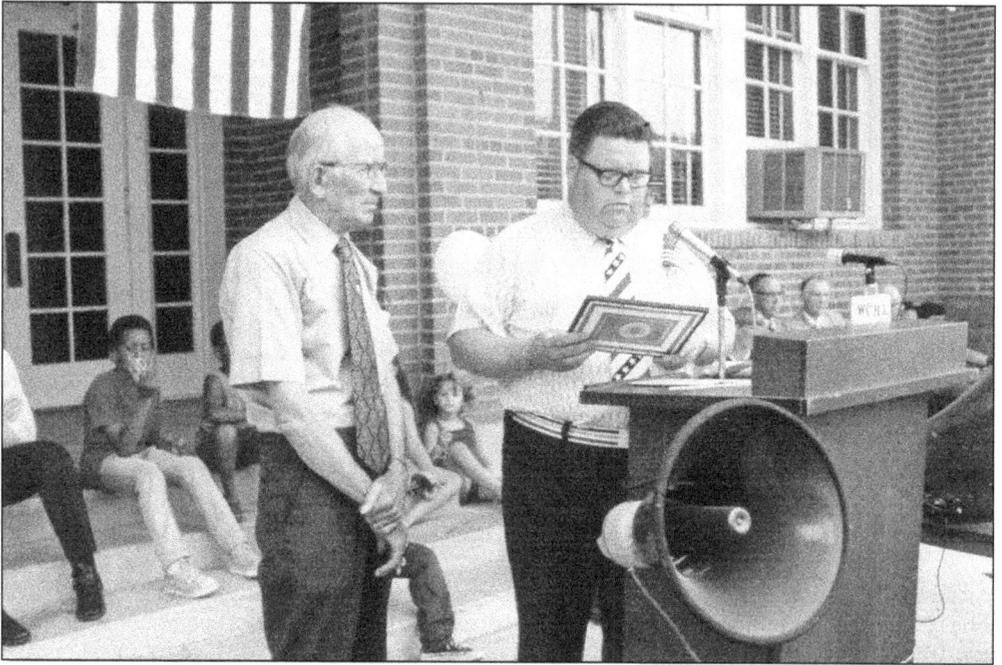

Under Mayor Robert Wells (1971–1975), extensive street paving, installation of water and sewer lines, and improvement of police and fire protection were undertaken. Wells worked to strengthen the sense of community and preserve the independence of Carrboro when many felt that the town should merge with Chapel Hill. Wells initiated the popular Fourth of July Celebration in 1974. Wells is shown presenting an award to Carl Ellington. (Courtesy of Richard Ellington.)

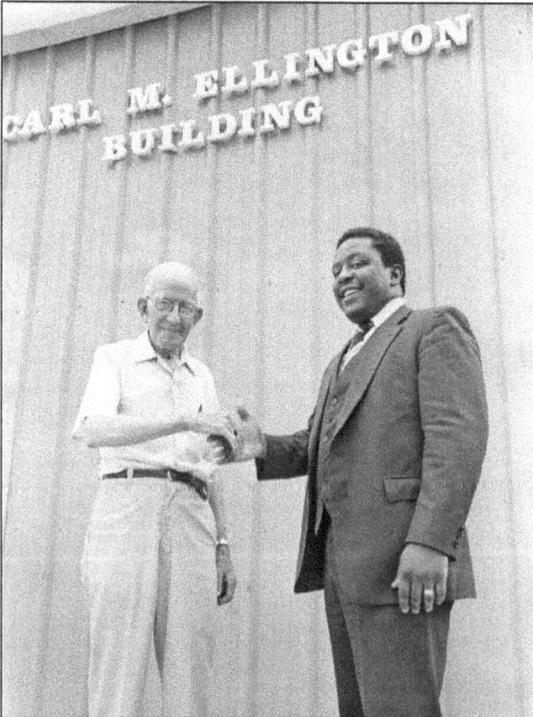

Robert Drakeford was the first African American mayor (1977–1983) of Carrboro. He was a reformer during a period of transition when young activists from the Carrboro Community Coalition replaced the old guard. Drakeford hired the town's first professional planner, established a loan program to encourage business entrepreneurs, and created the Carrboro Community Park, later renamed the Hank Anderson Community Park. The biggest issue during his tenure was planning the Chapel Hill–Carrboro Bus System. (Courtesy of Richard Ellington.)

The ArtsCenter "nourishes the arts, creativity, and community through education, performance, and exhibitions." This organization has been the leader of the cultural and artistic renaissance of Carrboro. Jacques Menache (below), a French artist, founded the ArtSchool in Carrboro 35 years ago. Menache offered painting lessons in a loft over present-day Armadillo Grill. His popularity demanded more space, and the program moved to Carr Mill in 1978. The scope and fame of the program continued expanding to include theater, writing, photography, music, and dance. In 1985, the ArtsSchool moved to its current location at 300 East Main Street. This building, known as the ArtsCenter, includes a 400-seat theater, a large central gallery for art exhibits, classrooms, and a smaller theater for dance, music, and other types of arts and crafts. (Photographs by Dave Otto.)

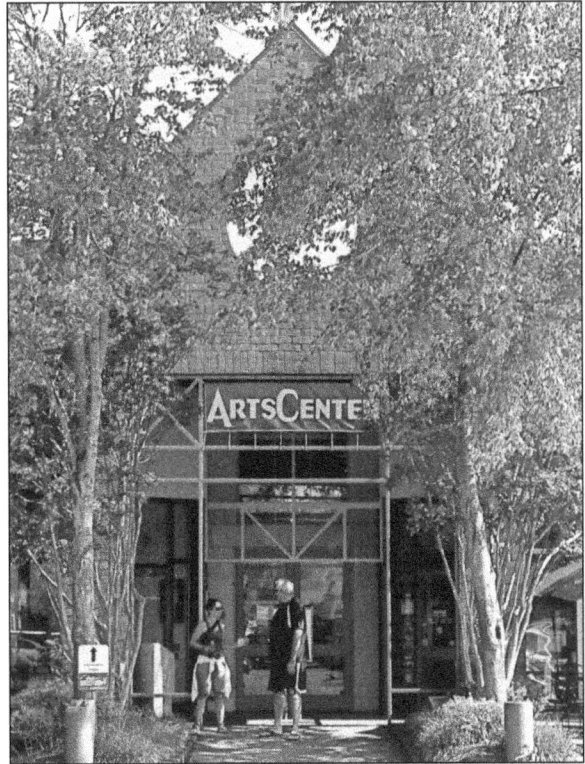

Mayor James Porto (1983–1987) presided over a rapid expansion of the town. A loan fund was established, which spawned Weaver Street Market. Bolin Forest and Pathway Drive developments were approved. Bonds were floated to add sidewalks and improve Greensboro Street. The most progressive land use plan in the state and a comprehensive transportation plan were approved. The counterculture began to thrive, and Carrboro became a haven for creative small businesses. (Courtesy of James Porto.)

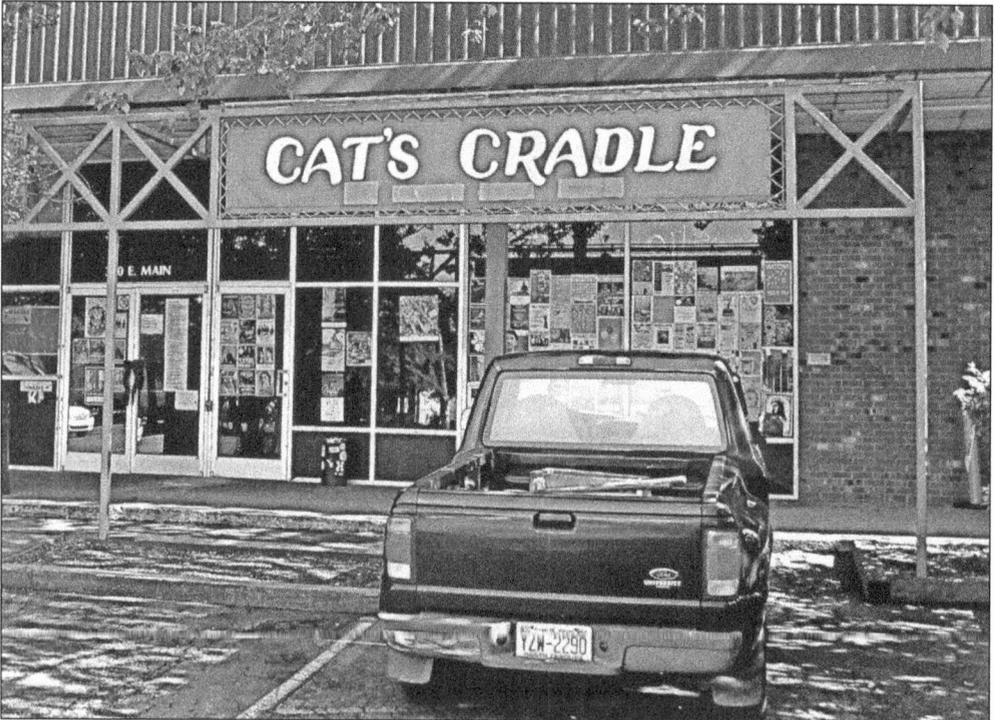

Cat's Cradle is a rock concert venue where many budding musicians and rock groups have launched their careers. According to Matt Barrett, the Cradle is considered by some to be the "musical Mecca of North Carolina, the jewel in the crown of Carolina culture . . . one of the best places to hear your favorite band." Needless to say, the Cradle is very popular in the Triangle area. (Photograph by Dave Otto.)

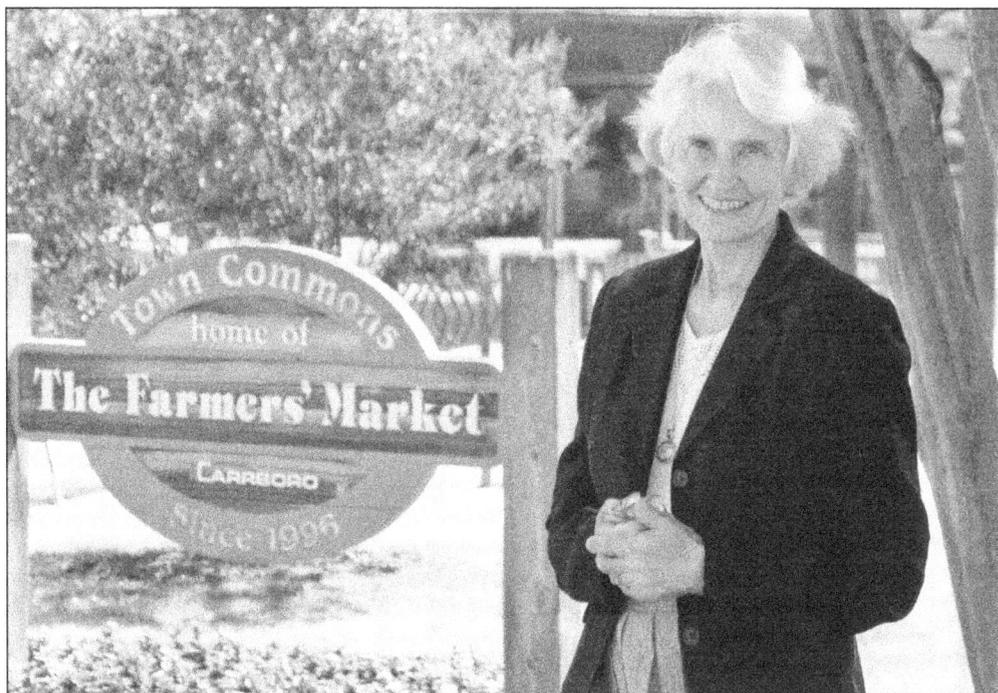

Ellie Kinnaird (above) served four terms as mayor (1987–1995). She championed the environment, arts, downtown revitalization, and neighborhood restoration. "We passed the strictest watershed protection ordinances in the state, built a nationally recognized Farmers' Market facility [below], restored endangered neighborhoods, and turned Carrboro into the 'Paris of the Piedmont.' " Ellie was completing her sixth term in the North Carolina State Senate in 2010. She has been a tireless advocate for education, social justice, and health. In 2010, Ellie was named a Chapel Hill–Carrboro "Community Treasure," an understatement for five decades of devoted service to local and state government. (Above, courtesy of Catherine Carter; below courtesy of Billy Barnes.)

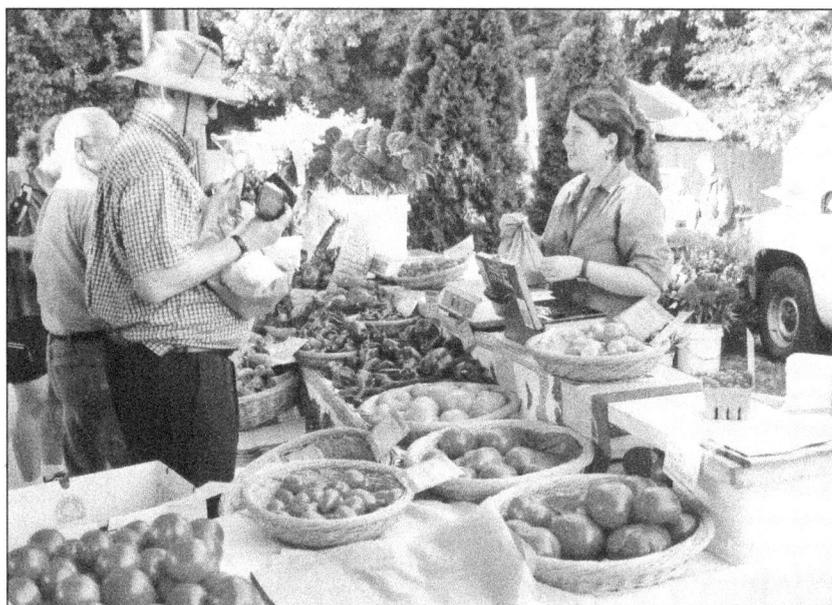

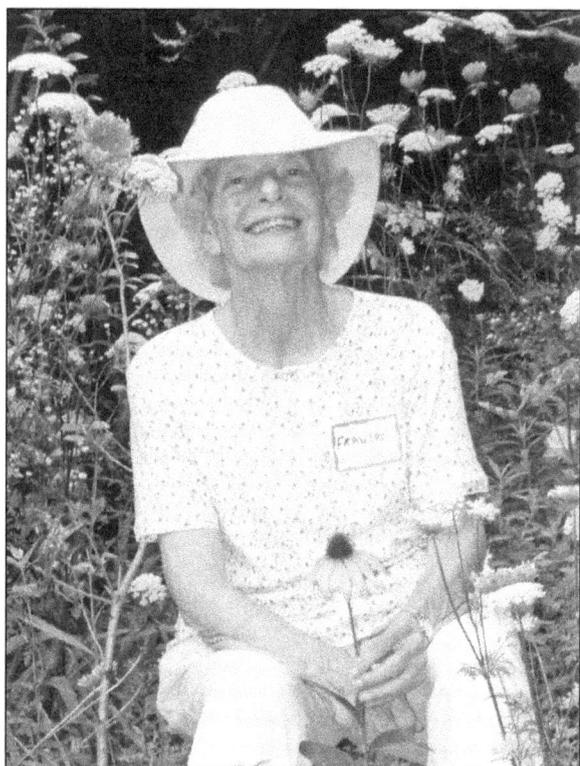

Frances Lloyd Shetley, a descendant of the early settler Thomas Lloyd, is another Carrboro legend. She has served on many town advisory boards, chaired the Transportation Board, and was an alderwoman from 1987 to 1997. In addition, she is an avid gardener and revered member of the Piedmont Wildflower Meadow team. A short bikeway connecting Shelton and Greensboro Streets has been named in her honor. The Wildflower Meadow is located at the Shelton Street end of the bikeway. The popular transit corridor exemplifies what is best about bikeways in Carrboro, and the Piedmont Wildflower Meadow demonstrates what a bikeway/greenway can become when the community invests time and energy to make it blossom! (Photographs by Dave Otto).

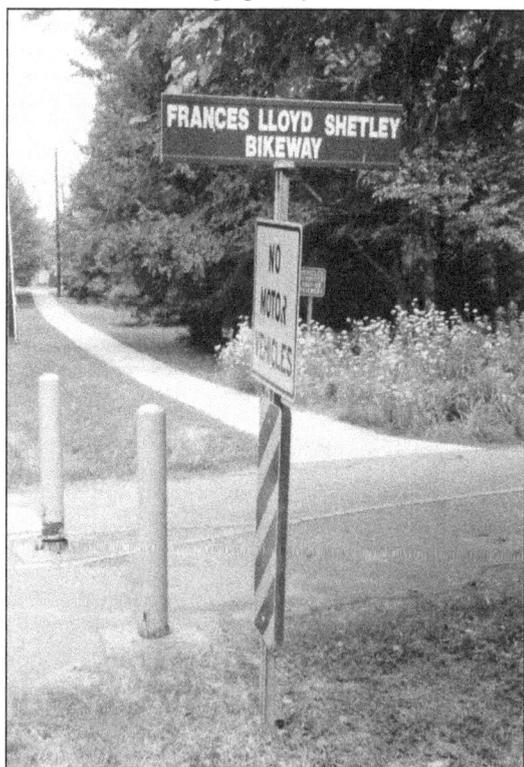

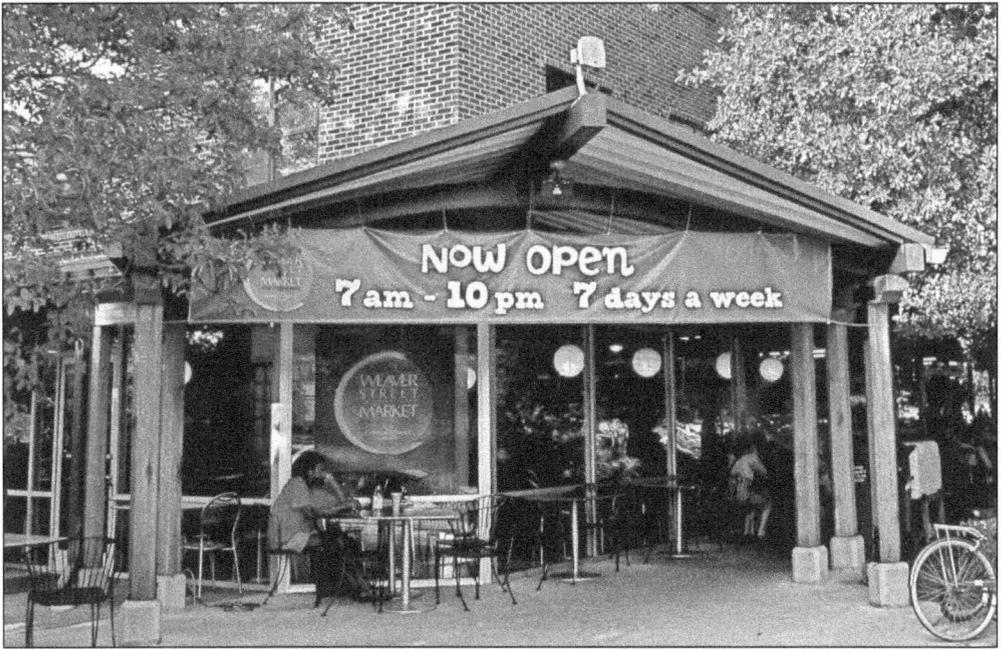

Weaver Street Market (WSM) is located beside Carr Mill in the heart of Carrboro. The market opened in 1988 and quickly became a social hub of the town. WSM is a cooperative organic market that specializes in locally grown products. The grassy yard with stately trees, simple benches and tables, and intriguing fountain provide a popular gathering place for friends, students, and businessmen. Goals of the market are to "reinvent a local sustainable food system, reinvigorate the downtown commercial center, and re-establish a sense of community centered around food." The market has been tremendously successful in achieving these goals with branches now in Southern Village and Hillsborough. (Above, photograph by Dave Otto; below, photograph by Jackie Helvey.)

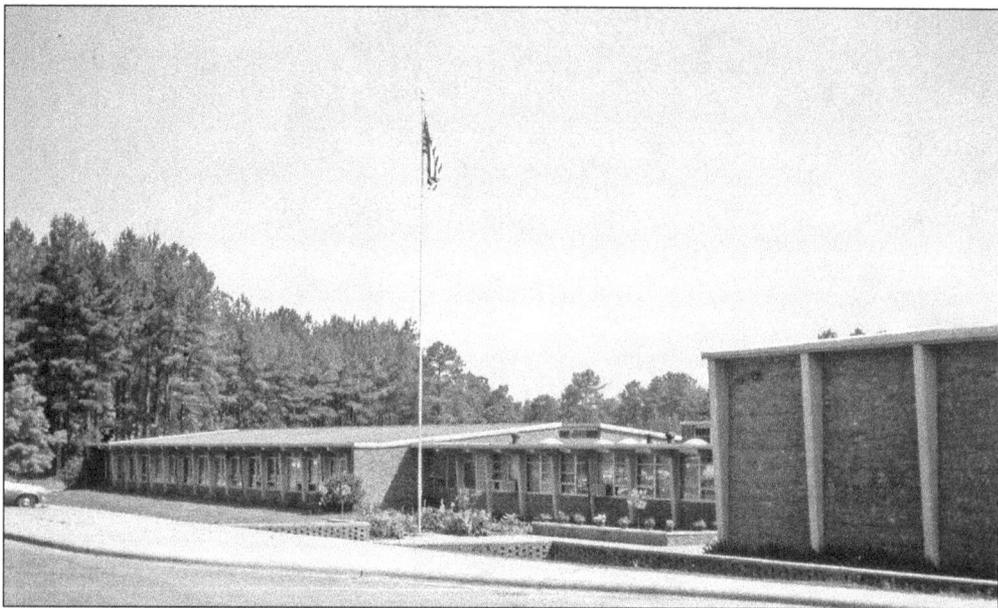

Carrboro Elementary School was part of the Orange County School System when it opened in 1959 but joined the consolidated Chapel Hill–Carrboro School System in 1960. The mascot is the bear cub. A special school garden, pictured on page 124, is designed to "inspire and educate students about the science, economics, and most importantly, the wonders and miracles of growing organic vegetables." (Courtesy of the Watts Collection.)

Rapid development in the Northern Transition Zone has attracted many new families to Carrboro during the past decade. Morris Grove Elementary School, on Eubanks Road, opened in 2008 in response to the need for more schools. The school is named after Morris Hogan, a former slave who opened a nearby school for African American children after the Civil War. The school mascot is the gecko. (Photograph by Richard Ellington.)

McDougle Elementary and Middle Schools are named after African American educators Charles and Lucille McDougle. Charles was a teacher, beloved principal of Orange County Training School and Lincoln High School from 1946 until 1966, and then a school administrator, devoting more than 40 years to education. Lucille taught elementary and high school for more than 40 years. The middle school opened in 1994 and the elementary school in 1996. School mascots are the dolphin (elementary) and mustang (middle). The schools are located on Old Fayetteville Road. (Photograph by Dave Otto.)

Carrboro High School (CHS), on Rock Haven Road, opened in 2007. CHS is the first silver-level LEED (Leadership in Energy and Environmental Design)-certified high school in North Carolina. The school quickly established its athletic prowess, winning the 2-A State Championships in women's cross-country and men's swimming and diving in 2009–2010. The school mascot is the jaguar. (Photograph by Dave Otto.)

The Inter-Faith Council (IFC) was formed in 1963 to address conditions of poverty in Chapel Hill and Carrboro. Crisis intervention in response to personal and family emergencies is the core of the group's volunteer service program. In 1999, the IFC moved from Wilson Court in Chapel Hill to the Douglas Building in Carrboro. The IFC has initiated a wide range of programs, including homeless shelters for men and women; the Community Kitchen and Food Pantry (worker Ty Westray at left); the Loan and Grant Fund; apartments for the elderly and disabled; medical and legal clinics for the poor; and many more innovative programs to fight poverty. Chris Moran has been the IFC director since 1995. (Photographs by Dave Otto.)

Club Nova was founded in 1987 to address the needs of Orange County residents living with mental illness. The organization provides a caring environment to nurture rehabilitation and reintegration with the community. Club Nova uses the successful model developed at Fountain House in New York City, which focuses on the strength and potential of members. There are 24 efficiency apartments located behind the clubhouse. Club Nova provides educational, recreational, social, and community support services for members. A group of members on the front porch of the clubhouse is shown in the picture above. Club Nova also operates a thrift shop on Main Street to raise funds for programs (below). Construction of a new campus designed by Giles Blunden is planned around 2015. (Above, photograph by Dave Otto; below, photograph by Richard Ellington.)

Mike Nelson was an alderman (1993–1995) and mayor (1995–2005) for five terms. Nelson was Carrboro's youngest, longest serving, and first openly gay mayor. "Long after folks forget . . . the annexation and controversial developments . . . there will be a Century Center, Music Festival, Poetry Festival, Adams Preserve and MLK Park. These things are my legacy." Nelson served on the Orange County Board of Commissioners from 2006 to 2010. (Photograph by Richard Ellington.)

Mark Chilton (shown in hat), mayor from 2005 to present, describes himself as an "environmental activist who believes that we must find economically sound and socially acceptable solutions to the crises that face our planet." His future vision includes more emphasis on commercial than residential development, particularly in downtown Carrboro, which will reduce pressure on the Rural Buffer. Chilton also advocates "bicycle- and pedestrian-only transportation corridors that will interconnect Carrboro and Chapel Hill." (Photograph by Dave Otto.)

Five

AFRICAN AMERICAN
HISTORY

Nellie and Toney Strayhorn were the first African Americans to settle in what is now Carrboro. Both were born into slavery. They purchased land and built a log cabin on Jones Ferry Road in 1879. Tony taught himself to read and write and became a skilled brick mason. Nellie died in 1950 at about age 100. Her great-granddaughter Delores Clark lives in the house today.

Although Orange County opened a few small, rural elementary schools for African Americans in the early 1900s, there were no public schools for them in Chapel Hill or Carrboro until 1917. In 1924, an African American businessman named Henry Stroud donated 9 acres north of Potters Field (now Northside) for a school. The African American community raised funds for construction. The school was called Orange County Training School until 1948, when the name was changed to Lincoln High School. In 1951, Lincoln High School was rebuilt on Merritt Mill Road in Chapel Hill. When the Carrboro–Chapel Hill schools were integrated in 1966, Lincoln High School was closed, and African American students were reassigned to Chapel Hill High School.

Little has been written about the impact on African Americans of integration and the closing of Lincoln High School. African American families were very proud of Lincoln High School. It was the finest black high school in the state. The Lincoln High football team and marching band won many state champions, including six between 1956 and 1966. Parents participated enthusiastically in the PTA, and the school served as an important social center for the African American community.

When schools were integrated, African American students and parents found themselves a minority. While incidents of overt aggression were few, Jim Crow attitudes did not change overnight. African American students worked hard to hide the frustration of losing their beloved school and the daily indignities they had to endure. Their parents, stripped of leadership in the integrated PTA, lost interest.

Four decades after integration, Lincoln High remains a vivid memory among those privileged to study there, and race is no longer a barrier to academic, athletic, or social success in the Chapel Hill–Carrboro School System.

Nellie (above, left) and Toney (above, right) Strayhorn were born as slaves. Until age 14, the Atwaters, who lived on Hillsborough Road near Chapel Hill, owned Nellie. Toney belonged to the Strayhorns at University Station near Hillsborough. Nellie and Toney were married after the Civil War. According to Ernest Dollar in 2010, "The remarkable part of the Strayhorn story is that they accomplished what many African Americans in the South could not at a time of extreme racial discrimination and violence. They prospered." As the family grew, additions were built around the log cabin that Nellie and Toney had built in 1879. The picture below shows the Strayhorn House as it appears today. (Above, courtesy of Delores Clark; below, courtesy of Watts Collection.)

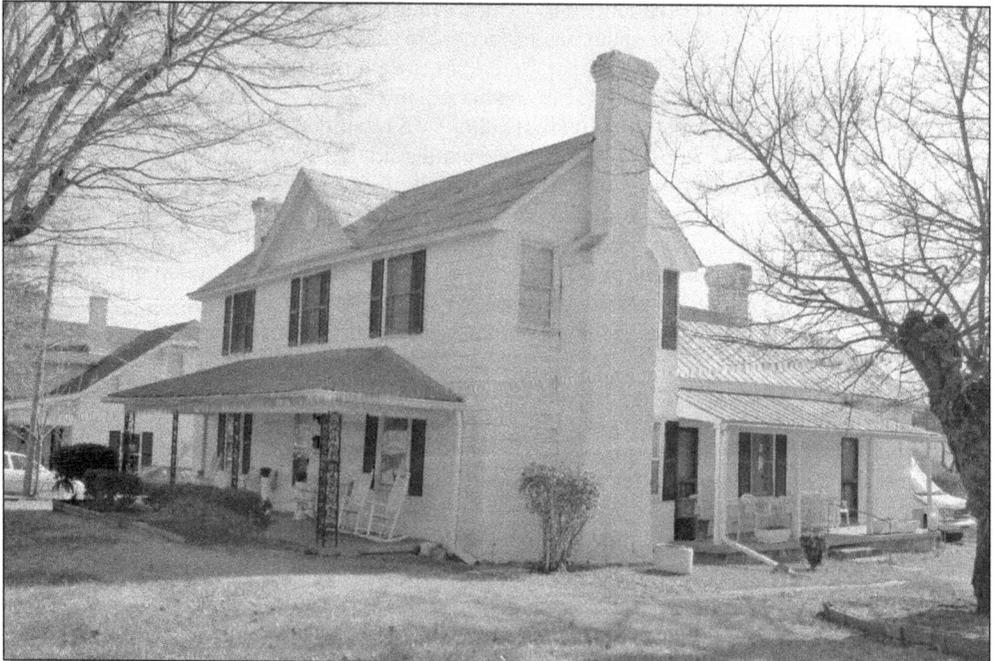

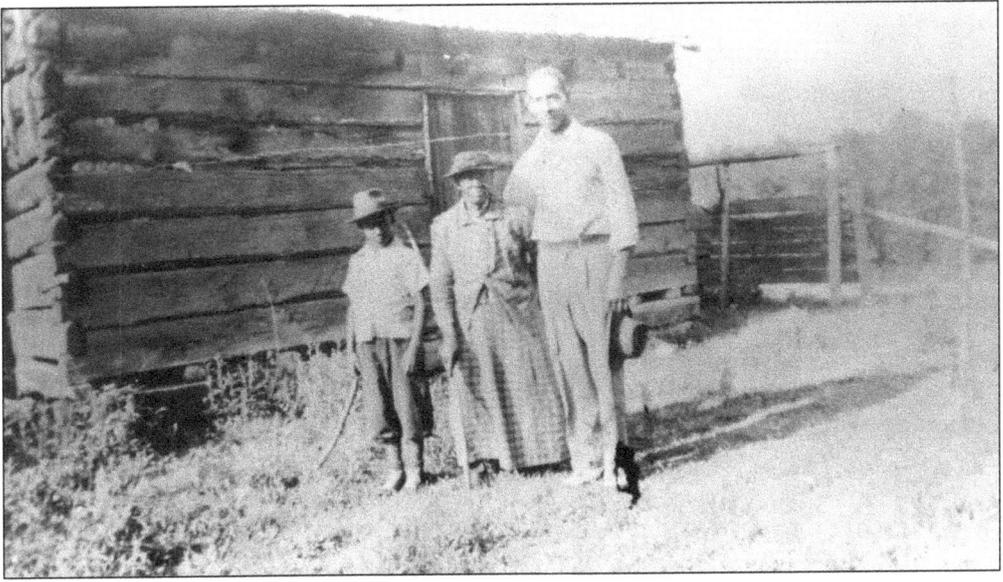

Willis Barbee Jr., Nellie Strayhorn, and Willis Barbee Sr. are pictured above in front of a cabin at the Wilson Strowd farm on Old Greensboro Road where Nellie's family lived before emancipation. In a 1942 issue of the *Chapel Hill Weekly* newspaper, Nellie described her life as a slave: "I used to plough with a mule named Duck, side by side with Mr. Strowd who owned my Daddy. . . . I can do everything in the field except split rails. . . . If folks had any slaves to sell, [they] carried them to Hillsborough and put them on a block just like cattle." Nellie is shown below with chickens in her backyard on Jones Ferry Road. (Both, courtesy of Delores Clark.)

The picture at left shows Nellie with two great-granddaughters, Delores Hogan Clark (left) and Georgia McCoy. Delores currently lives in the Strayhorn House; applications have been made to have this house listed on the National Register of Historic Places. With the help of the Preservation Society of Chapel Hill and the Town of Carrboro, Delores is working to restore the old house. Nellie is pictured below around 1945 with the legendary country doctor "Brack" Lloyd who provided medical care for all Carrboro residents, regardless of race or economic status. (Both, courtesy of Delores Clark.)

The Strayhorn family is pictured in front of the house on Jones Ferry Road around 1930. From left to right are Alfred Barbee, Jane Ford, Toney Strayhorn, Mary Barbee, Ethel Barbee, Sallie Strayhorn, Selie Faucett, Joseph Barbee, Algie Strayhorn, Margie Nunn Strayhorn, Laura Strayhorn, Willis Barbee, and Nellie Strayhorn. (Courtesy of Delores Clark.)

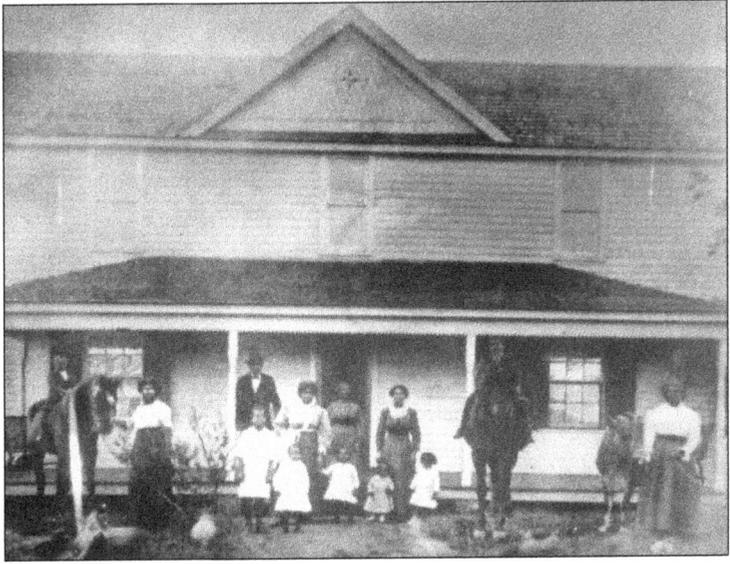

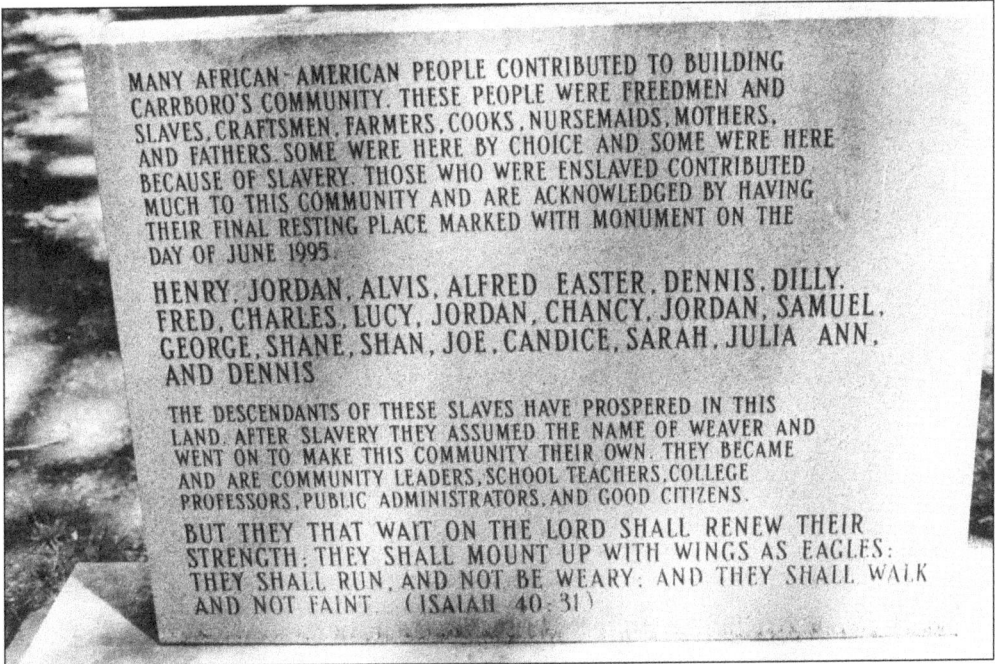

MANY AFRICAN-AMERICAN PEOPLE CONTRIBUTED TO BUILDING CARRBORO'S COMMUNITY. THESE PEOPLE WERE FREEDMEN AND SLAVES, CRAFTSMEN, FARMERS, COOKS, NURSEMAIDS, MOTHERS, AND FATHERS. SOME WERE HERE BY CHOICE AND SOME WERE HERE BECAUSE OF SLAVERY. THOSE WHO WERE ENSLAVED CONTRIBUTED MUCH TO THIS COMMUNITY AND ARE ACKNOWLEDGED BY HAVING THEIR FINAL RESTING PLACE MARKED WITH MONUMENT ON THE DAY OF JUNE 1995.

HENRY, JORDAN, ALVIS, ALFRED EASTER, DENNIS, DILLY, FRED, CHARLES, LUCY, JORDAN, CHANCY, JORDAN, SAMUEL, GEORGE, SHANE, SHAN, JOE, CANDICE, SARAH, JULIA ANN, AND DENNIS

THE DESCENDANTS OF THESE SLAVES HAVE PROSPERED IN THIS LAND. AFTER SLAVERY THEY ASSUMED THE NAME OF WEAVER AND WENT ON TO MAKE THIS COMMUNITY THEIR OWN. THEY BECAME AND ARE COMMUNITY LEADERS, SCHOOL TEACHERS, COLLEGE PROFESSORS, PUBLIC ADMINISTRATORS, AND GOOD CITIZENS.

BUT THEY THAT WAIT ON THE LORD SHALL RENEW THEIR STRENGTH; THEY SHALL MOUNT UP WITH WINGS AS EAGLES; THEY SHALL RUN, AND NOT BE WEARY; AND THEY SHALL WALK AND NOT FAINT. (ISAIAH 40-31)

In June 1995, a monument was erected in front of the Weaver family cemetery on West Main Street to commemorate slaves buried outside the fence in unmarked graves. The Weaver family was prominent in the early history of Carrboro (pages 18–19) and owned extensive property, including slaves. This monument honors the contributions of African Americans to the early development of the town. (Photograph by Richard Ellington.)

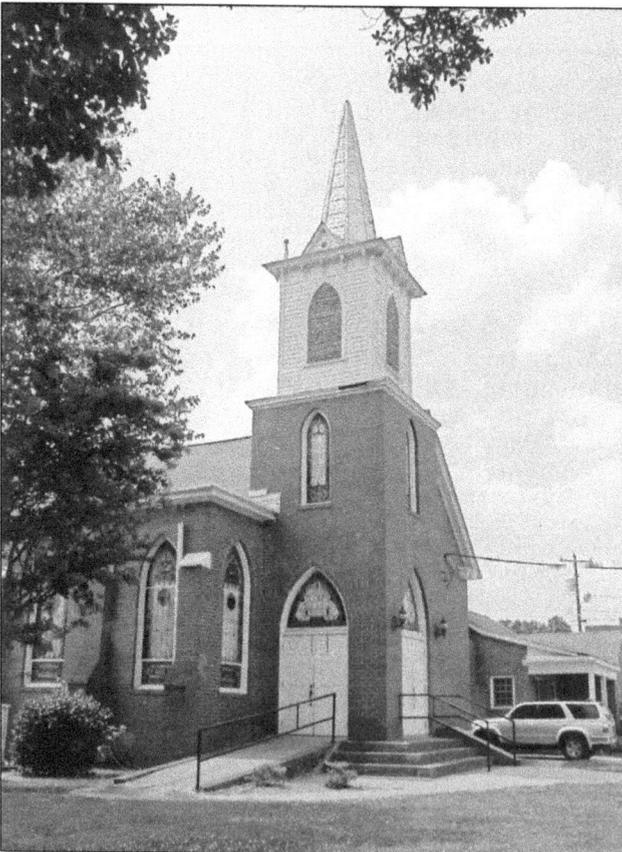

St. Paul African Methodist Episcopal (AME) Church, established in 1864, is the oldest church within city limits. Before emancipation, African Americans met in segregated sections of white churches. After the war, African Americans were encouraged to form their own churches. St. Paul AME was originally an amalgam of African Americans from local Methodist, Episcopal, and Baptist churches. Baptist members started their own church, the First Baptist Church of Chapel Hill, in 1870. Church services have been held in several different buildings, including the wooden church constructed in 1892 (above) and the current brick church (left). The congregation continues to grow and is planning a new campus on Rogers Road. (Above, courtesy of St. Paul AME; left, photograph by Dave Otto.)

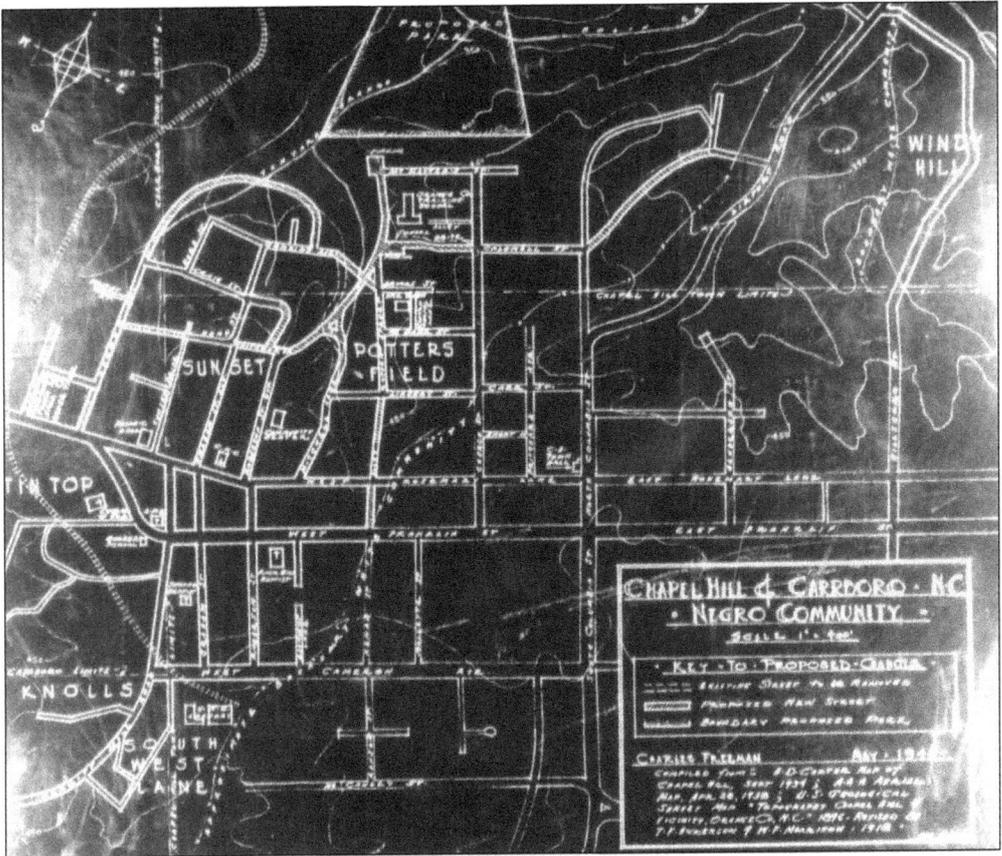

This map, drawn in the mid-1940s, identifies the traditional neighborhoods of Tin Top, Knolls, Sunset, Potters Field, and Windy Hill, where African Americans have lived for the past century. Potters Field is known today as Northside, and Tin Top is now called Carr Court. The Knolls neighborhood is now in Chapel Hill. With the rapid growth of both towns during the past few decades and rising land values, African Americans are finding it more difficult to remain in these neighborhoods. (Courtesy of Lincoln Center.)

Luther Hargraves (right) built affordable housing for African Americans in the early 20th century, including Tin Top in Carrboro, when banks would not lend to African Americans. During the Great Depression, Hargraves allowed tenants to continue living in homes when they could no longer pay rent. When the banks foreclosed, he lost everything. (Courtesy of Velma Perry.)

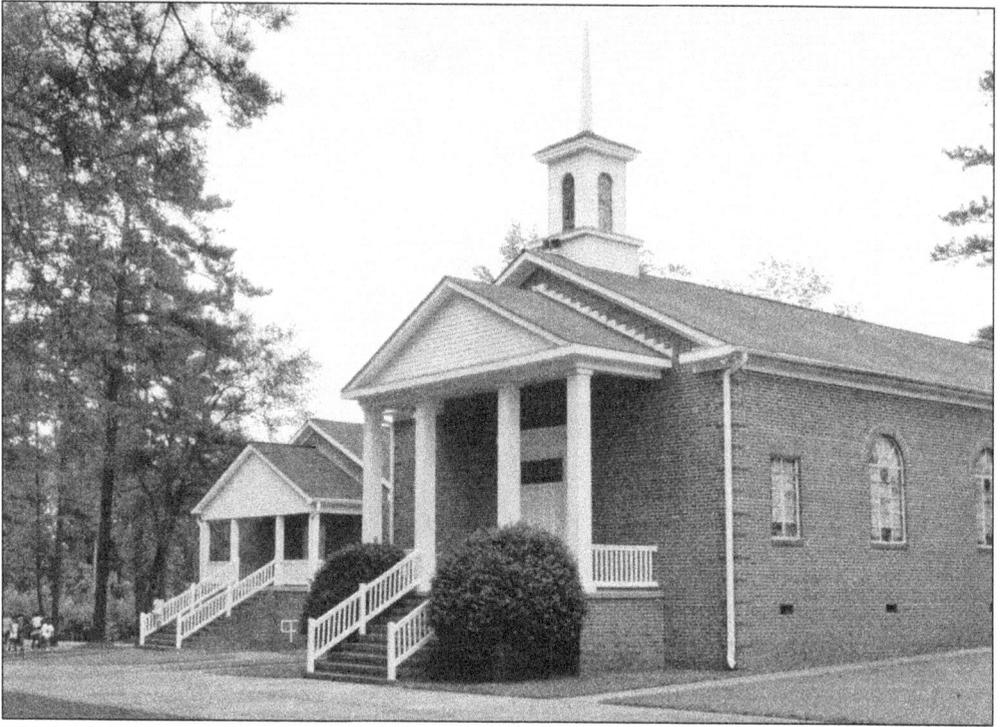

The Hickory Grove Missionary Baptist Church, established in 1877, is located on Bethel Hickory Grove Church Road a few miles west of Carrboro. The church was rebuilt in 1879 and renovated in 1905. The current structure was built in 1950 with the addition of the Youth and Family Life Center in 1991. The cemetery behind the church is the resting place for many African Americans prominent in Carrboro history, including the McCauley, Lloyd, Harris, Hogan, and Minor families. Morris Hogan, who built and operated the Morris Grove School on Eubanks Road, and his wife, Panthia, are buried here (below). (Above, photograph by Dave Otto; below, photograph by Richard Ellington.)

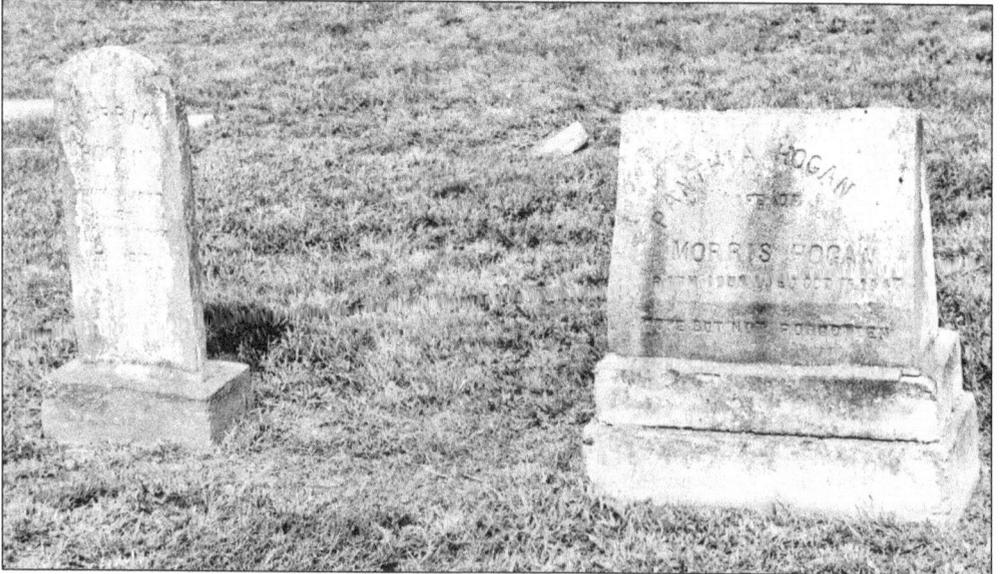

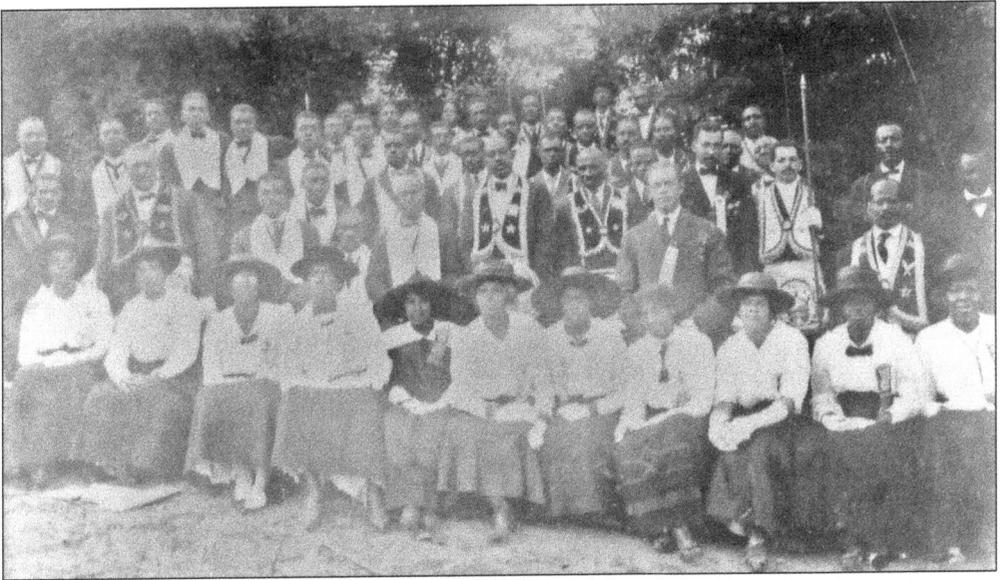

This early-20th-century picture of an African American civic group is thought to show the Knights of Pythias. The Fraternal Order of the Knights of Pythias was founded in 1864 to heal the wounds and calm the hatred created by the Civil War. The Chapel Hill–Carrboro chapter was founded in 1897. The basic principles of the order are friendship, charity, and benevolence. (Courtesy of Keith Edwards.)

In 1912, Dr. Louis Hackney opened "Hack's High School" on Merritt Mill Road for the education of African American youth in upper grades. Public funds, tuition, and contributions from local churches did not cover expenses. In 1916, Orange County bought the Hackney School and established the first Orange County Training School (OCTS). Eleven grades were taught at the school. OCTS moved in 1924 to the Northside neighborhood in Chapel Hill. (Courtesy of Lincoln Center.)

When the Hickory Grove School opened in 1907, it provided a rare opportunity for African American children to obtain a free education in the segregated South. Grades one through three were taught in the front and four through six in the back of the two-room schoolhouse heated by two potbellied stoves. The school closed in the early 1950s. Natalie and Gary Boorman purchased and restored the schoolhouse in 1993. In July 2010, former students, from left to right, L. C. Edwards, "Skinny" Farrington, George Bynum, Vivian Burnette, and Emily Rogers (daughter of Dorothy Farrington, a former Hickory Grove student) returned to reminisce about their experience at the school (below). The Hickory Grove Center, located on North Carolina 54 about 3 miles west of Carrboro, is used today by Natalie as a ceramics studio. (Photographs by Dave Otto.)

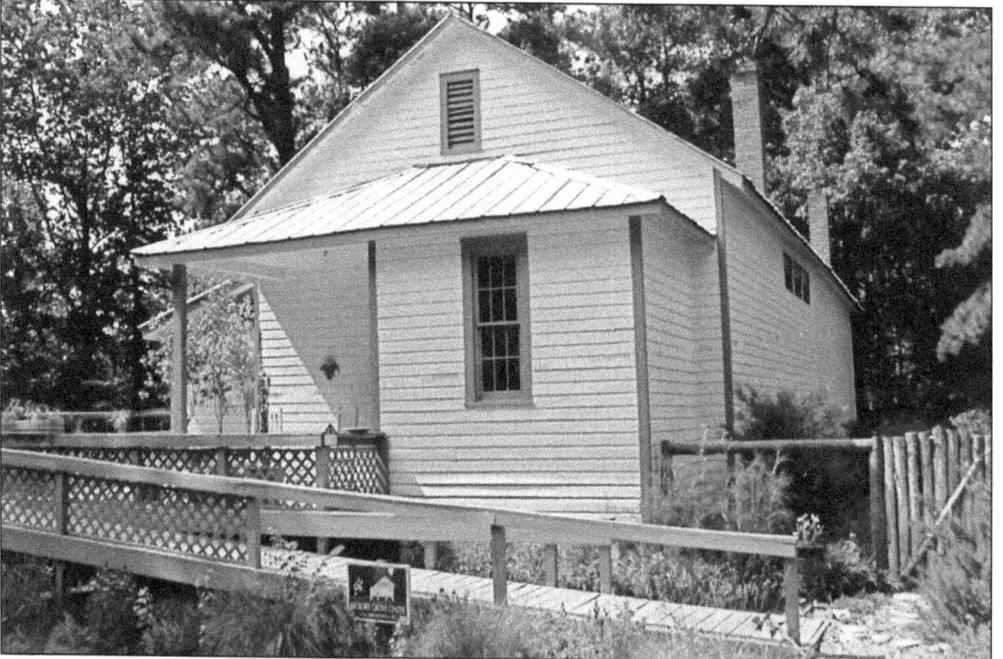

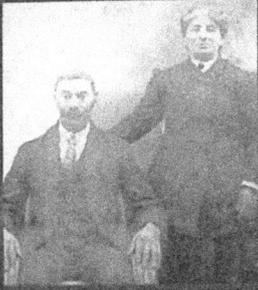

ORIGINS OF THE MORRIS GROVE ELEMENTARY SCHOOL

This school honors the name of the Morris Grove Elementary School that opened in the 1880's at 402 Eubanks Road to educate local Black children. It was one of a large number of racially segregated one-room Orange County schools that were built and operated by individual citizens. By modern standards, they had minimal furnishings and teaching materials. Public tax-based schools began to replace them in the 1920's. The Morris Grove School was later enlarged and encased in brick. Today it is still used as a residence.

The old school was built with donations of land, lumber and operating expenses by Morris Hogan (1853-1934). Both he and his wife, Pantha (1850-1940), were born into slavery. Following Emancipation, their successful ownership of two farms gave their ten children a comfortable middle-class life. They were charter and lifelong members of the Hickory Grove Baptist Church. Morris Grove School gave their own and many other Black children a valuable head start in a racially segregated society.

This plaque was prepared and transmitted to the Morris Grove Elementary School by the Chapel Hill Historical Society at the school dedication on October 26, 2008.

Memories of Morris Hogan's remarkable achievements and gifts have faded, but within this school they can shine brightly as timeless role models for all students.

Morris Hogan was born a slave in 1853. He learned to read but not to write. After the Civil War, he became a successful farmer, operating two farms near old North Carolina 86 and Eubanks Road. In the 1880s, Morris and his wife, Panthia, built and operated an elementary school for African American children on his own land on Eubanks Road. The original school was a one-room wooden building. The photograph above shows Morris and Panthia. A group of students from the school is pictured below. The school closed in the 1950s. (Both, courtesy of Morris Grove Elementary School.)

The second Orange County Training School was built in 1924 on 9 acres donated by Henry Stroud, a local African American businessman. The school was located in Northside, the largest African American neighborhood in Chapel Hill. Funds for the construction of the school were raised by the African American community, as well as a grant from Julius Rosenwald, president of Sears. Chapel Hill agreed to fund the school in 1930 only after the African American community voted to allow their homes to be taxed at a higher rate than white homes. The school went through 11 grades only. The faculty of the school in 1946 is shown in the picture above. (Both, courtesy of Lincoln Center.)

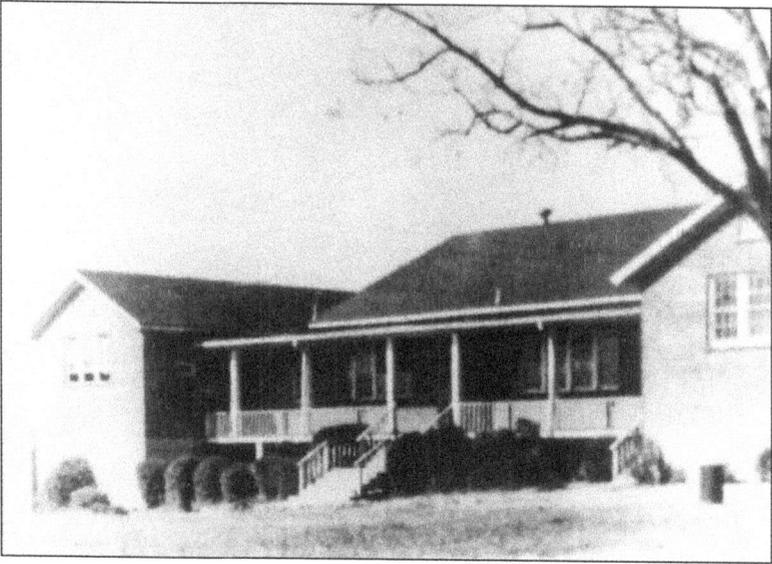

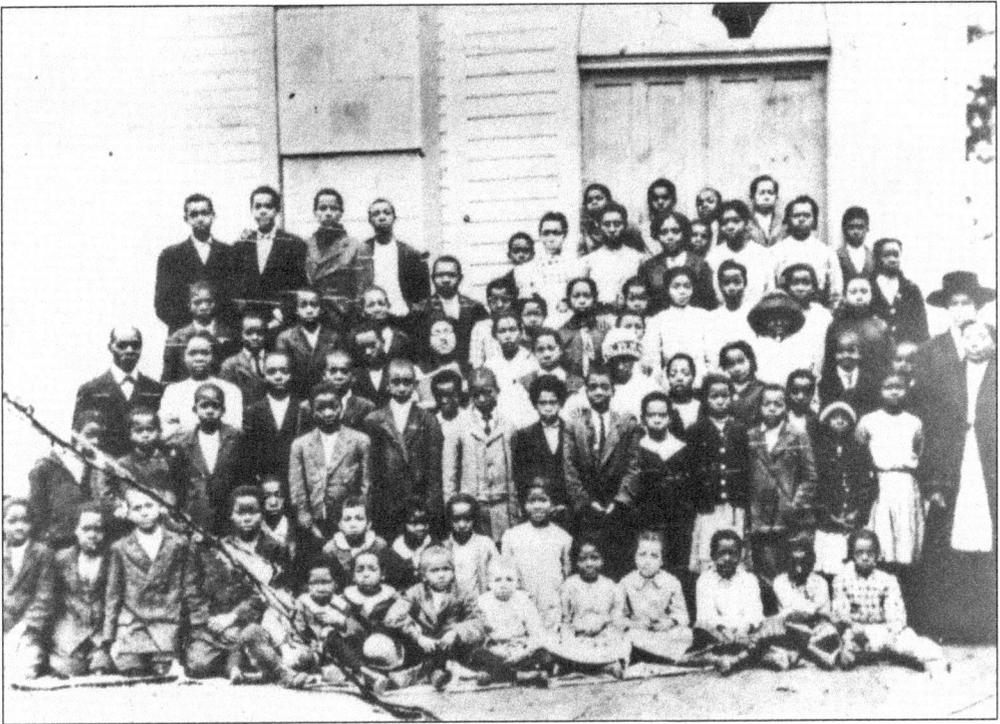

An early graduating class and faculty of OCTS are shown in the picture above, and 1939 football players appear in the picture below. (Both, courtesy of Lincoln Center.)

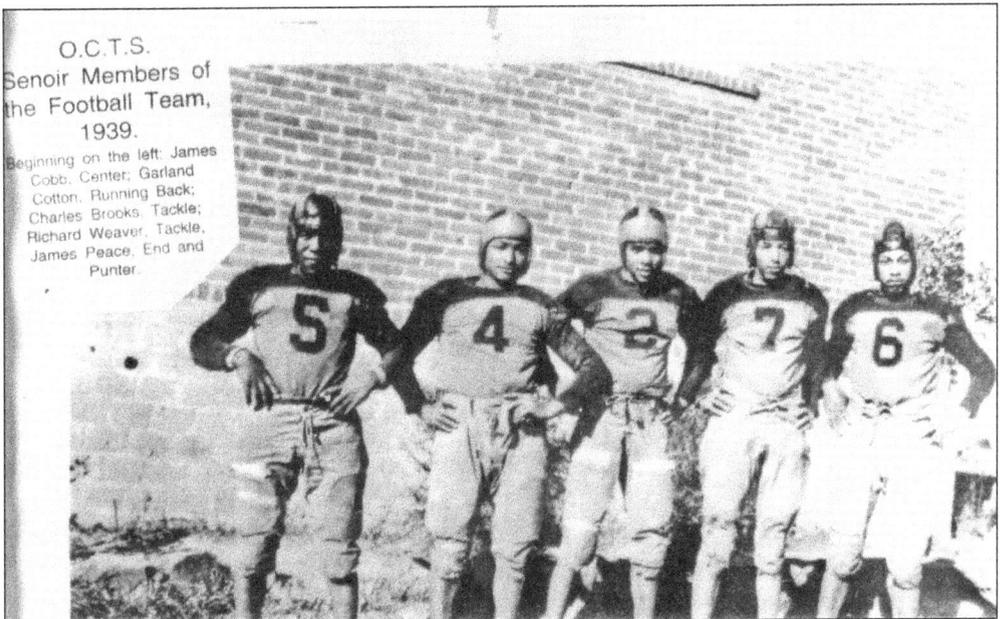

O.C.T.S.
Senoir Members of
the Football Team,
1939.

Beginning on the left: James Cobb, Center; Garland Cotton, Running Back; Charles Brooks, Tackle; Richard Weaver, Tackle, James Peace, End and Punter.

The name of the Orange County Training School for African American students changed twice—first to Orange County High School and finally to Lincoln High School. A diploma with the name "Orange County Training School" is shown above. The African American community voted to change the name to Lincoln High School in 1948, because the original name sounded too much like a juvenile reformatory. (Courtesy of Keith Edwards.)

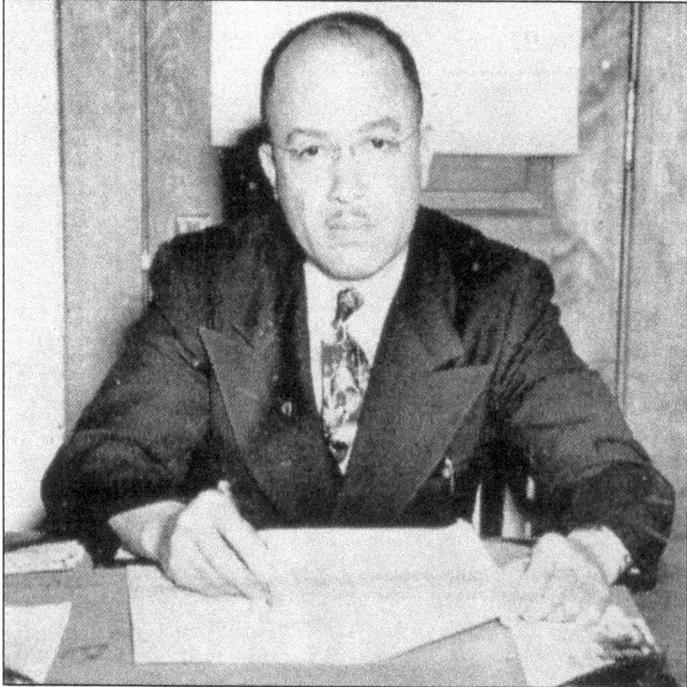

Charles McDougle was appointed principal of the Orange County Training School in 1946. McDougle demanded strict discipline of students and faculty but was widely respected as fair and caring. He encouraged students to study hard and to attend college. McDougle continued as principal of Lincoln High School until it was closed during the integration of Chapel Hill–Carrboro Schools in 1966. (Courtesy of Robert Gilgor.)

Northside Elementary School opened in 1951. More than 700 students attended Northside during the 1950s, when rural African American schools closed and students transferred to Northside. Ironically, Northside Elementary and Lincoln High—two centrally located schools—were closed in 1966, when Chapel Hill–Carrboro Schools were integrated, so that white students would not have to attend formerly African American schools. This picture is a health class at Northside Elementary. (Courtesy of Lincoln Center.)

The Lincoln High School Marching Band was one of the finest in the state. According to Thurman Couch, Lincoln High football superstar, "The band was the pride, the heart and soul of the school." The marching band won several state championships under the direction of Clark Egerton (1955–1961). (Courtesy of Lincoln Center.)

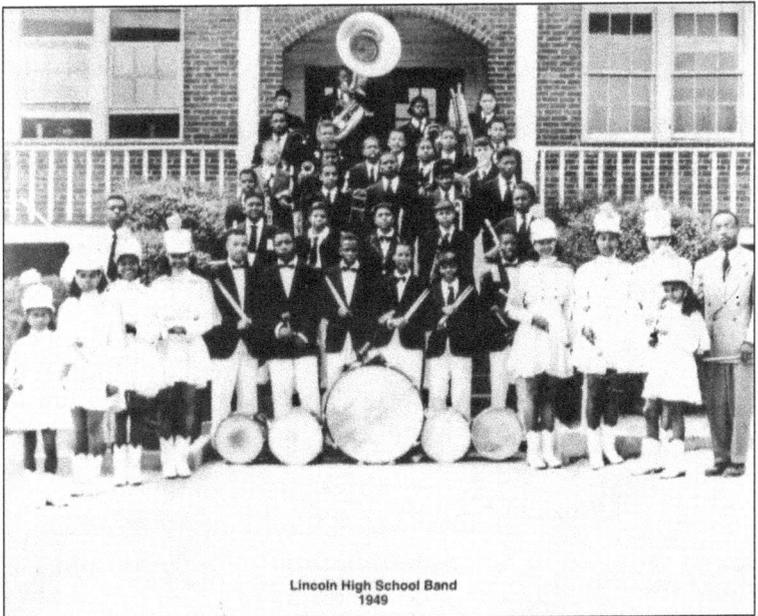

Lincoln High School Band
1949

113

Lincoln High School moved to Merritt Mill Road in 1951. The first graduating class of 1952 is shown in the picture below. Under the leadership of Charles McDougle, the school built an impressive record of academic and athletic achievement and earned a reputation as the finest African American high school in the state. The school provided African Americans with a sense of pride, community, and tradition. Lincoln Center reopened later as the administrative headquarters of the Chapel Hill–Carrboro School System. (Above, photograph by Richard Ellington; below, courtesy of Lincoln Center)

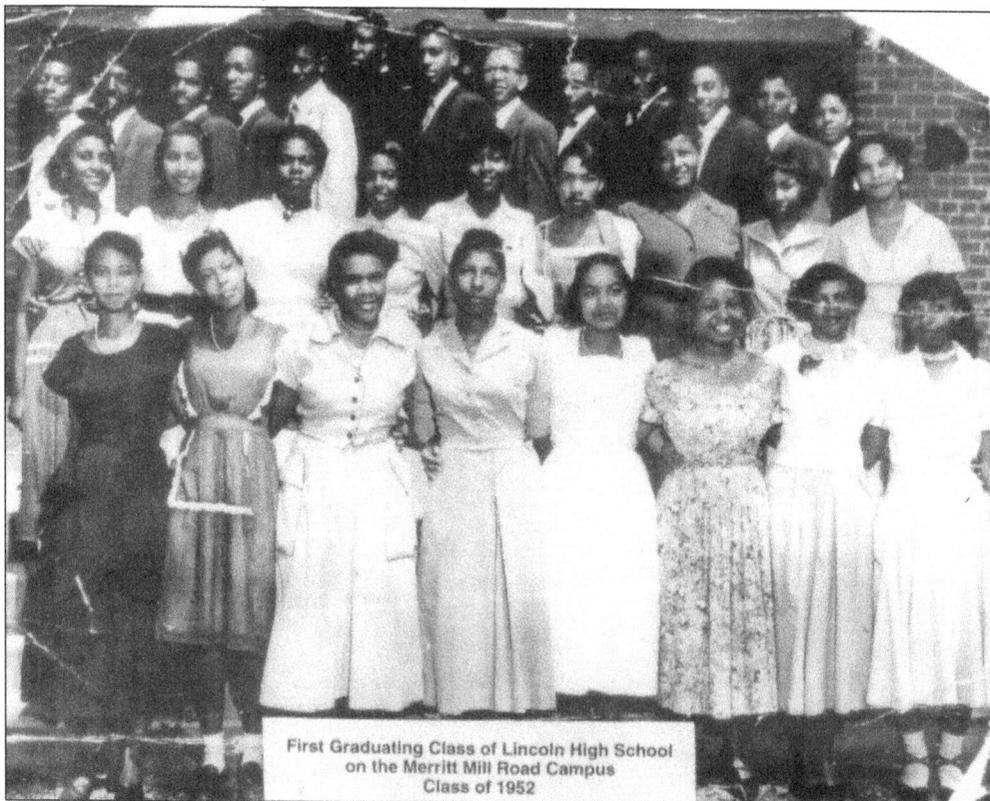

First Graduating Class of Lincoln High School on the Merritt Mill Road Campus Class of 1952

Lincoln High students and the community were very proud of the Tiger football team. Under coaches Willie Bradshaw (1956–1961) and William Peerman (1962–1966), the school was remarkably successful, winning four North Carolina Class 2-A championships (1957, 1960, 1961, and 1964) and two cochampionships (1956 and 1959). The 1964 Tigers were undefeated and untied. In fact, no team scored a single point against them! The legendary Peerman and his team are pictured above, and some of the Lincoln Tiger trophies are shown below. When the schools were integrated, Peerman was transferred to Chapel Hill High School, where he was demoted to assistant coach. To mollify frustrated African Americans, Chapel Hill High School adopted the Tiger as mascot. (Above, courtesy of Robert Gilgor; below, courtesy of Lincoln Center.)

The 1961 Lincoln High School Drum Majorettes are pictured at the top of the page. From left to right are Bilue Farrington, Delaine Perry, Victoria McClam, Virginia Edwards, and Barbara Farrow. (Courtesy of Lincoln Center.)

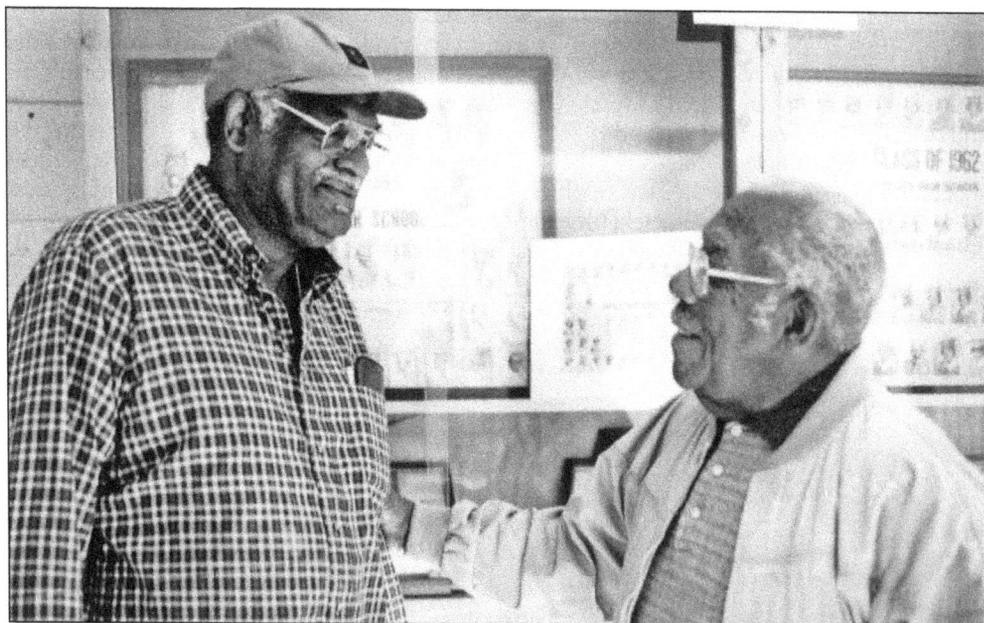

Hilliard Caldwell (left) and R. D. Smith (right), were prominent community leaders. Caldwell organized sit-ins during integration and served four terms as Carrboro alderman (1981–1997). When African American students rose up against the perceived callous administration of Chapel Hill High School in 1969, Caldwell was hired as liaison between the students and administration. R. D. Smith taught shop and automotive repair at Lincoln High and was assistant principal at Chapel Hill High School. Smith Middle School, on Seawell School Road, is named after R. D. and his wife, Euzelle. (Courtesy of Lincoln Center.)

Braxton Foushee (right) served three terms (1969–1981) on the Carrboro Board of Aldermen, served on the Orange Water and Sewer Authority Board of Directors (1986–1988), and is the longtime education committee cochair of the local NAACP. The last log cabin in Carrboro (below) was home to Charlie and Flora Lindsey and their family. The house was located near where Rosemary and Main Streets merge. (Right, courtesy of Braxton Foushee; below, courtesy of the Watts Collection.)

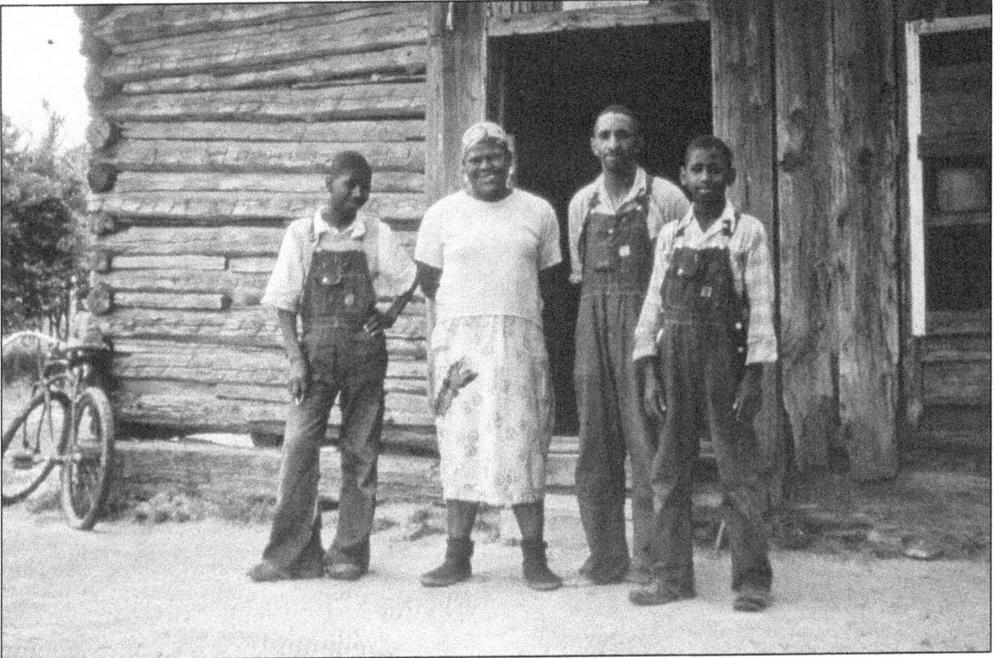

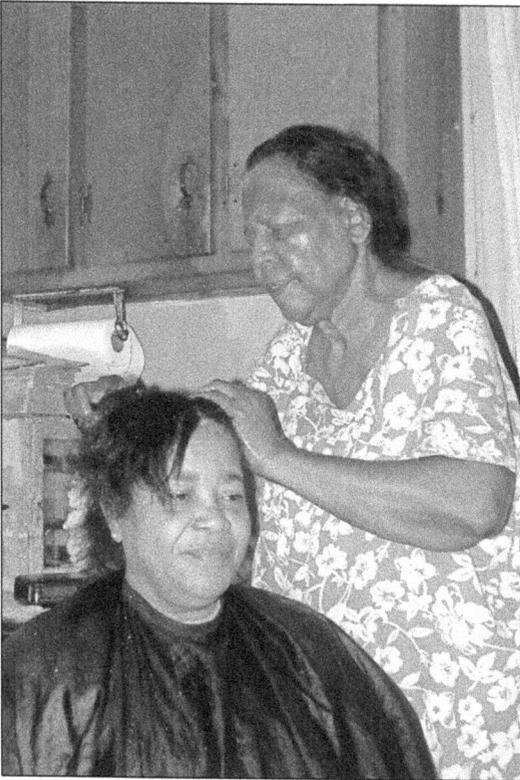

Eva Barnett is the proprietor of one of the oldest African American businesses in Carrboro. She opened Eva's Beauty Shop on Rosemary Street in 1970 but has been cutting, styling, and dressing women's hair for five decades! Willene Page (left) has been a happy customer for more than 25 years. The Alpha Kappa Alpha Sorority at UNC Chapel Hill recognized Eva in 2010 for her "non-traditional entrepreneurial success." The oldest African American business in Carrboro is the Midway Barbershop (below), which was opened by Stephen Edwards in 1946. The barbershop is located across Rosemary Street from Eva's Beauty Shop. Edwards's son Step runs the barbershop today. (Photographs by Dave Otto.)

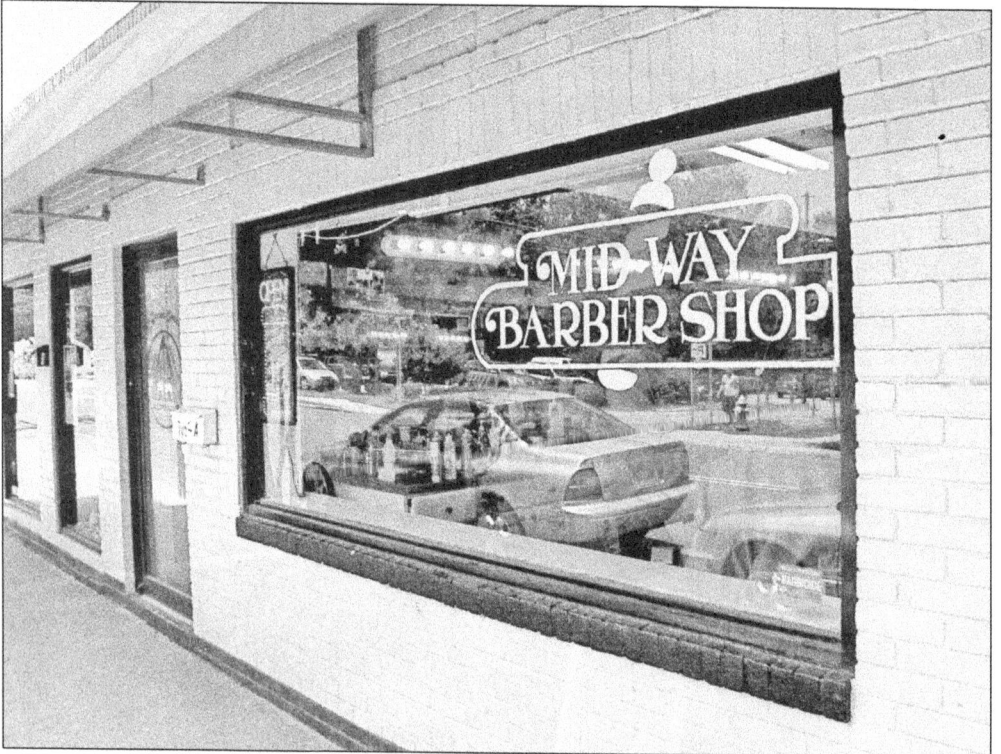

Six

CARRBORO'S FUTURE

During the past century, Carrboro evolved from a traditional working-class mill town to a vibrant community of students, artists, and activists. Earlier chapters focused on the past, but this chapter offers a peek at the future.

Three factors that will impact the future are demographics, land, and climate change. Carrboro has the highest population density in the state. The population in 2010 was about 20,000. A 45-percent increase in population occurred between 1990 and 2000, the highest growth rate in Orange County. Hispanics accounted for 40 percent of this growth. Carrboro has the highest Hispanic/Latino population in Orange County, and they will play an increasing role in Carrboro's future.

Lack of land is another important factor. Carrboro will be built out by 2020. Most recent development has been in the Northern Study Area. Strict ordinances constrain development in the University Lake watershed to the west. When no undeveloped land remains, the alternative is to build up. Construction of 300 East Main, Carrboro's first mixed-use high-rise, is scheduled to begin in 2010. Three other high-rise developments have been approved for downtown: Roberson Square (a five-story retail, office, and residential building at the corner of Greensboro and Roberson Streets); the Butler (a five-story building with 58 condominiums and first-floor offices on Brewer Lane); and the Alberta (a four-story mix of office, retail, and residential space on Roberson Street). These buildings will dramatically alter the landscape of Carrboro, which has prided itself on its old-fashioned appearance until recently.

Adaptation to climate change is already occurring. Fluorescent lights have replaced incandescent lights in many homes and public buildings. Hybrid vehicles are now common on roadways. Carrboro is planning greenways along Bolin and Morgan Creeks to encourage residents to use bicycles rather than cars to commute to work and campus. Urban vegetable gardens are also once again appearing in many neighborhoods.

Carrboro has shown a remarkable ability to adapt, to preserve historic neighborhoods and buildings such as Carr Mill, and to move forward with vigor and innovative ideas. Hopefully this book provides a deeper appreciation of Carrboro's colorful history, as well as a taste of future challenges!

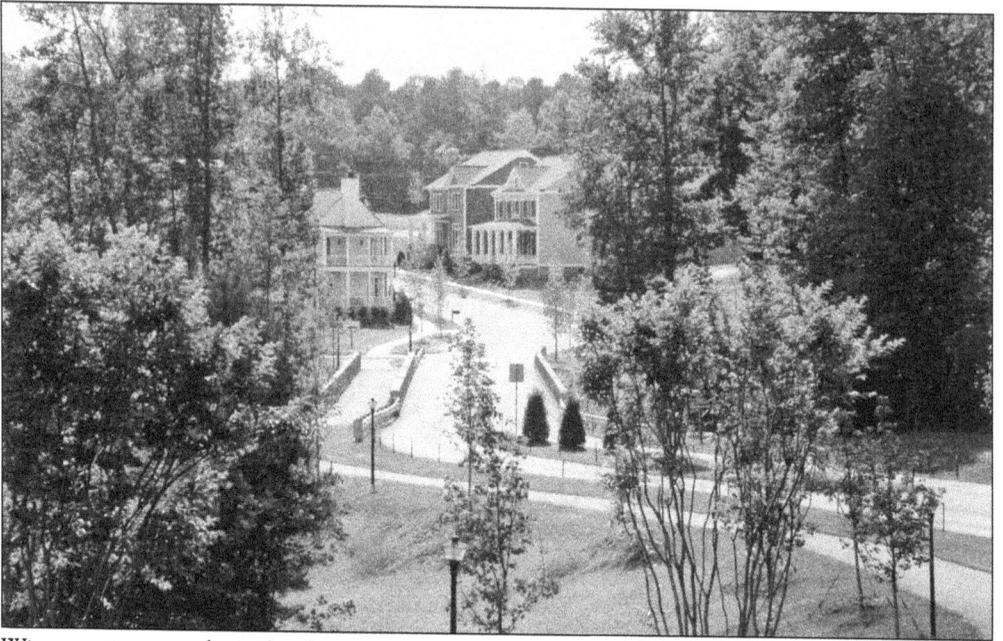

Winmore is a mixed-use development under construction on Homestead Road. The completed development will include a mix of single-family homes, town homes, and commercial lots. This development is the first combining residential and commercial units, a trend that will continue as the town runs out of buildable space. The upper view is the entrance road, which crosses Bolin Creek. The lower picture is the Faye Daniels House at Winmore. Daniels, who lived in the house for many years, rented space in the house to Andy Griffith when he was a student at the University of North Carolina in the late 1940s. (Photographs by Dave Otto.)

The 10-story Greenbridge complex (right) at the corner of Rosemary and Merritt Mill Streets in Chapel Hill is a taste of things to come in Carrboro. Greenbridge is a visionary project designed with sustainability principles in mind, the first mixed-use building in North Carolina eligible for gold certification in LEED standards. According to the March 14, 2007, *Independent Weekly*, the shape is unusual—"irregular and angular and split down the middle . . . a unique shape that will allow 90 percent of the units to be day-lit." Ground-breaking for 300 East Main, the first large high-rise development in Carrboro, is expected in early 2011. A helicopter view of this development is shown in the drawing below. The pedestrian corridor through the center of this complex is intriguing. (Right, photograph by Dave Otto; below, drawing courtesy of 300 East Main.)

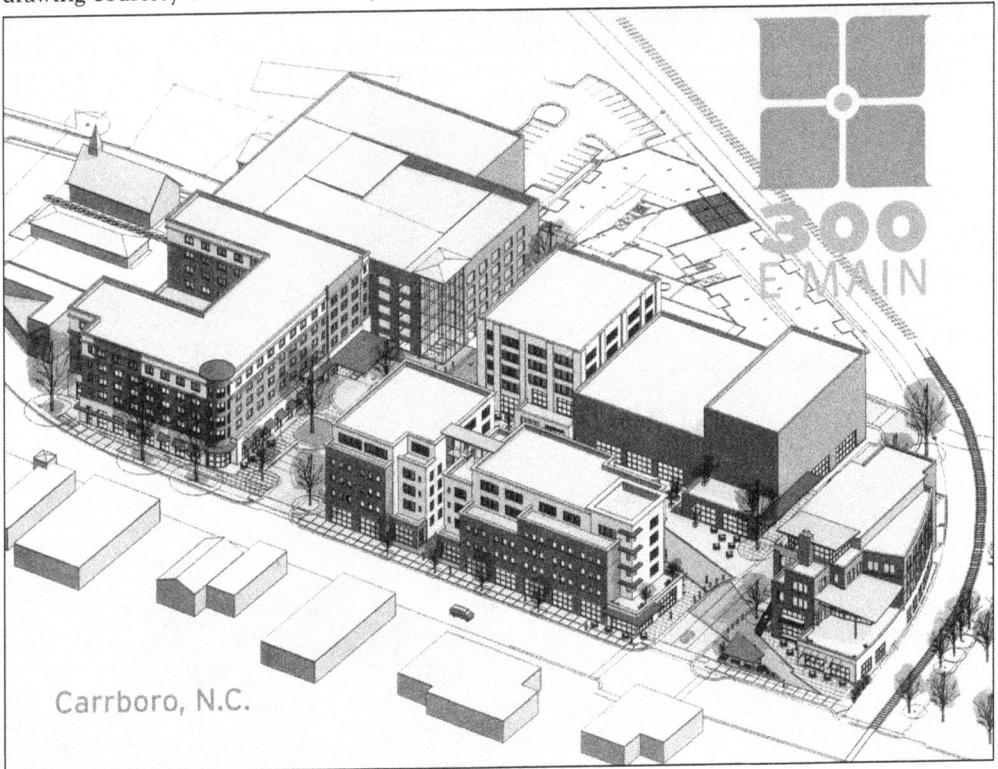

Carrboro, N.C.

Architectural drawings of the Alberta (above) building and the Butler (below) condominiums are reproduced on this page. The Alberta, to be built at the corner of Roberson Street and Roberson Place, will include office, retail, and residential space. The Butler building will contain 57 condominiums with office space on the first floor. Typical of many contemporary high-rise structures, these buildings are flat, rectangular boxes, quite different from the imaginative style of Greenbridge, but more compatible with the traditional appearance of downtown Carrboro. (Both, courtesy of the Carrboro Planning Department.)

02 | NORTH ELEVATION (FROM 300 E MAIN PROPERTY)

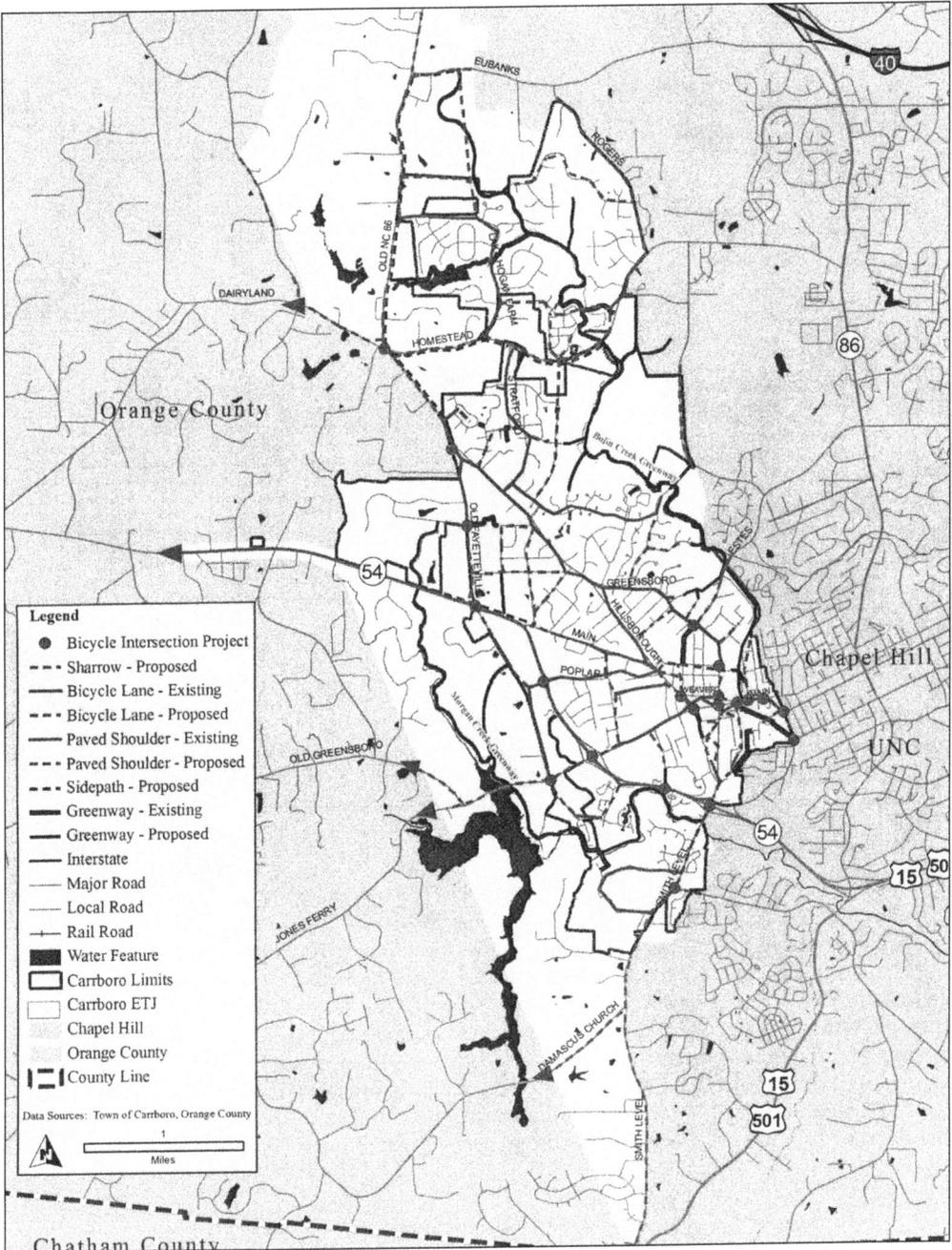

Existing and proposed Carrboro bikeways and greenways are shown on this map. An extensive system of on-road bikeways and a few off-road greenway segments already exist. Extended greenways are planned along Bolin and Morgan Creeks. These greenways will connect with comparable amenities along the two creeks in Chapel Hill. The proposed Bolin Creek Greenway will provide an off-road pathway extending from Lake Hogan Farms to the Chapel Hill Community Center. When completed, this 6-mile greenway will connect 44 neighborhoods, 7 schools, and 8 parks. The Morgan Creek Greenway will extend from Merritt Pasture in Chapel Hill to University Lake. (Courtesy of Jeff Brubaker, transportation planner, Town of Carrboro.)

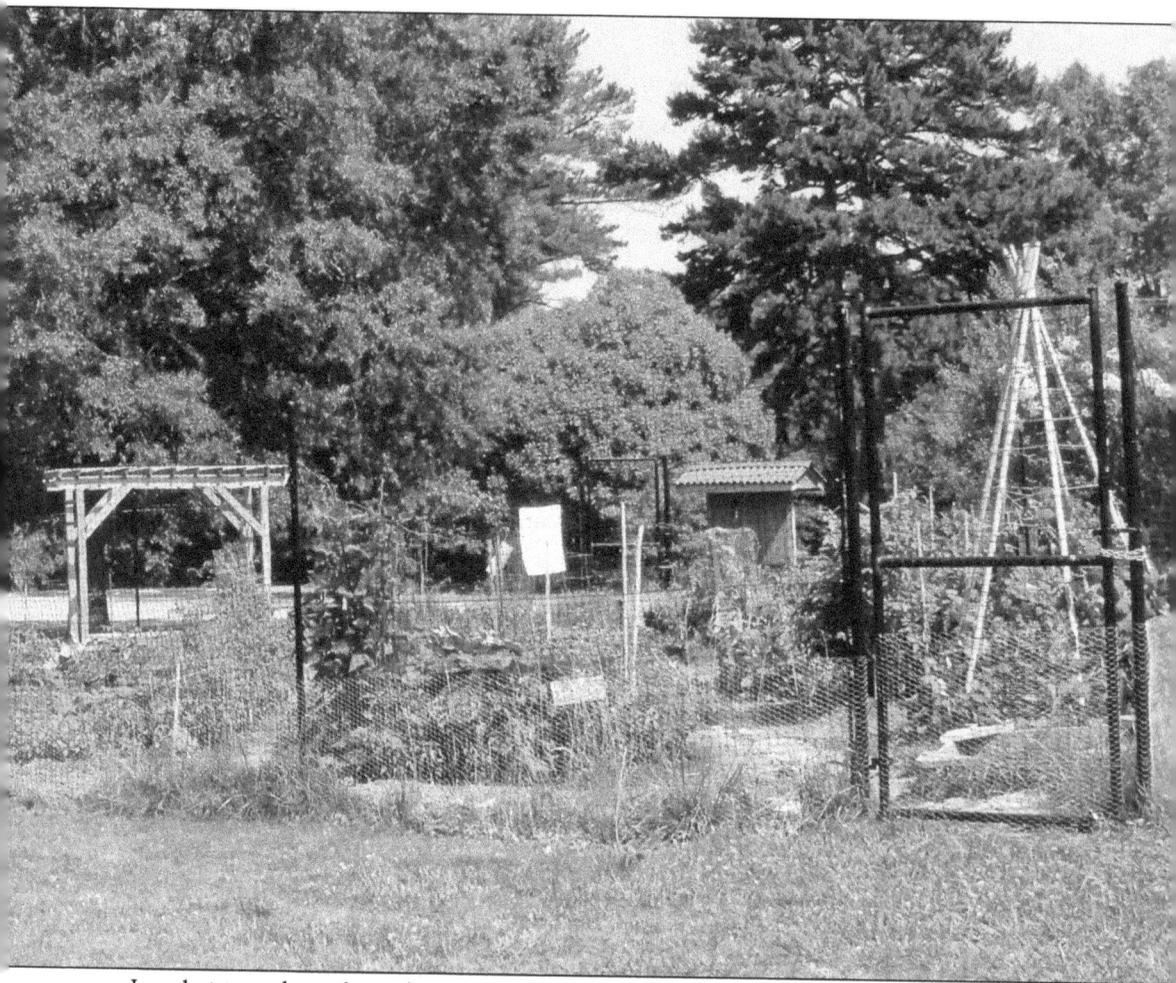

Local citizens have formed a group called Transition Carrboro–Chapel Hill (TCCH) to assist the community in adapting to climate change. Goals include encouraging the use of bicycles to commute to school and work in an effort to reduce the use of fossil fuels. Carrboro is a bicycle-friendly community that is very receptive to this effort. Another TCCH initiative is to encourage community and urban gardening to reduce dependence on food shipped from far away. A large garden can be found at the MLK neighborhood park on Hillsborough Street. Many urban gardens have sprouted up in neighborhoods around town, such as the one at the Carrboro Elementary School shown in the picture above. (Photograph by Dave Otto.)

The sight of a great blue heron is one of the joys of hiking or biking along the creeks in Carrboro. (Photograph by Dave Otto.)

BIBLIOGRAPHY

Barrett, Matt. *Matt Barrett's Travel Guides: Carrboro.* http://www.northcarolinatravels.com/carrboro/

Battle, Kemp P. *History of the University of North Carolina.* 2 volumes. Raleigh, NC: Edwards and Broughton Printing Company, 1907.

Brown, Claudia R., Burgess McSwain, and John Florin. *Carrboro, North Carolina: An Architectural and Historical Inventory.* Raleigh, NC: Contemporary Lithographers, 1983.

Chilton, Mark. From Forest to Mill Village and Beyond—Historical Geography, City Planning and Sense of Place. Presentation to the UNC Geography Department, January 23, 2010. http://piedmontwanderings.blogspot.com/

Dobyns, Brian, Perry Sugg, and Jean Earnhardt. *Baseline Documentation for Lloyd-Andrews Historic Farmstead.* Report from Triangle Land Concervancy. Raleigh, NC: Triangle Land Conservancy, 1998.

Dollar, Ernest. "Strayhorn House: History We Cannot Afford to Lose." *Chapel Hill News,* June 5, 2010.

Engstrom, Mary Claire. "Thomas Lloyd History." Hillsborough, NC: unpublished paper in Orange County Historical Collection, Hillsborough Public Library.

Gilgor, Robert. Summary of Interviews with OCTS/Lincoln High Mighty Tigers conducted in 2001. http://docsouth.unc.edu/sohp/, keyword "Gilgor."

Hardee, Rudolph. *Scrapbook of Carrboro, North Carolina.* Carrboro, NC: Calvary Baptist Church, 1983.

Hicks, Sally. "God's Greatest Vocation." *News and Observer,* Raleigh, NC: February 12, 1996: 1A.

Holder, Glenn. "Skipper of the 'Carrboro Limited' for 42 Years." *The Alumni Review,* University of North Carolina (1931): 19, 154–155.

Pearce, Emily E. *Rogers Road.* Raleigh, NC: Lulu.com, 2009.

Quinney, Valerie. "Mill Village Memories." *Southern Exposure,* volume 8 (1980)

Ryan, Elizabeth S. *Orange County Trio: Hillsborough, Chapel Hill and Carrboro.* Chapel Hill, NC: Chapel Hill Press, 2004.

Sturdivant, Joanna F. *The Status of the Small Mill Village: A Concrete Study of Carrboro, N.C.* M.A. Thesis, University of North Carolina, 1924. (North Carolina Collection, Wilson Library).

Tripp, Frances H. *Carrboro Sketches.* Unpublished collection of columns reprinted from the *Chapel Hill Newspaper,* 1981. (Available in the Chapel Hill Historical Society library.)

INDEX

Visit us at
arcadiapublishing.com

www.ingramcontent.com/pod-product-compliance
Lightning Source LLC
Chambersburg PA
CBHW080607110426
42813CB00006B/1431